EVERYTHING YOU KNOW ABOUT INDIANS IS WRONG

INDIGENOUS AMERICAS

ROBERT WARRIOR AND JACE WEAVER, SERIES EDITORS

*The Third Space of Sovereignty: The Postcolonial
Politics of U.S.–Indigenous Relations*
KEVIN BRUYNEEL

*The Common Pot:
The Recovery of Native Space in the Northeast*
LISA BROOKS

Our Fire Survives the Storm: A Cherokee Literary History
DANIEL HEATH JUSTICE

The Truth About Stories: A Native Narrative
THOMAS KING

Everything You Know about Indians Is Wrong
PAUL CHAAT SMITH

Bear Island: The War at Sugar Point
GERALD VIZENOR

The People and the Word: Reading Native Nonfiction
ROBERT WARRIOR

*Like a Loaded Weapon: The Rehnquist Court,
Indian Rights, and the Legal History of Racism in America*
ROBERT A. WILLIAMS, JR.

Everything You Know about Indians Is Wrong

Paul Chaat Smith

INDIGENOUS AMERICAS SERIES

UNIVERSITY OF MINNESOTA PRESS

Minneapolis • London

For publication information on previously published works in this book, see pages 191–93.

Published by the University of Minnesota Press
111 Third Avenue South, Suite 290
Minneapolis, MN 55401-2520
http://www.upress.umn.edu

Library of Congress Cataloging-in-Publication Data

Smith, Paul Chaat.
 Everything you know about Indians is wrong / Paul Chaat Smith.
 p. cm. —(Indigenous Americas series)
 ISBN 978-0-8166-5601-1 (hc : alk. paper) — ISBN 978-0-8166-5602-8 (pb : alk. paper)
 1. Indians of North America—Cultural assimilation. 2. Indians of North America—Ethnic identity. 3. Indians of North America—Government relations—1934–
4. Smith, Paul Chaat. I. Title.
 E98.C89S64 2009
 323.1197—dc22

 2008055791

Printed in the United States of America on acid-free paper

The University of Minnesota is an equal-opportunity educator and employer.

18 17 16 15 14 13 12 11 10 9 8 7 6 5 4

Lynora

Contents

Every Picture Tells a Story / 1

Part I. States of Amnesia / 7

Lost in Translation / 9

On Romanticism / 13

After the Gold Rush / 28

Land of a Thousand Dances / 37

The Big Movie / 43

The Ground beneath Our Feet / 53

Homeland Insecurity / 64

Part II. Everything We Make Is Art / 67

Americans without Tears / 69

Delta 150 / 79

Luna Remembers / 88

Standoff in Lethbridge / 103

Struck by Lightning / 113

Meaning of Life / 123

States of Amnesia / 138

Part III. Jukebox Spiritualism / 143

A Place Called Irony / 145

Life during Peacetime / 151

Last Gang in Town / 158

From Lake Geneva to the Finland Station / 163

Ghost in the Machine / 172

Afterword: End of the Line / 181

Acknowledgments / 189

Publication History / 191

Every Picture Tells a Story

History records that Ishi, a.k.a. the Last Yahi, the Stone Age Ishi Between Two Worlds, was captured by northern Californians in 1911 and dutifully turned over to anthropologists. He spent the rest of his life in a museum in San Francisco. (And you think your life is boring.)

They said Ishi was the last North American Indian untouched by civilization. I don't know about that, but it's clear he was really country and seriously out of touch with recent developments. We're talking major hayseed.

His keepers turned down all vaudeville, circus, and theatrical offers for the living caveman, but they weren't above a little cheap amusement themselves. One day they took Ishi on a field trip to Golden Gate Park. An early aviator named Harry Fowler was attempting a cross-country flight. You can imagine the delicious anticipation of the anthropologists. The Ishi Man versus the Flying Machine. What would he make of this miracle, this impossible vision, this technological triumph? The aeroplane roared off into the heavens and circled back over the park. The men of science turned to the Indian, expectantly. Would he quake? Tremble? Would they hear his death song? Ishi looked up at the plane overhead. He spoke in a tone

his biographers would describe as one of "mild interest." "White man up there?"

Twenty years later my grandfather would become the first Comanche frequent flyer. Robert Chaat was born at the turn of the century in Oklahoma, when it was still Indian Territory. It was our darkest hour. The Comanche Nation was in ruins, wrecked and defeated. The U.S. Army did a census at this time and found that 1,171 of us were still alive.

Grandpa Chaat was one of those holocaust survivors. He was a tireless fighter for the Jesus Road, who battled the influence of peyote and forbade his children to attend powwows. Yet he also taught pride in being Indian and conducted services in Comanche into the late 1960s. His generation was pretty much raised by the army, who beat them for speaking Indian and had them march like soldiers to school. Geronimo was the local celebrity, and my grandfather remembers meeting him before the old guy died in 1909. Fort Sill was a small place; I guess everyone knew Geronimo.

My mother remembers her dad's trips to Chicago and New York when air travel was often a two-day adventure. He sent his five children trinkets from the 1939 World's Fair, newspaper clippings about his speeches around the country, pictures of himself with Norman Vincent Peale.

She discovered the lantern slides on a trip back to Oklahoma in 1991. They were in a battered and ancient black case buried deep in a closet. These closets have given up more and more secrets as time has passed. A few years earlier, when Grandpa still lived in the tiny house in Medicine Park (soon he would move to a nursing home in town), he produced an eagle feather from one of those closets. The feather, he told my mother, belonged to an ancestor who was a medicine man.

The forty-eight square glass slides are about three by four inches, at least an eighth of an inch thick. Each has its own slot in the felt-lined case. They're heavy: a single one weighs more than an entire box of their modern equivalents. Generously engineered with metal and glass instead of cardboard and film, they are about as similar to today's slides as a 1937 Packard is to this year's Honda.

They show Indian lodges, tipis, Comanches of all ages in brilliant clothing, buffalo, horses, wagons, Quanah Parker's Star House, all in vivid, lifelike color.

Their meaning and purpose? Fund-raising, of course. There were even a few pledge cards in the case: "Indian Mission Fund. I pledge to pay the sum of _____ before May 1, 19_____." I could see Grandpa lugging his twenty pounds of glass slides through airports (still called "flying fields") because they would have been too precious to check through, the key to next year's budget or the church's building fund.

But what were these pictures? Mom could identify some of the locations and people, but most of them she could not. Maybe they weren't even Comanche. Perhaps the Dutch Reformed Church had a media consultant who put it together. The label points in this direction: "Chas. Beseler Co., New York," not some outfit in Lawton or Oklahoma City. Grandpa might have sent along a few of his own pictures, and the rest, for all we know, might have been from a photo agency in Manhattan.

To me the Indians in the pictures seem dignified, friendly, open to religious instruction and new cultural ideas. I imagine listening to Grandpa in a church meeting room in New York or Boston in 1937, hearing about the struggle for redemption and a better way of life. A people at a crossroads, he might say. The images underline his script: Indians in blankets with papooses on their backs next to Indians in starched western shirts and bandannas, posing for the camera on their way to a Jimmie Rodgers show. We see, ridiculously, an umbrella next to a wagon.

Which Will It Be, the Blanket or the Bible?

On second thought, it's obvious the Indians are resistance fighters pretending to cooperate. See that look in their eyes? They are American hostages denouncing imperialism in a flat, dull voice for the Hezbollah. They steal the photographer's gun when he's not looking. At the Gourd Dance tonight in the foothills of Mount Scott, they make plans for the future, plans the city fathers won't like.

We have been using photography for our own ends as long as we've been flying, which is to say as long as there have been cameras and airplanes. The question isn't whether we love photography, but instead why we love it so much. From the Curtis stills to our own Kodachrome slides and Polaroid prints and Camcorder tapes, it's obvious we are a people who adore taking pictures and having pictures taken of us. So it should hardly be a surprise that everything about being Indian has been shaped by the camera.

In this relationship we're portrayed as victims, dupes, losers, and dummies. Lo, the poor fool posing for Edward Curtis wearing the Cheyenne headdress even though he's Navajo. Lo, those pathetic Indian extras in a thousand bad westerns. Don't they have any pride?

I don't know, maybe they dug it. Maybe it was fun. Contrary to what most people (Indians and non-Indians alike) now believe, our true history is one of constant change, technological innovation, and intense curiosity about the world. How else do you explain our instantaneous adaptation to horses, rifles, flour, and knives?

The camera, however, was more than another tool we could adapt to our own ends. It helped make us what we are today.

See, we only became Indians once the armed struggle was over in 1890. Before then we were Shoshone or Mohawk or Crow. For centuries North America was a complicated, dangerous place full of shifting alliances between the United States and Indian nations, among the Indian nations themselves, and between the Indians and Canada, Mexico, and half of Europe.

This happy and confusing time ended forever that December morning a century ago at Wounded Knee. Once we no longer posed a military threat, we became Indians, all of us more or less identical in practical terms, even though until that moment, and for thousands of years before, we were as different from one another as Greeks are from Swedes. The Comanches, for example, were herded onto a reservation with the Kiowa and the Apache, who not only spoke different languages but were usually enemies. (We hated Apaches even more than we hated Mexicans.)

The truth is that we didn't know a damn thing about being Indian. This information was missing from our Original Instructions. We had to figure it out as we went along. The new century beckoned. Telegraphs, telephones, movies—the building blocks of mass culture were in place, or being invented. These devices would fundamentally change life on the planet. They were new to us, but they were almost as new to everyone else.

At this very moment, even as bullets and arrows were still flying, Sitting Bull joined Buffalo Bill's Wild West (the word "Show" was never part of the name) and became our first pop star. Like an early Warhol he sold his autograph for pocket change, and like Mick Jagger he noticed that fame made getting dates easier. He toured the world as if he owned it, made some money, became even more famous than he already was. Afraid of cameras? Talk to my agent first is more like it.

It was an interesting career move, even if it couldn't prevent the hysterical U.S. overreaction to the Ghost Dance that resulted in his assassination the same month as the Wounded Knee massacre.

Some think of Sitting Bull as foolish and vain. No doubt Crazy Horse felt this way. The legendary warrior hated cameras and never allowed himself to be photographed, although this didn't stop the U.S. Postal Service from issuing a Crazy Horse stamp in the 1980s. Maybe Sitting Bull was ego-tripping, but I see him as anxious to figure out the shape of this new world.

For John Ford, King Vidor, Raoul Walsh, and the other early kings of Hollywood, the Indian wars were more or less current events. Cecil B. DeMille, who made more than thirty Indian dramas, was fifteen at the time of Wounded Knee. They grew up in a world in which relatives and friends had been, or could have been, direct participants in the Indian wars.

The promise of film was to deliver what the stage could not, and the taming of the frontier, the winning of the West, the building of the nation was the obvious, perfect choice. Indians and Hollywood. We grew up together.

This has really screwed us sometimes, for example, the stupid macho posturing by some of our movement leaders in the 1970s. (If only their parents had said, *Kids! Turn that TV off and do your homework!* we might have actually won our treaty rights.)

But maybe it's better to be vilified and romanticized than completely ignored. And battles over historical revisionism seem doomed from the start, because the last thing these images are about is what really happened in the past. They're fables being told to shape the future.

All of the lame bullshit, the mascots, the pickup truck commercials, the New Age know-nothings, I used to find it embarrassing. Now I think it's part of the myth to think all that is bogus and the good old days were the real thing. The tacky, dumb stuff about this country is the real thing now. The appropriation of Indian symbols that began with the earliest days of European contact is over, complete. Today, nothing is quite as American as the American Indian. We've become a patriotic symbol.

For our part, we dimly accept the role of spiritual masters and first environmentalists as we switch cable channels and videotape our weddings and ceremonies. We take pride in westerns that make us look gorgeous (which we are!) and have good production values. We secretly wish we were more like the Indians in the movies.

And for the Americans, who drive Pontiacs and Cherokees and live in places with Indian names, like Manhattan and Chicago and Idaho, we remain a half-remembered presence, both comforting and dangerous, lurking just below the surface.

We are hopelessly fascinated with each other, locked in an endless embrace of love and hate and narcissism. Together we are condemned, forever to disappoint, never to forget even as we can't remember. Our snapshots and home movies create an American epic. It's fate, destiny. And why not? We are the country, and the country is us.

(What? No flash again?!)

Part I. States of Amnesia

Lost in Translation

The following comments were delivered as a presentation titled "Lost in Translation: Why the News Media Has So Much Trouble with Indians," Boswell Symposium, DePauw University, Greencastle, Indiana, March 15, 2004.

I work at the Smithsonian Institution's National Museum of the American Indian, and although I speak here as an independent critic and curator, I draw on that experience to look at why Indians, and Indian issues, are so often overlooked, misunderstood, misrepresented: in short, why the international community and the news media have so much trouble with us.

The answer to that question, as with so many others, is best provided by one person. He's one of the twentieth century's greatest philosophers, a man who speaks truth to power and who commands the attention of millions. As I'm sure you've guessed, I am, of course, speaking of legendary television producer Don Hewitt. The genius behind *60 Minutes* once explained how he managed to keep the show at the top of the ratings decade after decade, and why others who copy this apparently simple format always fail: he had rules. One of them was to avoid, at all costs, doing stories about Indians. Why? Because Indians talk too much, too slowly, and what they say is always complicated. With Indians it's never just "water"; it has to be "springs of life bestowed on us by our grandmothers." Why did Hewitt avoid Indian stories? Because we're lousy television.

He's completely right on all counts, and when I first came across that quote years ago it blew me away. Hewitt somehow understood one of the deepest truths about us, which I am sharing with you: although we are imagined as primitive and simple, we're actually anything but. He realized the Indian experience is an ocean of terrifying complexity. We are reputed to be stoic, but in reality it's hard to get us to shut up.

Even a talent as oversized as Don Hewitt (whose stock in trade was to make complex stories work on the unforgiving format of commercial television) says it's almost impossible. I propose, however, that Indians who won't shut up, and whose lives and political situations are bewilderingly complex, are only the tip of the iceberg.

The iceberg itself is the problem. And the iceberg is this: the Indian experience, imagined to be largely in the past and in any case at the margins, is in fact central to world history. Contact five centuries ago that for the first time connected the world was the profoundest event in human history, and it changed life everywhere. It was the first truly modern moment: continents and worlds that had been separated for millions of years became just weeks, then days, and now only hours away.

But how can the Indian experience be central when it is largely ignored and for most Americans encountered through cartoonish movies and in the names of rivers, cities, and sports teams? We are not marginal, and in the twenty-first century we are everywhere and nowhere, invisible and standing right next to you. Hardly any Indians live in Washington, D.C., unless you count all those Mayan Indians who clean offices and landscape gardens.

It all seems to suggest that everything most people know about Indians is wrong. Well, it is. That's the other profound truth I am sharing with you.

In February 1973, Indians in South Dakota took over the hamlet of Wounded Knee and were soon surrounded by hundreds of heavily armed federal troops. This won the Indian movement widespread international attention, including the most glittering of prize of all, the front page of the *New York Times*. Above the fold. Lots occurred over

the next two and a half months, including a curious incident in which some of the hungry, blockaded Indians attempted to slaughter a cow. Reporters and photographers gathered to watch. Nothing happened. None of the Indians—some urban activists, some from Sioux reservations—actually knew how to butcher cattle. Fortunately, a few of the journalists did know, and they took over, ensuring dinner for the starving rebels.

That was a much discussed event during and after Wounded Knee. The most common reading of this was that basically we were fakes. Indians clueless about butchering livestock were not really Indians.

In a funny and tragic way, this one incident had more resonance than the fact that the United States deployed Phantom jets and Vietnam-era weapons against a few hundred ragtag rebels armed mostly with shotguns and hunting rifles, or the subsequent criminal prosecutions of hundreds of activists that lasted for years and constituted one of the largest mass political trials in American history.

Sure, the illegal use of the military in the poorest jurisdiction in the United States is kind of interesting, but it was the cow-slaughtering deal that kept coming up. The Lakota patriots at Wounded Knee lost points for this. (I myself know nothing about butchering cattle, and would hope that doesn't invalidate my remarks about the global news media and human rights.)

That would be the last time in the twentieth century we ever made page A1 of the *New York Times* as a breaking news story.

Four years later, in September 1977, hundreds of Indians from throughout the Americas assembled in Geneva for a non-governmental organization conference. It was led by many of the same activists who were part of the American Indian Movement. The conference was a huge success. The U.S. State Department alerted embassies throughout the world to anticipate lots of tough questions about sterilization of Indian women and other human rights violations, and in the official documentation the United States issued a formal response, quoting the UN ambassador, Andrew Young.

Well, you know the punch line here. The Geneva Conference got virtually no coverage in the United States.

Yes, the news media always want the most dramatic story. But I would argue there is an overlay with Indian stories that makes it especially difficult, and that explains not only why an unprecedented international conference gets no ink but even why, when our actions meet their criteria, our incompetence in butchering livestock always overshadows the story of Phantom jets against .22s and shotguns.

What can one person do?

Not much.

So, I urge everyone, Indians included, to start with the assumption that everything you know about Indians is wrong. Begin not by reading about South Dakota but by looking for the Indian history beneath your own feet.

On Romanticism

rother Eagle, Sister Sky: A Message from Chief Seattle is a beau-
tifully illustrated children's book by Susan Jeffers. This pub-
lication spent more than nineteen weeks on the best-seller
lists and was chosen by members of the American Booksellers Associ-
ation as "the book we most enjoyed selling in 1991." Here's a passage
from the text:

How can you buy the sky?
How can you own the rain and wind?
My mother told me
 every part of this earth is sacred to our people.
Every pine needle, every sandy shore.
Every mist in the dark woods.
Every meadow and humming insect.
All are holy in the memory of our people.
My father said to me,
 I know the sap that courses through the trees as I know the blood
 that flows in my veins
We are part of the earth and it is part of us.
The perfumed flowers are our sisters.

We love this earth as a newborn loves its mother's heartbeat.

If we sell you our land, care for it as we have cared for it.

Hold in your mind the memory of the land as it is when you receive it.

Preserve the land and the air and the rivers for your children's children
and love it as we have loved it.

It's a great book with only one problem: it's a fabrication. *Brother Eagle, Sister Sky* is pretty much made up from start to finish. Who wrote these pretty words? Not the Suquamish leader Seattle. Not even Susan Jeffers, though she did some rewriting.

This speech, by now probably the most famous single piece of Indian oratory, was actually written in 1970 by a University of Texas instructor named Ted Perry. Perry was hired by the Southern Baptist Convention to write a documentary film on the environment. He came across a disputed (and probably fraudulent) version of a speech Seattle may or may not have given and rewrote it to express 1970s environmental ideas. At most Perry used a few lines of what Seattle may have said. At Expo '74 in Spokane, Washington, portions of the Perry–Seattle speech were plastered across the wall at the U.S. pavilion. This worked out well, since Expo '74's theme was the environment. The rest, as they say, is history.

The controversy concerning the origins of the speech began just as *Brother Eagle, Sister Sky* started its long tenure at the top of the bestseller lists. The fact that this book was written by and for white environmentalists was awkward, but the publisher handled the matter expeditiously. The best-seller lists simply reclassified the book from nonfiction to another category: advice, how-to, and miscellaneous. (That's where they put the cat books.) And they did more. The publisher brought out new advertisements featuring an endorsement from Jewell Praying Wolf James, said to be Seattle's great-grandnephew, who offered congratulations and thanks to the publisher for "taking our famous chief's words and transforming them into an experience all can use to stimulate an awareness of a natural world that is rapidly losing *its* beauty." *Brother Eagle, Sister Sky* continued to sell and sell and sell. But one reason the book's authenticity became a point of challenge

can be found in another story. This one concerns *The Education of Little Tree: A True Story,* by Forrest Carter, the autobiography of a Cherokee Indian's boyhood in Tennessee. Published by Delacorte Press in 1976 with virtually no promotion, the book slowly found a mass audience. It was re-released by the University of New Mexico Press and by the spring of 1991 had soared to the top of the *New York Times* nonfiction best-seller list. Reviewers and the public at large loved the story's strong environmental message, and the book proved especially popular with younger readers.

So now you're thinking, ha, Ted Perry again, right? Well, not this time. *The Education of Little Tree* was in fact written by Forrest Carter. The problem was that Forrest Carter turned out to be Asa Carter. And Asa Carter turned out, number one, not to be Cherokee, and, number two, to have been a legendary white supremacist. In the 1960s he led a Ku Klux Klan fringe group. In those days he was living large as a speechwriter for Alabama governor George Wallace. It was Asa Carter who wrote the electrifying battle cry: "Segregation now, segregation tomorrow, and segregation forever."

When all this was revealed in devastating detail by Emory University professor Dan Carter (no relation) in October 1991, there was mumbling about how Forrest must have mellowed over the years; that when he wrote *Little Tree* he was a different guy altogether. Yet a close reading of *Little Tree,* and his novel *The Rebel Outlaw Josey Wales,* which later became a Clint Eastwood movie about Comanches, shows a consistent worldview obsessed with the racial purity of family and kin. In all of Carter's writing, including the speeches he wrote for George Wallace, it's us against the world. Trust no one. So what happened? *Little Tree* was reclassified from nonfiction to fiction, and, like *Brother Eagle, Sister Sky,* continues to sell. Finally, it didn't really matter that the first Indian autobiography to win a mass audience of young people in the United States was both fake and written by a committed racist. It seems the penalty for fraudulent Indian books these days is getting moved from one best-seller list to another. Later editions of *Little Tree* include an introduction by Osage Indian academic Dr. Rennard Strickland, who discusses the controversy, agrees that Asa

Carter is the author, but still endorses the book as an accurate portrait of Cherokee life.

I've written about these two books at some length because to me they're perfect examples of the ideological swamp Indian people find ourselves in these days. We are witnessing a new age in the objectification of American Indian history and culture, one that doesn't even need Indians except as endorsers. Our past is turning into pieces of clever screenplay. And even the exposure of an Indian book as a total fake turns out to be little more than a slight embarrassment, easily remedied. The Indian intellectual community responded to this scandal with a deafening silence. Kurt Cobain, the late prince of grunge, appropriately from the city that bears the name of the Suquamish leader who so captivated Ted Perry and Susan Jeffers, wrote a lyric that described pretty well our reaction: "I found it hard / it was hard to find / Oh well, whatever, nevermind."

In the context of these publications and their checkered past I can't help thinking of Vine Deloria Jr., a Lakota and one of our best intellectuals. In 1969 he wrote *Custer Died for Your Sins,* a tough, funny book with the subtitle *An Indian Manifesto.* Fortunate timing helped make it a best seller. It was at the crest of the original Red Power movement of the 1960s: there were hunt-ins, fish-ins, and the occupation of Alcatraz Island. *The Unjust Society,* by Harold Cardinal, a Canadian Indian, and Stan Steiner's *The New Indians* seemed certain to be the first of a new wave of books about our current situation. But something else happened. Americans became fascinated with Indians all right, but not the ones still here. Instead, Americans turned to *Touch the Earth,* a sepia-toned volume of famous chiefs' greatest rhetorical hits. They read *The Memoirs of Chief Red Fox,* by a living Sioux chief no living Sioux had ever heard of. Chief Red Fox claimed to have personally witnessed the Battle of Little Big Horn. (This book was quickly revealed to be fake, but only after it sold more than any serious book about Indians ever had.) And, of course, the mother of all Indian books, Dee Brown's *Bury My Heart at Wounded Knee,* an entirely reasonable history of Indians that ends in 1890, without even a hint that some of us survived.

Well, all of this blew Deloria's mind, and in 1973 he drew this analogy. Imagine it's 1955, right after the landmark *Brown v. Board of Education* Supreme Court ruling on desegregation, in the midst of the Montgomery bus boycott. Martin Luther King Jr. holds a press conference, but it's a disaster; all the reporters ask about are the old days on the plantation and the origin of Negro spirituals. The freedom struggle pushes on, undaunted. Americans are transfixed by these dramatic events and rush out to buy new books on the cultural achievements of Africa in the year 1300. Two new Black writers, James Baldwin and LeRoi Jones, publish important books, but they're ignored in favor of a new history called *Bury My Heart at Jamestown*. People are terribly moved. Deloria continues, "People reading the book vow never again to buy or sell slaves."

Considering that recent decades have seen the most significant Indian political movement in a century, including much new sensitivity and education, we might have thought things had improved. But the familiarity of the situation around these recent publications leaves me feeling that things haven't gotten any better, only more subtle. The discourse on Indian art or politics or culture, even among people of goodwill, is consistently frustrated by the distinctive type of racism that confronts Indians today: romanticism. Simply put, romanticism is a highly developed, deeply ideological system of racism toward Indians that encompasses language, culture, and history. From the beginning of this history the specialized vocabulary created by Europeans for "Indians" ensured our status as strange and primitive. Our political leaders might have been called kings or lords; instead, they were chiefs. Indian religious leaders could have just as accurately been called bishop or minister; instead, they were medicine men. Instead of soldier or fighter, warrior. And, perhaps, most significant, tribe instead of nation. (For a more recent example of this, note how press accounts often talk about ethnic troubles in Europe, but tribal conflicts in southern Africa, Iraq, and Afghanistan.) Language became and remains a tool by which we are made the "Other"; the Lakota name Tatanka Iyotanka becomes Sitting Bull.

This is not to say that "bishop" was necessarily more accurate than

"medicine man," or that we have not made a term like "warrior" our own, or that translated Indian names aren't beautiful. It is to recognize that there are political implications to those decisions, and it is not one of multicultural understanding. The language exoticizes, and this exoticization has encompassed and permitted a range of historical responses from destruction to idealization.

Because our numbers are so few, the battle for a more realistic and positive treatment in the mass media has always been a necessary component of our struggle. The new traditionalism that does exist in Indian Country was won at great expense and effort. After all, it wasn't so long ago that Indian languages and ceremonies were discouraged and in many cases outlawed

In the 1970s it was enough to denounce silly books and movies about Indians, but today that reaction almost misses the point. What's different about our present situation is that it's become clear that we as Indian people love these books and the images they present as much as anyone else. In fact, both *Little Tree* and *Brother Eagle, Sister Sky* will probably find their way under many Indian Christmas trees and the fact of their authorship will not greatly affect their promising future with Indian readers any more than it will with non-Indian readers.

To me these new stereotypes show us that the myth-making machine has learned new and deadly tricks, much like the cyborg in *Terminator 2*. The ultimate result—the continued trivialization and appropriation of Indian culture, the absolute refusal to deal with us as just plain folks living in the present and not the past—is the same as ever. That's why challenging negative images and questioning who owns or produces these images are no substitute for a more all-sided oppositional effort. What's needed is a popular movement that could bring about meaningful change in the daily lives of Indian people.

In the 1970s, for instance, the American Indian Movement and other organizations challenged racist stereotypes while at the same time engaging a host of structural issues directly relevant to Indian people. These groups pushed for better housing and education, treaty recognition, an end to police brutality, the ouster of dictatorial colonial elites on reserves, and an end to exploitative lease arrangements.

It was in the context of this multifaceted social change effort that the fight for new imagery had a fuller meaning. Unfortunately, the current prospects for building such a movement are gloomy. But though things are bleak, co-optation is not inevitable. What has made us one people is the common legacy of colonialism and diaspora. Central to that history is our necessary, political, and in this century often quite hazardous attempt to reclaim and understand our past, the real one, not the invented one.

Five hundred years ago we were Seneca and Cree and Hopi and Kiowa, as different from each other as Norwegians are from Italians, or Egyptians from Zulus. One example of just how different is the splintering of languages. Greek and English and Russian all have the same Indo-European root. As different as those languages are, at one point they were very similar. In North America there were more than 140 different language stocks. The Americas were a happening, cosmopolitan place, and when Europeans first showed up one suspects the reaction was less the astonished genuflection the explorers reported than something more like, "So, what's your story?" When we think of the old days, like it or not we conjure up images that have little to do with real history. We never think of the great city of Tenochtitlán, the capital of the Aztec Empire, five centuries ago bigger than London at that time. We never imagine sullen teenagers in some pre-Columbian Zona Rosa dive in that fabled Aztec metropolis, bad-mouthing the wretched war economy and the ridiculous human sacrifices that drove their empire. We don't think of the settled Indian farming towns in North America (far more typical than nomads roaming the Plains). We never think about the Cherokee, who built a modern, independent nation, with roads and schools and universities and diplomatic recognition from European countries. After Sequoyah invented the Cherokee alphabet, it took just over a year for the entire nation to become literate. The Cherokee were just as typical as the Sioux, but you don't hear much about them.

America pre-Columbus was a riot of vastly different cultures, which occasionally fought each other, no doubt sometimes viciously and for stupid reasons. If some Indian societies were ecological utopias with

that perfect, elusive blend of democracy and individual freedom, some also practiced slavery, both before and after contact. And if things were complicated before the admiral showed up, they got even more so later. For centuries North America was perhaps the most intricate geopolitical puzzle on earth, with constantly shifting alliances between, with, and among Indians and Europeans. As Chuck Berry would say many years later, anything you want we got it right here. Yet the amazing variety of human civilization that existed five centuries ago has been replaced in the popular imagination by one image above all: the Plains Indians of the mid-nineteenth century. Most Indians weren't anything like the Sioux or the Comanche, either the real ones or the Hollywood invention. The true story is simply too messy and complicated. And too threatening. The myth of noble savages, completely unable to cope with modern times, goes down much more easily. No matter that Indian societies consistently valued technology and when useful made it their own. The glory days of the Comanches, for example, were built on the European imports of horses and guns. (We mastered both and delayed the settlement of Texas for 150 years, a public service we're proud of to this day.)

I have avoided here the usual recitation of broken treaties, massacres, genocide, and other atrocities. It's what we're supposed to talk about, but business as usual has been a dismal failure as far as dialogue goes, and I find guilt trips incredibly boring and useless. So when I say, for example, that the Americas are built on the invasion and destruction of a populated land with hundreds of distinct, complex societies, and a centuries-long slave trade involving millions of Africans, I offer this as an observation that is the minimum requirement for making sense of the history of our countries. This unpleasant truth is why Indians have been erased from the master narrative of this country and replaced by the cartoon images that all of us know and most of us believe. At different times the narrative has said we didn't exist and the land was empty; then it was mostly empty and populated by fearsome savages; then populated by noble savages who couldn't get with the program; and on and on. Today the equation is Indian equals spiritualism and environmentalism. In twenty years it will probably be something else.

I suggest that a powerful antidote to the manufactured past now being created for us is the secret history of Indians in the twentieth century. Geronimo really did have a Cadillac and used to drive it to church, where he'd sign autographs. Quanah Parker, the legendary leader of the Comanches, became a successful businessman after the war. He was part owner of a railroad, and endorsed farming and Jesus. At the same time he was a leader in the Native American Church and advocated the use of peyote. One of the most instructive lives is that of Black Elk, one of our greatest heroes and most revered spiritual leaders. His astonishing life included a stint in Buffalo Bill's Wild West

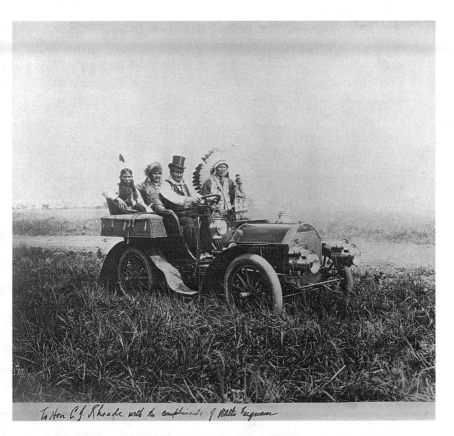

Geronimo and his famous Cadillac—except it was a 1905 Locomobile Model C. Courtesy National Archives, photo NWDNS 75-IC-1.

show and surviving the Wounded Knee massacre. An impresario-anthropologist named John Neihardt wrote of his fantastic visions in *Black Elk Speaks*. It's a book that has become quite literally a Bible. Apprentice medicine men use it today as an instruction manual for establishing their own practices.

I should clarify here that I am not Lakota and not particularly spiritual. Of course, to justify my own lack of spiritualism, it is necessary for me to cite the relatively pedestrian cosmology of my people, the Comanches. It seems like we had enough magic to get by, but everyone agrees our religion was a rather basic affair compared to that of the Hopi or the Sioux or the Egyptians. We're most famous for killing more settlers than any other Indian people, so I don't know, maybe we just didn't have the time. But anyway I was intrigued recently to come across a reference to Black Elk in which it was stated matter-of-factly that he was a Catholic most of his life. I found it fascinating that despite hearing about Black Elk for many years, I had no idea he spent most of his life as a Catholic. I learned that many believe Black Elk and white assistants sat down and invented practically a new religion, explicitly designed to blend teachings of Christianity and Lakota spiritualism. At the time, he was working as a catechist for the Roman Catholic Church of Nebraska. Essentially he was a lay priest. I also learned he had a first name, and that it was Nick. The *Who's Who* entry for Black Elk, then, probably would have described him as religious leader, entertainer, church bureaucrat, best-selling author. It would say he revolutionized Sioux religion with the help of anthropologists. Do any of these facts about Nick Black Elk invalidate his contribution to the Lakota people, or his spiritual teachings? I think that to say they do is to say the invented, impossibly wise sages are preferable to the people who actually lived. Nick Black Elk, an extra in Buffalo Bill's Wild West show, a paid employee of the Catholic Church, only becomes more interesting, not less, and his accomplishments even more remarkable. Those who would have it otherwise cherish the myth more than the genuine struggles of real human beings.

I believe all of our lives are just as crazy as Nick's. And when we refuse to acknowledge this, and pretend that it's otherwise, to pretend

we are real Indians, instead of real human beings, to please an antique notion of European romanticism, we may think we're acting tough but instead we're selling out.

Some people, Indians as well as non-Indians, will always prefer Ted Perry's version of Seattle's speech to Seattle's. And some will find the Black Elk of John Neihardt's book preferable to the intriguing, complex Nick Black Elk. In other words, some will prefer white inventions of Indians preferable to the real thing. There will always be a market for both nostalgia and fantasy. The cottage industry of Native Americana, formerly the province of hippies and enterprising opportunists, has become mainstream and professional. Today in the average chain bookstore in the United States, most of the Indian titles are in the New Age section. Well-meaning feminists conduct Indian rituals, and the men's movement has appropriated Indian drumming for its get-togethers. The myth-making machinery that in earlier days made us out to be primitive and simple now says we are spiritually advanced and environmentally perfect. Anything, it seems, but fully human. Over time these cartoon images have never worked to our advantage, and even though much in the new versions is flattering, I can't see that in the long run such perspectives will help us at all.

The victory of these new stereotypes and our seduction by them have serious implications for contemporary Indian life. In the old days—by this I mean the 1970s—there was a sense of irony and distance between whatever Hollywood or hippies or anyone else thought of Indian life. That seems to have all but disappeared, and many of us seem to have settled for the jukebox spiritualism of a manufactured image that in truth is just a retooled, updated version of the old movies we all used to laugh at.

I agree with Eduardo Galeano, who wrote, "I am not one to believe in traditions simply because they are traditions. I believe in the legacies that multiply human freedom, not in those that cage it. It should be obvious, but can never be too obvious: when I refer to remote voices from the past that can help us find answers to the challenges of the present, I am not proposing a return to the sacrificial rites that offered up human hearts to the gods, nor am I praising the despotism

of the Inca or the Aztec monarchs." As a cultural critic and participant in the contemporary art world, I reflect on these histories as a way of putting current events and ideas into perspective, in order to find my own place and direction within them. These broad cultural issues are a foundation from which I can look at my own work within this culture.

A few years ago I had the chance to visit a number of museums, interpretive centers, and heritage centers in the Canadian province of Saskatchewan. I was fortunate enough to get a backstage tour of the redesigned Natural History Museum in the capital city, Regina. The staff had completely rethought and redesigned the wing of the museum dealing with Indians. They consulted with Native people and hired Indians to paint and construct exhibits; I was especially impressed with a beautiful display of a modern canvas sweat lodge. Another had Indians in a tipi with a dog sled out front, and next to that were Indians in a cabin with a snowmobile out front. In these exhibits we managed not to be extinct.

I left the tour with nothing but respect for the efforts of a staff that obviously had thought long and hard about how to represent Indian culture. At the same time, for me the nagging question remained: Why are we in this museum at all? The English and the Ukrainians and the Germans aren't here. Only us, next to the dinosaurs. The museum I want to visit might show the history of the land now called Saskatchewan, and how humans have come and gone and changed the landscape. How Indians tricked buffalo into jumping off cliffs is worthy of an exhibit, but why stop there? How about one on Ukrainian farming techniques, or the socialist-inspired wheat cooperatives? How about an exhibit on the efforts of the Cree to learn farming, and the government policies that made those efforts almost impossible? Why not discuss the spiritualism of typical Saskatoon residents today? Give us a church next to that sweat lodge.

The big museums, together with the government itself in the United States and Canada, are key operators in the success or failure of Indian artists. They are playing a central role today in the development of contemporary Indian art—a great irony since many are still

in the process of properly relocating the tens of thousands of human remains in their collections, along with associated funerary objects. I bring this topic up not to run another guilt trip, since I've heard enough of those to last several lifetimes, but because I find it interesting that the same museums that carried out that ghoulish work of not so long ago, work that included scientific studies proving the inferiority of the red people, now rush to embrace the awesome accomplishments of this previously inferior race. I heard that fund-raising letter for the Smithsonian Institution's Museum of the American Indian in Washington, D.C., speculates that Indian astronomy was so advanced that it can perhaps aid in the exploration of Mars. This is something. Just in the space of a few decades they go from collecting our bones to saying we're smarter than NASA! One might even argue that a Native artist with talent has as good a shot at a viable career as white artists with similar abilities—perhaps even a better shot.

Despite this new and long-overdue attention, I believe making Indian art is a vocation fraught with danger, in some ways just as dangerous as those who participated in Sun Dances and peyote ceremonies when they were outlawed not so long ago. We can argue that we are part of an unbroken circle extending across half a millennium, but it's foolish to deny that in the here and now we exist as doubly marginalized cultural workers in a capitalist system. We know our audience will be overwhelmingly non-Indian. We know our work might be extravagantly praised and at the same time patronized and ignored in the circles where art matters. As artists, we need dialogue and criticism to improve our work, yet we must deal with the weird politics of not being simply artists but Indian artists.

Even the most adventurous contemporary Indian artist faces the prospect of a lifetime of Indian-only shows. Even fiercely intelligent, complex Indian art—without a reassuring eagle or buffalo in sight— runs the risk of becoming another form of exotic souvenir. Indian artists who choose to participate in the world of professional art critics and curators and museums, to dance with the prospect of fame and fortune, must face these contradictions head-on if they expect to survive with a shred of integrity. Ours is the first generation to have

enough writers and artists achieving success in the dominant culture to make up a crowd. And our backgrounds are often not so different from those of many other artists. Most Native artists went to university, have formal art school training, and professionally are not so different from their non-Native peers. But this does not mean we are the same, nor does it mean that we don't have something unique and valuable to offer. Silence about our own complicated histories supports the colonizers' idea that the only real Indians are full-blooded, from a reservation, speak their language, and practice the religion of their ancestors. Even though these criteria represent a small number of us as a whole, and fit few or none of us plying the trades of artist or writer or activist, we often consciously and unconsciously try to play this part drilled into us by the same Hollywood movies from which non-Indians get their ideas.

The process of incorporating traditional methods and worldviews into a form of expression that simply didn't exist a few centuries ago, a few lifetimes, really, is a monumental task that requires the greatest honesty and focused intelligence about our history and future as a people. It requires a foregrounded knowledge that virtually every aspect of being Indian in North America has been highly politicized, from the obvious examples of genocide and the deliberate destruction of language and religious practices. It means understanding that Indian culture is a valuable commodity that is bought and sold much like any other commodity.

For me, too much of Indian art settles for the expected protest, and the comforting, pastoral images that for the vast majority of us originate in exactly the same place as they do for non-Indians. Our predetermined role is to remain within the images of ecology, of anger, of easy celebration. There are many reasons the old myths are comforting and safe. Many Indian folks and our so-called friends in the Wannabe Tribe make a pretty good living dispensing jukebox spiritualism and environmental teachings. They believe being Indian means trying to be like the imaginary Seattle. History lessons from our recent past are irrelevant to the new Indian thought police, who prefer endless metaphysics on the essentially unknowable perfection of a past

that has little relation to their own lives. A cultural politics that chooses European images over the real history of our people is a politics that encourages the commodification of distorted, invented Indian values. It's a politics that insists Indians produce passbooks to make art.

These constructs lead into a box canyon from a John Ford western, this idea of the Noble Savage. Artists can help lead us out, by refusing to play the assigned role and demanding an honesty in their own work and that of others that truly honors the outrageous story of our continued existence. This new generation must dare for something bolder. For those willing to leave behind the cheap, played-out clichés, a great project awaits. It is nothing less than a reclamation of our common history of surviving the unparalleled disaster of European contact and the creation of something new and dynamic from the ashes.

Our survival against desperate odds is worthy of a celebration, one that embraces every aspect of our bizarre and fantastic lives, the tremendous sacrifices made on our behalf by our parents and grandparents and their parents. Dressing up, intellectually or literally, to someone else's idea of who we are insults that rich tradition of struggle and resistance, and turns our party into someone else's freak show, with us as the entertainment.

Not even Seattle talked like Seattle. Black Elk was not so different from our own goofy, imperfect uncles and grandfathers. The only reason Nick and Sitting Bull weren't playing Nintendo on the ship to Europe with Buffalo Bill is because it wasn't invented yet. Only when we recognize that our own individual, crazy personal histories, like those of every other Indian person of this century, are a tumble of extraordinary contradictions, can we begin making sense of lives.

Geronimo's Cadillac is waiting, and if we want, it can be a hell of a ride.

After the Gold Rush

People say life is about all kinds of things, but don't listen to them. Life is mostly about taking names and keeping score. And halfway through the first decade of the twenty-first century, here's what my scorecard says: nobody rules the Red Nation's aesthetic high ground like Zacharias Kunuk.

Here are some of the reasons why. Because in 2001 he gave us the bracing, spooky snowscapes of *Atanarjuat (The Fast Runner)*. Because he turned Igloolikians into movie stars and best boys and sound engineers and production designers. Because he imagined that an indigenous film made by indigenous people could win audiences and awards all over the world. Because after the movie came out we all turned Eskimo and wore plastic knockoffs of those narrow slit sunglasses and pretended they were made of whalebone. Because he took one of the most isolated Indian towns in the hemisphere to the first rank of international cinema. Zacharias Kunuk's little movie about a prehistoric folktale from Nowheresville sits on shelves in every well-stocked video store on five continents. *The Fast Runner* proved our dreams can come true.

How long will Zach keep his number one ranking? Who knows. Hopefully not long. The project, after all, is to learn from his example

and then leave him in the dust, as quickly as possible. Even if we don't succeed in this, there are other ways he could lose the title. For example, he might make a few bad movies in a row, or become a Scientologist. But until then, Z's our top dog.

His new film is called *The Journals of Knud Rasmussen* (2006), and it's about the introduction of Christianity to Igloolik in the 1920s. Kunuk describes it this way: "It tries to answer two questions that haunted me my whole life: Who were we? And what happened to us?"

Those questions—so breathtakingly honest, so smart, so timely, and so urgent—stopped me cold. Who were we, and what happened to us? For Kunuk, these two questions frame an explicitly anticolonial project, an investigation seeking answers and knowledge. The project isn't about what he knows, but about what he doesn't know.

This is not the way most Indian artists in the United States approach their next project. Too many Indian artists approach their work with statements, not questions. And the statements are along the lines of: this is who we are, and this is what happened to us.

Now, here's what I want to know: if Kunuk, who is a stone-cold Inuit from this town named for igloos far above the Arctic Circle, a

Still from *The Journals of Knud Rasmussen,* Isuma Distribution, Montreal, 2006. Igloolik Isuma Productions, Kunuk/Cohn Productions, Barok Films. Courtesy of Gillian Robinson.

place so remote that to get there from Montreal it takes two days of air travel, a village where they still hunt seals and polar bears, if this guy, who hates to travel because it's always too hot and too crowded, if he doesn't know who his people were, or what happened to them, doesn't it seem a little strange that we, his southern cousins, have so many answers, and so few questions?

Here are some interesting facts about Scottsdale, Arizona, courtesy of our friends at Wikipedia:

> Scottsdale was originally inhabited by Hohokam. From circa 300 BC to 1400 AD, this ancient civilization farmed the area and built some of the most ingenious irrigation canals the world has ever known. The name Hohokam translates as "vanished," as the civilization mysteriously disappeared without a trace.
>
> Before European settlement, Scottsdale was a Pima village known as Vaşai Svaşonǐ, meaning "rotting hay." Some Pima remained in their original homes well into the 20th century. For example, until the late 1960s, there was a still-occupied traditional dwelling on the southeast corner of Indian Bend Road and Hayden Road. By now, however, all Pima have either been priced out of town or moved into newer homes within Scottsdale; primarily South Scottsdale, the Salt River Pima–Maricopa Indian Community, or elsewhere.

I'm thinking, you know what, I bet most of those Pimas moved elsewhere.

As it happens, I'm writing from a hotel room on Indian School Road, not too far away from the southeast corner of Indian Bend Road and Scottsdale Road. I'm here on Indian business, researching an Indian exhibition about an Indian artist for the National Museum of the American Indian.

> The Hohokam's unbelievable legacy is their creation of more than 125 miles (200 km) of canals to provide water for their agricultural needs. The remnants of this ancient irrigation system were adapted and

improved upon in 1868 by the first Anglo company to stake a claim in the Valley of the Sun, when Jack Swilling set up the Swilling Irrigation Canal Company.

Scottsdale is one of the richest towns I've ever visited. Some people call it the Beverly Hills of the Desert. There are dealerships for cars you've never heard of, unless you are familiar with brands like Saleen, Panoz, Spyker, and Maybach. Apparently driving a Ferrari barely gets you noticed.

> Many celebrities have homes here, including musicians Alice Cooper, Dave Mustaine, Rob Halford, Brandy Norwood, Stevie Nicks, Glen Campbell, Rod Stewart, the late Lou Rawls, athletes Phil Mickelson, Danica Patrick, Mike Tyson, Charles Barkley, Wayne Gretzky, Muhammad Ali, radio personality Paul Harvey, actors Leslie Nielsen, Vince Vaughn, Rick Schroder, cartoonist Bill Keane, and porn star Jenna Jameson. . . . Arizona's handful of billionaires also enjoy residing in this area including the late Geordie Hormel, Bennett Dorrance and the Sperling Family.

Transparency is a popular word these days, but it's rarely practiced. The flawed genius of Wikipedia is that you really get to see all the edits and controversies behind the scenes. In this article, it's about things like whether Phil Mickelson lives in Scottsdale or not, and if the tone is a little too boosterish. (Yes, it is.) Overall, though, I think it's a pretty solid piece of work, and I forgive them for using the word "unbelievable" in describing the canals because later they include Jenna Jameson in the same sentence with Paul Harvey.

Scottsdale is a satellite city of Phoenix, which was named for the legendary mythical bird in honor of the vanished Hohokam people and their famous canals. Phoenix is the sixth-largest city in the country—and one of the fastest growing, despite the fact that the climate is absurd. My encyclopedia of choice reports that Phoenix has "some of the hottest seasonal temperatures anywhere. In fact, out of the world's large urban areas, only some cities around the Persian Gulf,

such as Riyadh, Saudi Arabia, and Baghdad, Iraq, have higher average summer temperatures. The temperature reaches or exceeds 100 degrees Fahrenheit on an average of 89 days during the year, including most days from early June through early September." Can you imagine what it must have been like building those canals a thousand years ago?

I heard once that Kunuk hates hot weather and big cities. I try to picture him poolside at the Phoenician Resort, the place I wish I were staying. "Every desire for comfort and convenience is anticipated and satisfied with grace and style." In Phoenix and especially Scottsdale, the better restaurants and shops are equipped with "misters," an irrigation system installed on the outside of buildings. The machines spray humans with water and in their own, modest way, attempt to air-condition the desert itself.

There's not a lot of air-conditioning in the Erica Lord story. Her biography is framed by apparent dichotomies. Her mother is Finnish American, her father Inupiaq/Athabaskan; she grew up in two places—a largely Indian village of three hundred people in central Alaska, and in white towns in Michigan's Upper Peninsula. She mostly lives in cities but always returns home, and isn't sure where home is.

Lord's father was an activist, which is a polite way of saying that he was a militant, a partisan, a fighter in that splendidly flawed, sometimes brave, too often tragic, frequently ridiculous, and always entertaining adventure called the Indian movement. And that was part of a much larger drama called the sixties, even though it showed up in the Red Nation a few years late and mostly took place in the seventies.

She remembers her dad quoting Malcolm X: "We didn't land on Plymouth Rock, Plymouth Rock landed on us." That's the sixties in a nutshell: an Indian militant in the middle of Alaska whose referents are Massachusetts and the Nation of Islam. For some people, and obviously I am one of them, it's impossible to think or write about that era without nostalgia. And even if we could, we probably wouldn't. We like our sixties nostalgia. A lot. Erica Lord, on the other hand, is deeply unsentimental about the imaginary landscape of the 1960s.

The Lord homestead is in a town called Nenana. Between two rivers and on the railroad to Fairbanks, it must be one of the most connected and cosmopolitan Indian villages you'll find in central Alaska. The discovery of gold in Fairbanks made Nenana a boomtown in the first decade of the 1900s. President Warren Harding stopped by in 1923 to drive the gold spike that completed the Alaska Railroad. The gold rush ended long ago, and now there's a steady stream of tourists on their way to Denali National Park and a lottery called the Nenana Ice Classic, where you place a bet on when the ice will break in the Tanana River. You could win $250,000 if you guess right. Lord remembers living on the wrong side of the railroad tracks, the ferocity of the she-moose, and a ramshackle tennis club. She remembers driving to Fairbanks with her dad, or sometimes just driving in circles around the village. That's where the political education sessions always took place, in the truck.

It's possible the weather in Nenana is even worse than in Scottsdale. More extreme, anyway: the record high is 98 degrees, the record low

Video still from Erica Lord's installation *Binary Selves,* 2007. Courtesy of the artist.

is 69 below zero. Scottsdale, incidentally, is where Lord's sister lives today. She might be walking through a mister outside a smart boutique at this very moment.

In Alaska, the Indians are shareholders of their own corporations, as opposed to citizens of sovereign (or formerly sovereign) nations, or neocolonial tribal governments. On paper at least, the Indian corporations are rich. This all came about because of the oil pipeline that was built in the 1970s, which required a political solution to the Indian problem to keep the oil flowing.

Lord spent most of her youth in Michigan's Upper Peninsula. She remembers tough, working-class white towns on Lake Superior, her doomed efforts to pass for white, and the fury of local citizens about court decisions that ruled Indians did indeed have rights to fish based on treaties. How did Lord know her neighbors were furious? Mainly because they drove around in cars with bumper stickers that read, "Kill an Indian, Save a Fish," and wore T-shirts with "Kill a Squaw, Save Two Trout" printed on them. She would suck in her cheeks and try to widen her eyes, which could only have made more obvious her colored skin and those aboriginal cheekbones straight out of central casting. And in fact, one could easily imagine Erica Lord starring in her own movie, about those two places and her struggles to navigate them.

You've seen this movie, of course. We all have. It's called "walking in two worlds," and although nobody knows for sure when the first version came out, on account of its being lost in the mists of time, we know it was a long time ago. Walking in two worlds is a movie that is constantly being remade, a paradigm, a way of thinking, and a way of living. It's an all-in-one solution for what ails red people in these confusing times.

Erica Lord doesn't want to star in this movie. In fact, she hates the movie. She also hates the novel, the sound track, and the outdoor Easter pageant. I can also report that she despises the hip-hop, death metal, and Zuni versions of walking in two worlds as well.

When you look at Erica Lord's work, it doesn't take long to figure this out. As far as she's concerned, walking in two worlds is a rusting,

broken contraption held together with stubbornness, colonized think-
ing, and baling wire. As I explained before, she is not very sentimental,
and you can easily picture her at dusk up there some crisp fall evening
in the Great North Woods. She's at the controls of a front-end loader,
wearing a flannel shirt and slowly, methodically driving that walking
in two worlds paradigm into a big ditch. Then she gets out and walks
over to the thing, douses it with gasoline, and strikes a match.

In a 2006 artist statement, Lord throws down a familiar gauntlet.
She wishes to "raise questions as well as declare convictions; challenge,
deconstruct, and influence a new way of thinking about contemporary
Native people, our life, and our art." In a classic line that echoes simi-
lar manifestos dating back to the middle of the preceding century, Lord
argues that "it is time to redefine our representation as Native people."

To be an Indian artist means always arguing about the rules, the
process, the judges, the reviews, where the shows are and where they
aren't. In her work and artist statements, Lord joins a grand tradition
of red artists dating back half a century. In 1958 Oscar Howe famously
protested his exclusion from the Philbrook Art Center's annual art
fair. The judges said his entry was "a fine painting, but not Indian."

Howe responded: "Are we to be held back forever with one phase
of Indian painting that is the most common way? Are we to be herded
like a bunch of sheep, with no right for individualism, dictated to
as the Indian has always been, put on reservations and treated like a
child and only the White Man knows what is best for him[?] . . . One
could easily turn to become a social protest painter. I only hope the
Art World will not be one more contributor to holding us in chains."

But although there are echoes of Howe in Lord, that doesn't mean
it's all echoes. Lord strikes at the very heart of essentialist thinking that
keeps the walking in two worlds paradigm in business:

I want to challenge ideas of cultural purity or authenticity as well as
discuss ideas of attraction, repulsion, exoticism, and gender or feminist
notions. . . . I want to raise questions as well as declare convictions;
challenge, deconstruct, and influence a new way of thinking about
contemporary Native people, our life, and our art. It is time to redefine

our representation as Native people. Until recently, those outside the communities, imposing an outsiders' view of our world, have largely dictated images of Native people. And when we do speak, it is most often directed towards the cultural tourist. Through art and media, the cultural shapers of this generation, it is time for us to self-determine, to control our representation and image, and to address modernity, development, and discuss the myth of an authentic culture.

Walking in two worlds is the expression of that myth, and the appeal of that myth is obvious. Walking in two worlds is ideological Vicodin, and because we're the descendants of the greatest holocaust in human history, you can expect most of us to keep getting our prescription refilled for the foreseeable future.

Kunuk's questions are also both a statement and a challenge. With them, he humbly acknowledges that despite his lifetime of engagement with precisely these issues—"Who were we, and what happened to us?"—the questions are so vast, so crucial, that his journey will never end. It is a measure of Kunuk's intellectual honesty and passion to deeply understand his own life, and the lives of his ancestors and his village, that he chooses to ask rather than explain. And it is a measure of his generosity as an artist that he invites interested people from all over the world to join his investigation.

At its best, this is what serious art practice is about: choosing the right questions and finding ways—visually, intellectually, emotionally—to explore them with viewers. It is not really about answering them. Often a successful investigation will not answer a single one, and instead raise new questions.

Walking in two worlds, on the other hand, is in the explanation, self-affirmation, and lecture business. It often comes across as smug and self-involved, at times seemingly oblivious to others' experiences of rupture, loss, grief, displacement, and dispossession.

In her installation *Binary Selves* (2007), Lord is forever leaving the Alaskan village of Nenana. She and her father reshoot the video every time she's there, taking chances, together making a movie that will never be finished.

Land of a Thousand Dances

As a people, there can be little doubt that Indians care too much about the movies. It's embarrassing sometimes, well, actually a lot of the time. We follow casting, production, shooting schedules of each new Hollywood feature about us with the anxiousness of European investors. (We kept each other posted on those ever-changing release dates for *The Dark Wind* for the better part of the first Bush administration.) We debate the merits of each new Indian film with passion and at great length, like film students in Upper West Side coffee shops. We critique plot, clothes, hair, history, horses, horse riding, language, and makeup. We get very involved.

Indians and Hollywood go way back, further than either one of us might care to remember. Indian film directors in the 1920s? Yep. One of the first movies ever released (1894) starred Indians and was directed by Thomas Edison. Something about a Ghost Dance. We've been acting in movies for more than a century, cursing them and loving them since day one.

The movies loom so large for Indians because they have defined our self-image as well as told the entire planet how we live, look, scream, and kill.

Indian filmmakers are prisoners of this creation, and it's no wonder that many of the Indian films that do exist are about stereotypes and even Hollywood movies.

We could hardly be expected to just ignore this, so we don't. We pay close attention, perhaps too close. If it's true that Indians have been deeply involved in the movie business, it's also true that those films aren't really about Indians in the first place. They aren't made for an Indian audience, and they were not written by Indians.

People weep about Hollywood's treatment of Indians and make the case that we're owed something because Jack Palance played Geronimo. Who cares? Not Hollywood, that's for sure. Just look at how everyone else is treated in most movies.

They don't call it "the industry" for nothing. People make movies for love and money, to get dates and buy cars and drugs, and always have and always will.

Lately, though, we've crossed the line somewhere and forgotten that it's entertainment and not a vehicle invented to first denigrate and then uplift our race. I believe our ancestors were smarter than that, about movies and a great many other things. (Of course, they were stupid about a lot of things too.)

But I don't think they would bother to attack critics for giving bad reviews to a movie written and directed by white people about Indians, as some Indian newspapers did when a timid backlash against *Dances with Wolves* emerged in 1992.

That shows how confused many of us are, that we would act as unpaid press agents for a film that is based on a novel and screenplay about Comanches, and then shifted to South Dakota only after the production designer—and this is kind of poignant—finds a shortage of buffalo in Oklahoma. And not a single Comanche or Kiowa character, some based on actual historical figures, is changed.

I mean, yo, Kevin, Mike: saying Ten Bears is Sioux is like saying Winston Churchill is Albanian.

It's the movies, and in the movies you can do anything, even make Ten Bears Sioux or Churchill Albanian, but don't toss out bouquets for service to the struggle and for historical truth.

I think in the old days we would have found the buffalo stampede stirring ("Hey, Reginald, don't you think it was smart of them to move production to South Dakota?" "You betcha, Eldon, paid off big time during the stampede"), dug the score, and moved on to other matters.

Now, many of us think how well *Geronimo: An American Legend* does at the box office will represent a significant advance for the Indian Nations.

We are the Indians. On the screen, up there? That's a movie about Indians.

The films we write about and debate and criticize are usually about the idea of us, about what people think about that idea, about Vietnam, the West, or buildings and food. Often, we're simply a plot device or there to provide visual excitement. That many of us would place real hopes and dreams of advancement in the hands of a business renowned for its single-minded focus on the bottom line speaks volumes about the intellectual state of Indian Country these days.

Indian filmmakers face tremendous obstacles in learning their craft, locating funding, obtaining the kind of real criticism and support that any artist needs to advance. But I believe this crisis dwarfs all others. There is a terrible problem Indian intellectuals (and believe me, if you're red and want to make films, you qualify) must face head-on, and that is that these days we're spinning tales invented by others.

For Indian filmmakers today there is no task more urgent than reclaiming a tradition of invention and storytelling by any means necessary, an intense desire to be on the world stage, and an unshakable demand not simply to star, or even produce, but to write and direct our own stories and visions.

But whose traditions and whose stories?

A few summers ago I did a reading at an adult literacy class of a few dozen older Indians. This was in Saskatchewan. Amid cigarette smoke and Styrofoam cups of instant coffee, the students struggled with learning how to read a language they spoke very well. Arranged on a table were a few dozen books, all of them about Indians and written for elementary to junior high school students. Not one book was written by an Indian.

Some of us come from traditional families steeped in resistance, educated by carefully remembered oral histories and speaking our native languages. But most of us do not, and that's particularly true for those of us who've taken up pen or camera. We get much of our information from the same place everyone else does.

A book called *Touch the Earth* had a huge impact on my family when I was growing up. A sepia-toned picture book of the greatest rhetorical hits of various Indian chiefs, it captured perfectly what we wanted to believe about our past, and not coincidentally provided a snapshot of environmental feel-good sentiments of the 1970s. That slapdash book, written by an English woman and still in print, offered a kind of truth that was much easier to take than what my grandparents, more or less raised by the army in Fort Sill had to offer. So it is with many of us.

Indians can be just as good at turning out hackneyed, clichéd stories of noble savages as any white person. We defer to no people when it comes to bad taste, and feature a full complement of hacks, crooks, scammers, and those who want nothing more than wealth and fame.

But Indian filmmakers, as opposed to those who want jobs in the industry, must care. And not just about who exactly wrote it, but about understanding the story in its context. It means being skeptical and inquisitive, not believing that because a speech in a book says it's by an Indian chief, it is, or that a ghostwritten autobiography necessarily tells the whole story.

An Indian film aesthetic must challenge the manufactured images if it seeks to represent our lives and experiences. This doesn't necessarily mean long hours in dusty archives (although that wouldn't hurt—a history by a librarian at the University of Illinois called *Bury My Heart at Wounded Knee* is treated as both gospel and the final word on the nineteenth century). But it does mean a deeply skeptical approach to the history, and not just that "white people told us" or what is taught in schools, or endless cheap shots at easy targets (and I write this as one who could easily be brought up on those charges), but a serious attempt to question and investigate what we know as Indian people, and how we know it.

That is simply too important a task to delegate to librarians and other fans of Indians, no matter how sincere they may be.

For all the new respect and attention, the fact is that Indian folks have produced relatively few novels, or works of history, nonfiction, and journalism. And that's why, for many "Indian" projects, the source material is often from whites. (Of course, others can write and have written intelligently about Indians; the problem is when work by Indians is a small percentage of what exists.)

The shocking truth is that our real stories are so much more entertaining, so much stranger, so much more interesting than the tedious recitation of wrongs and elders trying out their Old Lodge Skins imitations.

An Indian film will star the beautiful losers, belligerent drunks, failed activists, and born-again traditionalists who make up our community. It will be brave enough to engage issues like the civil wars that tore through some communities in the 1970s, the terrible plagues of isolation, alcoholism, and poverty. It will not turn away from complex issues like debates over identity. (Can you believe it? South Africa was dismantling apartheid while some Indian artists and activists insisted that without being enrolled with the U.S. government you were not officially an Indian, and artists not so enrolled could even be prosecuted.) To fly, Indian film must embrace the extraordinary complexities of Indian life, in the past and the present. It must face up to both the ugliness and the beauty of our circumstances.

A real Indian film about Geronimo might start with the reservation days, his days at Fort Sill, his still-debated conversion to Christianity, his hard drinking and skilled gambling. It would not be afraid to show him dead in a ditch of exposure. It would not be afraid to show him bitter and angry, feeling betrayed by his people.

Despite a rich history of Indians in Hollywood, in a real sense the first Indian films are just now being made. Maybe on three-quarter-inch video in Montana, or in south Minneapolis, or in the East Village of Manhattan. The format doesn't matter. It will have many different faces and styles, but it won't look like anything that's come before.

Let a hundred flowers bloom. Let's use film as billboards, propaganda, and cheap entertainment. Let's use it to record oral histories and basket weaving. Let's make blockbusters and soap operas and who knows, maybe a remake of that lost TV show from 1966 called *Hawk,* about an Indian detective in Brooklyn.

But let's make sure some of those flowers show our communities, past and present, as they really are, with all their beauty and ugliness and sadness and joy. Five centuries ago this continent was rocking, a place more diverse and outlandish than Europe, with empires evil and kind, with high-tech cities and agrarian paradises.

We come from the Land of a Thousand Dances, and our cinema, if it's really ours, will celebrate each and every one of them.

Let's make films for us, in the same way that filmmakers in Bombay or Fort Greene tell intimate stories of their own experiences, knowing that by making it specific it can be of universal interest.

Respect is nice, but it isn't power. And in the parlance of Hollywood, the question for Indian filmmakers and writers and cinematographers is this:

Do you want to direct? Or not?

The Big Movie

Our Indians are no longer dangerous. We understand today better than ever that we have wronged them much and often, that we have misjudged and slandered them in the past. Now the reaction has set in, and it is surely a curious phase of the white man's civilization that his latest invention is helping to set the red man right in history. All of the more artistic Indian films exalt the Indian, depict the noble traits in his character and challenge for him and his views and his manner of life the belated admiration of his white brother.

—*The Moving Picture World,* August 1911

About five years ago I realized that I had no memories of seeing Indians at the movies or on television while I was growing up.

Even now I recall nothing of the thousands of hours of Hollywood westerns I must have watched during the late 1950s and 1960s, in Oklahoma and the suburbs of Washington, D.C. It certainly wasn't because I found the medium lacking. I love television and always have. To this day I learn from it constantly, but somehow the thousands of flickering Indians that must have entered my consciousness disappeared without a trace.

There was no shortage of hardware, either. We had multiple televisions, my family being the kind of consumers whom advertising agencies classify as "early adopters." Televisions were in the kitchen and the den, and later I often smuggled a portable black-and-white set into my room and watched late into the night, using earphones to subvert curfew.

The amnesia is selective. I remember *The Twilight Zone, Mayberry RFD, Lost in Space, The Mod Squad, The Man from U.N.C.L.E.,* and

The Ghost and Mrs. Muir. I remember the assassinations, *Apollo 8,* and the night Lyndon Johnson told us he would not run for reelection, peace being more important.

Indians, sure. Uncle Sly and Aunt Maude, Grandma telling us how glad she is not to live in a tipi, and the Comanche Reformed Church (a sign near the door proudly announces last week's take: $82.50) packed with the faithful, singing Indian hymns where the only words I could ever make out were "Jesus Christ." As befits a people classified as prisoners of war and raised in a military fort, those of my grandparents' generation didn't talk much about the old days. I never heard them discuss *The Searchers* or *Two Rode Together,* tales of Comanche rape and kidnapping and murder that critics agree are among the best American films ever made.

Not that I remember, anyway.

The first moving pictures of Indians that anyone knows about were made by Thomas Edison in 1894. One was a little kinetoscope number called *Sioux Ghost Dance,* and even though it showed no such thing it was nonetheless a hit on the penny arcade peep show circuit. Modern cinema was still years in the future, but Indians were already establishing market share.

More than two thousand Hollywood features and hundreds of radio and television series later, the western rocks on. Critics through the ages have pronounced it dead and buried, but most of them are the ones dead and buried while the western is still here.

Cars replace horses, flying machines turn into 747s, communism rises and falls. Through it all the western escaped obsolescence by brilliantly reinventing itself time and time again.

So adaptable is the western, an art form as supremely American as jazz or baseball, that in the 1960s the Italians rode to its rescue, breathing new life into a format that seemed hopelessly old-fashioned by creating the spaghetti western: brutal, ironic and up-to-the-minute cool. Synonymous with Indian bashing, the number one moneymaking western of all time is *Dances with Wolves.*

We're coming up on the second century of westerns, but even that understates their importance. They have always been with us and

always will be. Flip channels if you want, try self-induced amnesia, but these efforts are useless, because the western is encoded in our cultural DNA. If you live in North America, westerns are the Book of Genesis, the story of our lives.

Attention must be paid.

Investigations of the western begin with a man named William F. Cody. He's our Moses, a self-made legend, partly fact and partly fiction, the genius who shaped the myth. In 1869 Ned Buntline, whose given name was Edward Z. C. Judson, famed writer of dime novels, traveled to Nebraska in search of a hero. He found the twenty-three-year-old William Cody, already a veteran of gold rushes, the Pony Express, and the Union Army. His nickname was a result of employment as a hunter-supplier for the Union Pacific Railroad.

Cody became a national figure through reports of his exploits in the *New York Weekly*. He appeared in stage productions based on his life, but it was a part-time affair. Mostly, he continued with being Buffalo Bill.

In 1883 he created Buffalo Bill's Wild West show and hired out-of-work Indians and cowboys. Troupe members included such all-star veterans of the Indian Wars as Sitting Bull, Black Elk, Gall, and Gabriel Dumont.

Why'd they do it? Here's one explanation, from a 1980 essay by Ward Churchill, Mary Anne Hill, and Norbert S. Hill: "Sitting Bull and other plainsmen who participated in spectacles such as Cody's and those of Pawnee Bill and Colonel Frederick T. Cummins had their reasons. There was a pressing need for revenue for their impoverished peoples, an ingrained desire for mobility, perhaps a hope of communicating some sense of their cultural identity to an ignorant and overbearing race of conquerors. But surely if the latter is the case they failed . . . before the prejudgemental myopia of their land- and mineral-hungry hosts."

Well, could be. Maybe they felt Bill's circus was a chance for cross-cultural exchange and went for it. Maybe they had to just keep moving, although this "ingrained desire for mobility" business sounds to me a bit like saying "all God's chillun got happy feet." Some believe

that Indians would never in their right mind choose to participate in kitsch like Buffalo Bill's Wild West. However, I speak from personal experience in arguing that Indians are as likely to have bad taste as everyone else.

Most accounts indicate Cody was liked and respected by his Indian employees, who knew exactly what they were doing. Like Cody, the Indians were part-time entertainers and full-time legends. They made history, then re-created the history they made in popular entertainments that toured America and Europe.

Just as art critic Philip Monk makes the case that Canadian contemporary art "passed from pre-modernism to so-called post-modernism without a history of modernism," so too can it be argued that our leaders anticipated the impact of the information age. Never given much of a chance with industrialism, we moved straight into ironic, cartoonish media experiments. If some prefer to see them as gullible dupes (let's see, Sitting Bull was a brilliant leader who forced the United States to sue for peace, and definitely nobody's fool, except of course for that embarrassing business with Cody), I see them as pioneers, our first explorers of the information age.

Unlike in the movies, everything was fabulous confusion. Here's an example: It's December 1890 on Pine Ridge Reservation in the southwest corner of South Dakota. The Ghost Dance religion was sweeping Indian Country. Wovoka, the Paiute some called Messiah, promised to vanquish the whites and return the buffalo. Indians were leaving the reservation for the Black Hills. The government was spooked and sent thousands of soldiers to put down a possible uprising.

They worried most about Sitting Bull, now back on the reservation after his vacation in Canada. General Nelson Miles called up Sitting Bull's friend and sometime boss William Cody. He was on staff with the governor of Nebraska and just back from another boffo European tour. In a bizarre confluence of show biz and diplomacy, General Miles asked Cody to talk some sense into Sitting Bull.

The meeting never happened. It's said Cody stayed up late the night before drinking with cavalry officers. Instead of Cody, an Indian agent with agendas of his own sent Indian cops to arrest Sitting Bull. The cops

were terrified, and when the Sioux leader refused to submit he was shot. Sitting Bull's white horse, a gift from Cody, was trained to kneel at the sound of gunfire. This the horse did, as his master lay dying.

Two weeks later, the massacre at Wounded Knee.

And twenty-three years after Wounded Knee, General Miles, Cody, and dozens of Indians who were there the first time re-created the events of that unfortunate December. The government cooperated in the film, hoping it would help with recruitment in a possible war with Mexico. Miles played himself and served as the film's technical adviser, which drove everyone nuts because he insisted on complete authenticity. This meant that because eleven thousand troops participated in a review after the hostiles surrendered, eleven thousand troops were going to be used in the movie. His demands that the Badlands sequence be shot in the Badlands, despite the enormous cost of moving the camp, caused so much bitterness that it finally ended his friendship with Cody.

General Miles also worked as a press agent for the movie, saying in one interview, "The idea is to give the whole thing from the start—the Indian dissatisfaction, their starving condition, the coming of the false 'Messiah' who stirred them to revolt, the massing of the troops, the death of Sitting Bull and, finally, the surrender. All of these incidents will be gone over, just as they happened. Some of the Indians will be there who fought against us. They will fight again, but there will be no bullets. All that is over."

They shot Sitting Bull again, and General Miles insisted on shooting the Battle of Wounded Knee just where it had originally happened, on the mass grave of Big Foot's band.

The night before, rumors swept the camp that some of the Indian extras were going to use live ammunition. Cody called a midnight meeting and told the Indians that the movie would celebrate their resistance. The next morning, although both sides were extremely reluctant to begin firing, they managed to reenact the battle/massacre.

Many Indians broke into tears.

After filming was completed, they spent six months editing. This was during a time when studios turned out movies by the week.

Finally it was shown before the secretary of the interior and other top officials of the Wilson administration, who said they loved it.

Other reviews were mixed. One critic called the film "war itself, grim, unpitying and terrible . . . no boy or girl should be allowed to miss these pictures. If you are a lonely man or woman pick up some equally lonely kiddie and take him for an afternoon with the great leaders of our army, with the great chiefs of our Indian tribes and two hours in the open world that has been made sacred by heroic blood of the nation's fighting heroes." A Lakota named Chauncey Yellow Robe trashed the movie in a speech to the Society of American Indians, reserving particular scorn for Miles and Cody, "who were not even there when it happened, went back and became heroes for a moving picture machine."

After a few screenings it mysteriously disappeared. Cody died in 1917, and for nearly a century the film was nowhere to be found. Even the title wasn't known for sure: at various times Buffalo Bill's lost masterpiece was called *The Indian Wars Refought, The Last Indian Battles; or, From the Warpath to the Peace Pipe, The Wars for Civilization in America,* and *Buffalo Bill's Indian Wars.*

The most expensive, elaborate western of its day was the victim of its own identity crisis. For Cody, it was the most spectacular movie ever made, the triumph of a fabled career. For Miles, it was part documentary, part training film. For the government, it was a recruiting device. For the critics, it was a battle showing the victory of Western civilization.

The final result must have been too close, too real. Critical distance could not be established when original combatants were actors, and when the set was the site of battle and massacre. It was a movie, but it was no western.

The films we know came later, as Hollywood matured (or at least got its act together). From the 1920s through the 1950s, cowboys and Indians were a lucrative staple of the industry.

The United States also was just getting its act together. National identity was still shaky, with the Civil War over but not resolved, a frontier still largely untamed, and vast regional differences. Reports of

armed resistance by Apaches, Cherokees, Yaquis, and others circulated into the 1920s. In 1909 a Paiute accidentally killed an in-law and vengeful whites chased him across Southern California. The accompanying hysteria made it clear many Americans were not convinced the Indian Wars were over, and even if they were, many wished they weren't. (This event became the subject of a 1969 pro-Indian movie called *Tell Them Willie Boy Was Here,* starring Robert Redford, Katharine Ross, and Robert Blake.)

The directors who pioneered the modern western grew up when the Indian Wars were recent, even current events. D. W. Griffith was born in 1875, Cecil B. DeMille in 1881, Raoul Walsh in 1887, and King Vidor in 1894. John Ford, born in 1894, said "I had four uncles in the Civil War. I used to ask my Uncle Mike to tell me about the Battle of Gettysburg. All Uncle Mike would say was, 'It was horrible. I went six whole days without a drink.'"

Geronimo, Wounded Knee, Sitting Bull, and Custer were no more distant to these guys than Vietnam and Watergate are to many of us.

The form they invented has several characteristics. First, it's set in the past. The films are implicitly about America's history. Second, they are set on the frontier. (This could be almost anywhere, since every inch of the continent was frontier at one time.) Third, westerns set up a language that extends the metaphor of the frontier into paired opposites of, for example the wilderness versus civilization, the individual versus community, savagery versus humanity.

John Ford, the king of westerns, set his most famous movies about Indians in Monument Valley, a landscape that might be described as Martian, to contrast the alienness of the land with the flimsy covered wagons and lonely outposts. Often the Indians seemed alien as well, but they seemed to belong there, while the Americans looked like intruders, or tourists.

Some westerns demonstrate a real interest in Indians, but in most we exist as a metaphor. The definitive moment in *The Searchers* is at the movie's close. The search is over, the rescue accomplished. Ethan (the rescuer, played by John Wayne) is asked to stay with the family he has reunited against all odds. Framed by a doorway, half in sunlight,

half in darkness, the tormented Ethan says no. Still at war with demons from his past, he can't submit to a domestic life. His personal war goes on, and as he leaves the cabin to take his place in the wilderness we know it has nothing to with Indians. The Comanches he's been fighting for two hours are simply a plot device to get to this moment of terrible pain and alienation.

Imagine something instead of Western history. For most of us, it can't be done. We think, okay, these movies are not exactly accurate (not that they ever claimed to be), and maybe we get closer to the truth if we turn them upside down. Maybe Indians didn't yelp. Maybe the whites were bloodthirsty savages. The master narrative will admit good Indians and bad whites; a western may even present the Long Knives as supremely vicious and evil and the Indian cause just, yet still not challenge the basic premise of a frontier, a wilderness, an inevitable clash of cultures that ends in conquest.

In *Dances with Wolves,* for example, there exists not a single positive white character. Many of the whites are physically disgusting. The film's title is the name of the protagonist, who becomes Indian and marries a white captive who is also now Indian. The government forces are incompetent, cowardly, and brutal. The message is delivered with all the subtlety of a sledgehammer. The Americans are portrayed as primitive Nazis with bad table manners.

Reduced to its essentials in this way, *Dances with Wolves* seems to be a devastating, revisionist history. In effect, however, the film is a moving, patriotic hymn to all that is majestic about the United States, which includes the beautiful Lakota and their tragic passing. The achievement of *Dances with Wolves* is extraordinary. It turns an indictment of genocide into a valentine to America. Audiences identify with the Indians as part of their heritage, a kind of national mascot. (In the fall of 1992, according to press reports, McDonald's, a corporation synonymous with patriotic values, was close to a deal to sell videocassettes of the movie with purchases of hamburgers and fries. These promotions are called tie-ins, and the phrase couldn't be more appropriate.)

One might ask, okay, maybe it is one-sided and overblown, but aren't we entitled to a little of that after thousands of one-sided and

overblown racist westerns? It's a fair question. The night of the Academy Awards in the spring of 1991, one television network showed the ecstatic reaction of children from the Pine Ridge Reservation in South Dakota. Who can argue that those kids who desperately need positive images and role models are not uplifted, even with all the movie's flaws?

Well, I won't argue with that. I think it is positive for many. I also think it leads to a dead end, because the opposite of a lie isn't necessarily true or useful. The master narrative thrives on us/them oppositions.

The 1992 remake of *Last of the Mohicans* provides another illustration of what is permitted and what isn't. Director Michael Mann, the inventor of television's *Miami Vice,* gave interviews describing his uncompromising research of the eighteenth century, his obsession with getting everything right, and the importance of showing the complex politics of the era. He said back then, if you were an American settler, the Mohawks were your rich neighbors.

I see no reason to doubt that Mann had every intention of including this idea in his movie, but he didn't. It can't be done, because the master narrative does not include settled, prosperous farming towns of Indians. Pictures of Indian towns challenge the idea of settlers clearing a wilderness and instead raise the possibility that Europeans invaded and conquered and pillaged heavily populated, developed real estate. (*Dances with Wolves* offered us an inviting and warm village, but temporary villages with tipis are acceptable. They do not represent property.)

This isn't because some studio boss got a call from the Trilateral Commission. It's because the audience knows about Indians, and knows Indians didn't live in settled farming towns. To be outside the narrative, then, is not to exist. A film that attempted to show something more historically accurate would appear to audiences to be like science fiction, a tale from a parallel universe.

The master narrative (let's call it the Big Movie) is like an infinitely elastic spiderweb that grows stronger with every change of pattern and wider after each assault. Subversion appears impossible.

Collectively, this is the accomplishment of westerns: they reconcile horrible truths and make them understandable, acceptable, and even

uplifting. And because they execute this reconciliation in a way that reinforces status quo values they are a powerful mechanism that serves and strengthens the dominant ideology.

The Big Movie is always up-to-date and these days is an equal opportunity employer. Indians are welcome to amplify or change aspects of the story, and with talent, luck, and the right contacts they have as much chance to succeed as anyone else. It won't be easy, but it's possible and in the long run inevitable that we will see westerns written and directed by Indians.

For those who want not a piece of the pie but a different pie altogether, the task is both urgent and far more difficult. It requires invention, not rewriting. Instead of a reimagined western, it means a final break with a form that really was never about us in the first place.

The stories of the continent must be told. A vacuum is impossible, and humans demand an explanation. So far, the only one that exists is the Big Movie. It says with perfect consistency that we are extinct, were never here anyway, that it was our fault because we couldn't get with the program. It says we are noble, are savage, and noble savages.

There's another narrative waiting to be written. It tells Sitting Bull's story: Did he complain about his agent? Did he really propose marriage to his secretary, a rich white woman from Brooklyn named Catherine Weldon, who lived in his camp in those final days? And let's say they did get hitched, could it have worked? It fully imagines that mysterious cipher Crazy Horse (as a kid his nickname was "Curly") and Almighty Voice and Poundmaker and gives voice to the women nobody remembers.

Even more important, it tells the story of our all-too-human parents and brothers and sisters and uncles and aunts, just plain folks who were nothing like the Indians in the movies even though some of us tried hard to be like them. It tells a story of resistance, of laughter and tears in a doomed land cursed by the legacy of slavery and genocide, a place that's perhaps forever beyond redemption but still the only place we've got.

It's a long shot but worth a try. Besides, in the Big Movie, we'll always be extras. In our movie, we could be stars.

The Ground beneath Our Feet

It is necessary that, with great urgency, we all speak well and listen well. We, you and I, must remember everything. We must especially remember those things we never knew.

—Jimmie Durham, Cherokee artist

All histories have a history, and one is incomplete without the other.

History promises to explain why things are and how they came to be this way, and it teases us by suggesting that if only we possessed the secret knowledge, the hidden insight, the relevant lessons drawn from yesterday's events, we could perhaps master the present. A history is always about who is telling the stories and to whom the storyteller is speaking, and how both understand their present circumstances.

The preposterous, wonderful, and breathtakingly ambitious project known officially as the National Museum of the American Indian (NMAI) seeks to tell a new kind of history, a new way, yet it too has a history like all others. And like the others its reading is incomplete without knowing how and when it came together, the conventional wisdom of the age, the furious debates the historians engaged in or avoided, who collected the pieces and assembled them, the name of the persons who wrote the first drafts and the final edits, who paid for it and why, where the missing footnotes and excised chapters are kept (if they were kept). In other words, no history is complete without knowing the history of the history.

Because this history is about Indians, a word that exists only with the idea of the discovery that created the modern world, the story of its creation could begin almost anywhere and with anyone: a sunrise at Chichén Itzá a thousand years ago, the floor of the London Stock Exchange last week, or a meeting of Smithsonian trustees in 1989. This small piece of that impossibly vast history is about the centrality of land and place in the Indian universe, and so it begins with a press conference in Los Angeles in 1962, because only by remembering how deeply Richard Nixon hated reporters can one appreciate the poignancy of his decision seven years later to fill in the White House swimming pool.

The press conference is one of the most famous in American political history. Two years after losing to John Fitzgerald Kennedy, Nixon ran for the California statehouse and lost badly. A furious Nixon blamed reporters for his defeat: "You won't have Dick Nixon to kick around anymore, because, gentlemen, this is my last press conference." *Time* magazine declared his career over. Journalists eagerly wrote his political obituary.

But was it true? Richard Nixon out of politics? It was a landscape difficult to imagine: American politics without Nixon was like Las Vegas without casinos, or Detroit without cars. For a while, it seemed Nixon really had retired from public life. He moved to New York, a place where he had no political future even before he was dead, and joined a law firm for which he represented Pepsi-Cola. Even his enemies, forever suspicious (and yet forever surprised), breathed easier. With Nixon, however, things were rarely what they seemed, and his Manhattan exile would become the staging ground for one of the most remarkable comebacks in American politics. Six years after that last press conference, he won the presidency, and four years later carried forty-nine states in one of the greatest landslides in American history.

Soon after moving into the White House in 1969, Nixon offered an olive branch to his enemies in the fourth estate and ordered that the White House swimming pool be filled in to create a more spacious area for the press. This was, after all, a new Nixon, less partisan, more

statesmanlike, a Nixon willing to let bygones be bygones. He and the press would start over, and to show his good intentions the president sacrificed the pool built by Franklin Roosevelt so that his new friends could move into a luxurious clubhouse built especially for them.

A few years later, with his daring, unthinkable opening to the Red Chinese, a new phrase would enter the language: "Only Nixon can go to China." He was the very last person one could imagine toasting Chairman Mao, and precisely because Nixon's anticommunist credentials trumped everyone else's, only he could recognize China and get away with it. On some level, the swimming pool diplomacy was even more amazing, because Nixon's hatred of the press was intimate and personal, and China was, well, China.

In those early months of the new administration, when anything seemed possible, even friendly relations with the East Coast press, Nixon's team shopped for a minority group they could make theirs. The country was a bitter and divided place, with race riots in the summer and massive antiwar demonstrations in the fall. Nixon campaigned on a pledge to end the war and, he said, "bring us together." If he ended the war, presumably the demonstrations would end as well. But blacks were hostile to Nixon and probably always would be. He had to bring together more than white people. The solution: Indians. Not much was known about them, they were fresh and interesting (for example, did you know thousands of them lived in cities now?), and the president's domestic policy wizards saw opportunity to improve simultaneously the lives of Indians and the image of their boss.

The historical record does not show Nixon to be personally invested in his Indian policy. He delegated and rarely inquired about how things were going at the Bureau of Indian Affairs or whether the Cheyenne were feeling any better about their prospects. After all, there were Vietnam, China, and détente with the Soviet Union to contend with. Still, the historical record also shows that Nixon was profoundly influenced by one Indian: his football coach at Whittier High School, a man known as Chief Wallace Newman. "I think that I admired him more and learned more from him than from any man I have ever

known aside from my father." Coach Newman taught his players two fundamental lessons: the importance of striving and the importance of winning. "He inspired in us the idea that if we worked hard enough and played hard enough, we could beat anybody." Nixon knew early on he was neither a gifted athlete nor a gifted student; he could only make the team through a superior work ethic and a refusal to ever, ever, give up, to ever quit. It is both highly speculative and irresistible to quote Nixon on Newman when discussing Nixon on Indians, just as studies on Nixon and Vietnam rarely fail to point out that Nixon's mother was a devout Quaker. (And if Quakers are renowned for their pacifism, they also are only slightly less celebrated for their friendly relations with Indians.)

Nixon may have cared nothing for Indians himself. Yet Indians cared about him. Today his administration is widely regarded as one of the most pro-Indian of the twentieth century, one that reversed the hated termination of federal reservations and restored Indian lands to tribes, and ushered in a new era of self-determination. Nixon's White House actually took Indians seriously and engaged Indian policy at the highest levels, and for that is remembered fondly by many Indians even now. Which is surprising, given that in the days and nights before Nixon's greatest political triumph, his landslide reelection in 1972, hundreds of angry Indians very nearly blew up the Bureau of Indian Affairs building, just six blocks from the Executive Mansion.

Nixon's five years as president coincided almost perfectly with a firestorm of Indian rage that seemed to come out of nowhere and turned Indian country upside down. The selection of Indians as the administration's model minority played a major, though unintended role in making this happen. In November 1969, a few dozen college students broke into a federal facility in California. It was technically a protest, but by the standards of the day just barely. A few weeks earlier, a quarter of a million marched in Washington against the war. Yet because the college students in California were Indians, and Indians were Nixon's chosen minority, this trespassing case attracted the attention of senior White House staff, and instead of being arrested the Indians found themselves negotiating with representatives of the president of

the United States. The federal facility was the abandoned maximum security prison called Alcatraz, and once the White House sent negotiators the publicity stunt became a matter of state, and all the ingredients were in place for a radically new Indian movement.

For the activists, Alcatraz was not a case of trespassing but occupation, or reoccupation. The students called themselves Indians of All Tribes and the rocky island reclaimed Indian Territory. For the next three and a half years, Indians occupied missile sites, tribal governments, bridges, and parks in a dozen states. Thousands took part, and unlike the other movements of the day, this one involved the very young and the very old, and all ages in between. Except for Alcatraz, college students never again led; if the white population that most fervently supported Nixon were the regular, gainfully employed, law-abiding folks known as "Middle Americans," the American Indian Movement (AIM) was led by former Honeywell executives (Dennis Banks) and accountants (Russell Means)—older guys long out of school whom one might call Middle Native Americans. They understood perfectly the poetics, risks, and rewards of political theater in the age of television, and mounted successful productions again and again. But they could never have done it alone. Without the drama of a White House envoy at Alcatraz, that takeover would have been a mildly interesting one-day story. With it, the occupation lasted nineteen months and won press coverage around the world.

In the fall of 1972, a tougher Indian movement, seasoned and battle-tested, weary but determined, rolled into Washington. The caravan was named the Trail of Broken Treaties, and had started from the West Coast months earlier. Along the way the caravan stopped at reservations and activists spoke about the reasons for their journey. They believed an urgent need existed for a national demonstration that told the federal government Indian treaties were not a dead letter but binding agreements that must form the basis for a new relationship with the United States. They found enough support to keep going and in the first week of November arrived in the capital.

It was a disaster from the start—a chaotic result of bad planning, mixed signals, and paranoia on all sides—and came very close to being

a full-scale catastrophe. The promised housing arrangements were inadequate or nonexistent, and the exhausted Indians gathered at the one place they believed could not turn them away: the Bureau of Indian Affairs. Days of negotiations to find suitable housing ultimately failed, and the colonial headquarters was transformed into a rebel fort. A tipi looked out on Constitution Avenue, and a banner announced the building's new name: Native American Embassy. Inside files were trashed and dumped into the street below. SWAT teams readied their assault, and above them furious Indians in war paint slapped together gasoline bombs, hoping they knew what they were doing, and hoping even more they wouldn't have to use them. Weapons were a makeshift affair: AIM warriors guarded the embassy entrance with armchair clubs and bows and arrows ripped from display cases. There was so much gasoline in the building, most of it in Molotov cocktails, that you could smell it from the street. Disaster was finally averted, thanks to high-level talks by Nixon's Indian troubleshooters and $66,000 in travel money provided by the federal government. The building survived, barely. A *Washington Post* headline a few weeks later read, "Damage to BIA third heaviest ever in U.S.," meaning damage to government property. The first heaviest was the British sacking of Washington in 1814; the second was the 1906 San Francisco earthquake.

It was a disaster for Nixon's Indian crisis managers, who stood accused by critics on the right of coddling the militants, and a public relations fiasco for Indians as well. They had failed to appreciate that the final days of a presidential campaign was the worst possible time for a demonstration in Washington. It never became a national story and the stories that were written focused on vandalism, not treaties. AIM had looked bad before (to call AIM disorganized was merely an observation, not a criticism) but never quite this bad. Warriors who days earlier shouted to reporters they stood ready to die for their people stood patiently in line the morning after Nixon's reelection, waiting for their gas money to be counted out for the drive home. AIM's many enemies, within the Indian world and without, hoped this humiliating defeat signaled the end of this crazy season of occupations.

Four months later AIM and Oglala activists seized the village of Wounded Knee. It was an electrifying event, and AIM's warriors looked anything but defeated as they faced federal marshals with M16s across a thousand yards of frozen South Dakota prairie. Armored personnel carriers moved into position and Phantom jets zoomed overhead. Television networks hired Lear jets to ferry film to Chicago of the warriors and the jets so that it could lead the evening news. In the last days of February 1973, Indians were biggest story in the country.

The siege at Wounded Knee lasted ten weeks, and after the first few days rarely made the newspapers. It ended with no clear winners, and many losers, among them two dead Indians, a paralyzed U.S. marshal, and the small village where dozens lived destroyed. AIM never recovered, and the federal government spent millions prosecuting every single person they could find who participated in the occupation. Hundreds were charged. The trials spanned two years and took place in three states.

Meanwhile, back at the White House, the swimming pool gambit had failed right along with the Indian model minority strategy. The new White House pressroom hosted the most contentious press conferences in the history of the republic. At one, Nixon announced he was "not a crook." In back rooms, Nixon made lists of enemies that included no Indians but many journalists. Many people disagreed with their president and felt he *was* a crook, and as the Watergate break-in slowly turned into a constitutional crisis, their number increased. Nixon, it appeared, had given up his swimming pool so that his traditional enemies could attack him in comfort.

In the months following the BIA takeover, the bureau's considerable art collection turned up in Indian homes across the land. Most people who took part in the Trail of Broken Treaties felt Washington, D.C., was no place for the art of Indian people and saw nothing wrong with taking the cultural treasures of their people. These were acts of liberation, not theft.

In August 1974, Nixon resigned the presidency. His successor is famous for two things, his brilliant statement on assuming office that "our long national nightmare is over" and for being very clumsy.

Gerald Ford was in fact the most gifted athlete ever to become president. He was an All-American football player at the University of Michigan, and turned down offers from the Green Bay Packers and Detroit Lions to play in the NFL. As president he tripped a few times in front of television cameras, and a mediocre comedian named Chevy Chase turned his impression of a stumbling Ford into a national sensation, and because television and popular culture rule the world, a couple of missteps became the truth about President Ford. It wasn't true, but it didn't matter.

President Ford didn't care about any of that, but he did like to swim, so he ordered a new swimming pool constructed on the South Lawn. In 1975 a National Park Service curator named Robert S. Marshall sifted through the excavated dirt, looking for the Indian artifacts he knew would be there. He found seventeen quartz chips and flakes, a pottery fragment, and other debris from eras known to archaeologists as Late Woodland and Archaic.

It was a completely unremarkable, perhaps even disappointing haul. Washington was built on Indian debris; everyone in the field knew that. William Henry Holmes, a celebrated artist, geologist, archaeologist, and a founding member of the city's legendary Cosmos Club, wrote a century earlier that artifacts were so numerous in this town, "in certain localities . . . they are brought in with every load of gravel from the creek beds, and the laborer who sits by the wayside breaking boulders for our streets passes them by the thousands beneath his hammer; and it is literally true that in this city, the capital of a civilized nation is paved with the art remains of a race who occupied its site in the shadowy past."

Leonard Crow Dog was saying much the same thing. A few weeks before Christmas in 1974, a curious proceeding was under way in federal court in Lincoln, Nebraska. Historians, legal experts, and Sioux elders presented testimony arguing that the Wounded Knee charges should be tossed because the 1868 Fort Laramie Treaty was still valid, and federal presence on the Great Sioux Nation was illegal. The judge made clear that he found this point of doubtful relevance; he indulged

the hearing while all but promising to ignore it. Leonard Crow Dog, his father Henry Crow Dog, and a dozen other Lakota traditionals sat in the jury box and posed for a photograph. It captured exactly the moral authority and weight of evidence the Sioux brought to bear during the hearing. Judge Warren Urbom denied their request to dismiss charges, but his lengthy, emotional ruling made it sound like the Indians lost on a technicality and not on the merits of the case. "It cannot be denied," he wrote, "that official policy of the United States until at least the late 19th century was impelled by a resolute will to control substantial territory for its westward-moving people. Whatever obstructed the movement, including the Indians, was to be—and was—shoved aside, dominated, or destroyed. Wars, disease, treaties pocked by duplicity, and decimation of the buffalo by whites drove the Sioux to reservations, shriveled their population and disemboweled their corporate body. It is an ugly history. White Americans may retch at the recollection of it."

Leonard Crow Dog spoke of both the 1868 Fort Laramie Treaty and excavation for President Ford's swimming pool when he told the court: "We are the evidence of the Western Hemisphere." Probably Leonard Crow Dog was not monitoring developments on the South Lawn (although with Crow Dog you could never be sure of what he knew or how he knew it), yet the pottery fragments would surely have been of no surprise. This "literal truth" of swimming pools and streets that William Henry Holmes wrote about is only the smallest part of what Crow Dog meant, however. His evidence is far grander than objects buried under government buildings or treaties between the Sioux and the United States. Crow Dog speaks of the Western Hemisphere as an Indian place—every bit of it, even the White House itself—a place thoroughly occupied for a very long time, a place whose discovery by Europeans created the world we live in today, a place we can't truly know until we dig deeper and look harder, until, finally, we examine the evidence.

The newest occupant of this ancient place known in recent days as the National Mall is charged with this impossible task. Should the

National Museum of the American Indian be the Louvre, or the Holocaust Museum? Should it speak to non-Indians, or Indians? Should it be celebratory, or somber? Challenge white people, or challenge Indians? Is it about beautiful objects, or history?

Yes.

With so many stories, who will decide which ones to tell? What about Chief Newman, Tecumseh, and Montezuma?

Precisely.

The newest occupant will also be the last, at least for as far as we can see, because the NMAI rises from the last open space on the National Mall. This might be the most amazing piece of earth in America. From above, the Mall is like a jigsaw puzzle. There is Washington, the father of the country, and Lincoln, who saved it. A great art museum to rival any in Europe on one side, a vast warehouse of the American rockets that conquered space on the other. It is America at its best, a country big enough and reflective enough and generous enough not only to acknowledge a fiasco like Vietnam but to remember it with the stunning black granite walls of the Vietnam Veterans Memorial. African slave labor built the Capitol dome, yet the structure signals freedom and hope in spite of that legacy, or perhaps because of it. The Mall is a fabulously weird theme park of the country's idea of itself over the past few centuries, a boulevard of broken dreams, liberation, and astonishing achievement. The planet's smart money is still betting Lincoln was right, this nation is humankind's last best hope, and is there better proof of America's outrageous ability to change (and not change) than this new palace carved from Indian rock?

Three years from the Mall in the mid-1970s contain more stories than every Smithsonian museum in the city could tell, yet the new Indian museum must tell stories from throughout the hemisphere and throughout time. It is a task that is at once absurd, impossible, and urgent, and it must be done well because the chance won't come again anytime soon. It must be a place of memory, memorial, hope, and grief; a place where questions are as important as answers and no facts are beyond dispute; and a place that honors the Indian past and Indian future.

The NMAI must be a place where the evidence is presented in a thousand voices and in a thousand ways; a place where visitors make up their own minds; and a place where the most important exhibit comes after everyone leaves, as visitors, for the very first time, look closely at the ground beneath their feet.

Homeland Insecurity

I spent the summer of 2005 visiting two art markets and thinking about two T-shirts. The art markets were in Santa Fe, New Mexico, and Venice, Italy. Like a running commentary on both, the T-shirts were everywhere. One shows Winchestered Apache warriors, including Geronimo, looking into the camera. They're not smiling. The text reads: "Homeland Security: Fighting Terrorism Since 1492."

This shirt is famous, you've probably seen it, and since you're reading this book, you might even own one. "Homeland Security" had already established itself as a cultural icon, and you see it everywhere in Indian Country. It was that rarest piece of conceptual art, both a critical and a commercial success. People loved that shirt. You would see all kinds of people wearing it, and here I mean to say lots of white people wore it. Which was good for the people who made it, but also changed the way it was received, and therefore changed its meaning. In my professional opinion as a Native American cultural critic, I would say its popularity had pretty much decimated its street credibility, and by the summer of 2005 the shirt had jumped the shark and was on its way to becoming kitsch.

The second shirt isn't nearly so famous. The design isn't as striking, and the words are harder to read, rendered in two colors, overlapping

the image, a line drawing that can't compete with Geronimo and his crew. The text, however, is a killer: "I'm part white but I can't prove it."

Don't get me wrong, both shirts are brilliant achievements, and they deserve a place in that Turtle Island time capsule that will show our descendants what life was like back in the middle of the first decade of the twenty-first century.

"Homeland Security" is a smart, tough work, but not tough or smart enough to prevent it from becoming kitsch. For most North American Indians, it affirms a basic truth: we were invaded, we resisted, and we're not real happy about the way things turned out. The thing is, Geronimo—as the big-budget 1993 film, with all the requisite Indian movie stars in front of the camera and the blessing of various important Apaches, showed—belongs to everyone. That's why the movie was called *Geronimo: An American Legend.* I mean, they didn't call it *Geronimo: An Apache Legend.* Geronimo, then, becomes an American hero fighting for his people and his country. So the message of homeland security easily turns into a message of American patriotism and a critique of the excesses of the U.S. government's response to 9/11—to the Homeland Security Act. You could easily imagine it being a hit with right-wing militias, given their Aryan mystification of Indians. Like most things we make, the homeland security T-shirt almost instantly is admired, interpreted, and bought by others. Which is why it remains a great piece of conceptual art, because what could be more perfect than seeing it for sale at a gift shop in the Denver airport? We did lose, and in that particular game, the rules were winner take all.

I don't expect to ever see "Part White" in an airport gift shop. It's too dark, too funny, and too Indian. It just doesn't work on the backs of white people, and doesn't make any sense on the backs of our brothers and sisters of color. "Part White" is a work of genius, a scalpel aimed at the scary heart of North American Indian anxieties that keep us up late at night. Those little nightmares include the lonely angst that comes from being, since the fall of apartheid in South Africa, the only people on earth who walk around with government cards that verify our percentage of blood, which we're happy to present to anyone

who asks. The nightmares include the vicious internal fights going on with those handfuls of tribes that are actually getting rich with casinos. They include the unstoppable demographic future that awaits us, when more and more Indians have less and less Indian blood. Because we don't know how to change the rules that decide who is Indian and who isn't, and don't even know if we want to. But everybody has an idea of where this percentage thing is going, and the image that comes to mind often involves trucks or buffalo going over cliffs.

The shirt is also a clever preemptive response to the unsolicited and unwanted information that a sizable percentage of white folks that we meet are part Indian. But the audience for "Part White" isn't them, it's us.

Part II. Everything We Make Is Art

Americans without Tears

I have this theory about Indians.

 I don't really think about it very much, because it is so much a part of my worldview that I take it completely for granted, like breathing. Over the past two decades, this theory informs nearly every word I've written, every exhibition I've curated, and every political project I've undertaken.

I have never shared this theory before, except with a few close friends, usually in a tavern, but I feel the time has come to present my theory to the world at large. It seems like the right thing to do, and the catalogue for the exhibition No Reservations: Native American History and Culture in Contemporary Art, held in 2006 at the Aldrich Contemporary Art Museum in Ridgefield, Connecticut, seems like the right place to do it. Transparency, the desire to advance the discourse, and so forth.

Actually, the theory is not really about Indians, it's about everyone else. And before I tell you what my theory is, I must explain that like most theories there are exceptions and anomalies, and theories about human beings can't really be proved, so probably this is all just educated guesswork at best.

Here's the thing: although I don't mean to hurt anyone's feelings, I know that some people are not going to like my theory. In fact, I'm quite sure that my theory will hurt some people's feelings. Obviously I feel bad about that; otherwise why would I have waited so long to reveal it to the world?

I'm almost ready to tell you, and I know you're almost ready to have me tell you. I just have to go over the stipulations. Let's agree that terms like "Indians" and "non-Indians" and "white people" and "history" and "culture" and "black people" and "the United States" are vague and essentializing and that we agree with contemporary science that the notion of separate human races is lame and provably false, that race is not culture, and history is very complicated. Let's agree that my theory is about North America in the second half of the twentieth century to the present. And let's remember the exceptions we agreed to earlier.

Okay, so here it is: Generally speaking, white people who are interested in Indians are not very bright. Generally speaking, white people who take an active interest in Indians, who travel to visit Indians and study Indians, who seek to help Indians, are even more not very bright. I theorize that in the case of white North Americans, the less interest they have in Indians, the more likely it is that one (and here I mean me or another Indian person) could have an intelligent conversation with them.

I further theorize that, generally speaking, smart white people realize early on, probably even as children, that the whole Indian thing is an exhausting, dangerous, and complicated snake pit of lies. And that the really smart ones somehow intuit that these lies are mysteriously and profoundly linked to the basic construction of the reality of daily life, now and into the foreseeable future. And without it ever quite being a conscious thought, these intelligent white people come to understand that there is no percentage, none, in considering the Indian question, and so the acceptable result is to, at least subconsciously, acknowledge that everything they are likely to learn about Indians in school, from books and movies and television programs, from dialogue with Indians, from Indian art and stories, from museum

exhibits about Indians, is probably going to be crap, so they should be avoided.

My theory believes that humans start out as pretty much the same, that it's culture that shapes our ideas about buildings and food and contemporary German art and the history of the United States. My theory argues that no reasonably sentient person of whatever background could seriously dispute the overwhelming evidence that Indians are at the very center of everything that happened in the Western Hemisphere (which, technically speaking, is half the world) over the past five centuries, and so that experience is at the heart of the history of everyone who lives here. That sounds like hyperbole, but actually it understates things. Contact between the two disconnected halves of the world five centuries ago changed the planet and created the world we live in today, so, really, the Indian experience is at the heart of, or pretty damn close to, the history of everybody, period. Not just corn and potatoes, but the Atlantic slave trade. Gold and silver, ideas, microbes, animals.

Yet that can't possibly be true, because everything you learn teaches you that the Indian experience is a joke, a cartoon, a minor sideshow. The overwhelming message from schools, mass media, and conventional wisdom says that Indians might be interesting, even profound, but never important. We are never allowed to be significant in explaining how the world ended up the way it did. In the final analysis, Indians are unimportant, and not a subject for serious people.

To understand why, check out John Carpenter's failed 1988 science fiction movie called *They Live*. An unemployed construction worker in a city very much like present-day Los Angeles finds a pair of sunglasses. He tries them on, and the world he sees through these shades is terrifyingly different from the one he knows. Ordinary-looking people are scary aliens. The billboards and television ads, magazines, all appear to have been designed by an extraterrestrial Barbara Kruger, carrying sans serif messages that read "Obey" and "Submit to Authority" and "Stay Asleep." On the dollar bill, no George Washington, just the words "This Is Your God."

Here's the ad copy for the movie: "They influence our decisions

without us knowing it. They numb our senses without us feeling it. They control our lives without us realizing it. THEY LIVE." And, "A rugged loner (RODDY PIPER) stumbles upon a terrifying discovery: ghoulish creatures are masquerading as humans while they lull the public into submission through subliminal advertising messages. Only specially-made sunglasses make the deadly truth visible."

Despite mediocre acting and low-rent production values, and even taking into account that the movie's full title is *John Carpenter's They Live,* this is really a wonderful film.

Sometimes people ask me, "Say, what is it that you curators do anyway?" The answer is simple: we design, build, and distribute specially made sunglasses that make the deadly truth visible. Curating is humble work, and God knows it doesn't pay very well, but we are proud to be fighting the ghoulish creatures from outer space and their allies, the humans who collaborate with them for financial gain. But you know what? These sunglasses are nothing but trouble. Once you put them on, you are doomed. The ghoulish creatures from outer space have better weapons, better security, and have made deals with sellout humans. They run everything, and it's only a matter of time—in the case of *John Carpenter's They Live,* about 90 minutes—before you are hunted down and killed.

Nobody, and certainly not me, welcomes the prospect of being hunted down and killed by murderous aliens. As an abstract proposition, sure, it's easy to say it's better to die on your feet than live on your knees. But who knows how any of us might respond when the abstract question becomes concrete?

In the case of the band of resistance fighters led by Aldrich Museum curator Richard Klein, we do know. The ten artists represented in No Reservations: Native American History and Culture in Contemporary Art have seen the deadly truth, stood their ground, and now present us with a dazzling new line of hegemony-busting Ray-Bans. Klein's people tell me the 2007 model uses the latest nanotechnology manufacturing techniques to improve things like infrared waveform detection, but those are issues that I am not qualified to assess or explain. I can tell you this, however: these shades rock. Compared to the

sunglasses we had to use back in the day, well, you can't even compare them. These things are the Hubble Space Telescope of alien detection.

Klein has organized No Reservations in a spirit of respectful dissent from the prevailing codes of how Indian contemporary art should be presented. The code strongly advises that Indian artists should be in a group show with other Indians. The code also advises that only Indians have authority to speak on Indian issues, and Indian issues should be about "land" or "identity" or "we are/have always been/will always be here" and that Indians are "sacred" and so forth. The proper role of a white curator is to facilitate the neutral presentation of Indian artists and their work, and to have no real opinion on the content. The proper role of white artists, well, they don't really have a role.

The code has been in effect for a couple of decades now, and to state things bluntly, it feels deader than disco. In the United States, a few dozen Indian artists regularly get exhibitions, almost never at major galleries or museums. In Canada, Native artists have a much higher profile generally, and two artists, Rebecca Belmore and Brian Jungen, are considered at the very top of contemporary Canadian art. In both countries, a major discussion these days involves the need for Indian artists to be included in exhibitions with non-Indian artists.

We have to acknowledge that the Native art discourse is partly to blame for the reluctance of non-Indian curators to propose such exhibitions. The essentializing vibe of much of the current work, and how it is packaged, reads as a take-it-or-leave-it proposition, and not one that invites discussion. Some of us do have attitude problems, maybe we are defensive and impatient, unable or unwilling to hear constructive criticism, too quick to label honest critiques as racist insults. Let me state this plainly: we must be open to genuine dialogue. We have made mistakes, lots of them, and we have much work to do.

At the same time, there are valid reasons for the resentment Red Nation artists and curators feel. For example, we watched as not long ago Chinese conceptual artists exploded on the international art scene. Most American art curators knew little about those artists, their work, or the context for the work. What did the American curators do? Did they whine about how they didn't know how to approach this work,

that they hadn't studied Chinese conceptual art in school? Did they doubt their ability to understand another culture? No. Like serious contemporary art curators all over the world, they went to school and pretty soon were au courant with all things regarding Chinese conceptual art.

Curator Lowery Stokes Sims remembers that only a few decades ago, it was a common experience for black artists to send slides to galleries, receive phone calls from curators who said, interesting, come on down, let's talk, and when the artist arrived, inconveniently dark-skinned, the curator would politely apologize and say their gallery doesn't "do black art." That probably still happens sometimes, but it is not common practice.

We ask why the American art world can adjust and change in those cases but so far have failed to engage, program, and critique Indian artists.

Curator, critic, and Cornell professor Salah Hassan asks, "Why does the Other always have to speak for the Other?" No Reservations shows us that, at least sometimes, they don't.

This is the big secret: that we do have a common history, that there really weren't any Indians in 1492, there weren't really any Europeans either, that everything was so fabulously complex and so different from how we're taught to think about it. A crucial moment in the history of the world becomes a lesson plan in ethnology, a story about strange religions, pots, and textiles. The lesson plan speaks of "whites" and "Indians," when the humans involved had no idea of either.

The big secret is that history isn't over, that Fairfield County, Connecticut, remembers King Philip's War even if it pretends to remember no such thing. Everyone is implicated in this history, it made us who we are, and therefore it is in the interest of anyone and everyone curious about how things came to be the way they are.

We live in a conspiratorial age, and it would be convenient if there were a grand scheme to explain it all. The Roman Catholic Church, the kings and queens of England, the Trilateral Commission, or perhaps even aliens. But I think it is much better that there is no such conspiracy at work, because if there were, our history would be just

some paperback novel you could finish in two
be that.

The history of Connecticut is weird and da
I wish I were smart enough to summarize
paragraph, but I'm not. Not even Jill Lepoi,
winning book about the conflict, can do that. Know wny.
that claimed more casualties per capita than any conflict on American
soil in the past three hundred years, the war that incinerated half of
the English settlements in New England, defies summarization in one
paragraph.

The great project that awaits is to acknowledge the awesome complexity and find new avenues of investigation. Simply reversing the bogus dichotomies doesn't get us anywhere. The project isn't about the good guys being bad, and bad guys being good, but about finding new ways of seeing and thinking about the history that is all around us. Because of the centrality of the Indian experience, and because of the particular place of privilege white people inhabit in relationship to that experience, many whites have only a few choices. They can become "interested in Indians" and completely ignore that centrality; they can recognize the centrality but shy away from engaging the issue because it's all too complicated (the smarter ones), or, if they're both smart and brave, they can honestly engage in a dialogue, as the artists in No Reservations have done. That isn't only subversive, it's really difficult. Few can do it at all; hardly anybody knows how to do it well.

David Milch is one who knows. In his thrilling HBO television series *Deadwood,* he recognizes the centrality of Lakota experience even though there are no Lakota on-screen. Milch achieves a disorientating, shocking modernity in his reimagining of Americans searching for gold that they know legally belongs to the Great Sioux Nation. The Americans also know they are outlaws in the eyes of the United States. Calamity Jane, Wyatt Earp, and George Hearst are nothing like you would expect, yet seem exactly right. They are not from the 1870s, they are from right now.

Edie Winograde's color photographs of staged reenactments in the American West in the twenty-first century startle us with the simple,

nt device of shooting the scene from a distance, and including cars
d trucks in the background. When I first saw them, I immediately
thought of *Deadwood,* and also that astonishing scene from *The Man
Who Fell to Earth* in which a time-traveling black limousine races down
a nineteenth-century dirt road to the bewilderment of onlookers.

Speaking of cars, Lewis deSoto embraces the transgressive nature
of No Reservations through the interesting method of building a car
from a parallel universe. In this one, the line of cars manufactured
by Chrysler Corporation under the name DeSoto did not go out of
business in 1961. It prospered, and in 1965 released a model called the
Conquest. Lewis deSoto, perhaps a descendant of Hernando de Soto,
the dim adventurer who careened through the southeastern United
States before there was a United States, actually drives this car on
American highways. The operating instructions, meticulously faithful
to mid-1960s car manuals, carry the text of the *Requiremento,* which
guys like Hernando de Soto were supposed to read to the locals they
encountered. Lewis deSoto has also built an SUV marketed to rich
tribal leaders from gaming tribes in California.

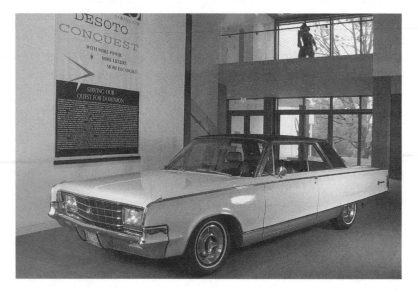

Lewis deSoto, *Conquest,* 2004. Courtesy of the artist.

Matthew Buckingham navigates the intricate political history of the Hudson River (which isn't exactly a river) in his forty-minute film *Muhheakantuck—Everything Has a Name* (2004). Buckingham reminds us that the first "Indian" Henry Hudson encountered spoke French.

Scale, centrality, invasiveness are key strategies here. Yoram Wolberger gives us perfect replicas of those innocuous plastic toy Indians. Except he has blown them up to more than eight feet tall, and suddenly they become not so amusing. Jeffrey Gibson appears to strangle the building itself with his remarkable silicone paintings. In keeping with the spirit of honest and open engagement, the General Electric Corporation, whose world headquarters is just down the road from the Aldrich, donated the silicone in Gibson's work.

Actually, during the run of the exhibition, muralist, painter, and political artist Rigo 23 has renamed part of the Museum "Taté Wikikuwa Museum, 1999–2006." This section features the paintings of

Yoram Wolberger, *Red Indian #1 (Chief)* and *Red Indian #2 (Bowman)* from the Cowboys and Indians series, 2005–7. 3-D scanning, digital enlargement, reinforced cast fiberglass composite and pigmented resin, approximately 8 × 7 × 2 feet. *Red Indian #1 (Chief)* from the collection of Mr. William Kreysler and Mrs. Jacque Giuffre. *Red Indian #2 (Bowman)* courtesy of the artist and Mark Moore Gallery.

Leonard Peltier, a member of the American Indian Movement who has been in prison for the past quarter century.

On the museum's second floor, above the counterfeit cars that never existed yet still manage to cruise down the Connecticut Throughway, are Marie Watt's preposterous columns composed of folded blankets. They are immense, hilarious, and somber. They tower over everything and are so huge they make the DeSotos seem like toys. Watt's blankets number over a thousand and come from everywhere, embroidered with the dreams and nightmares of the twentieth century. When the exhibition closes, they will be distributed to Connecticut's poor.

Duane Slick is a renowned Indian painter. He may also be a conceptual artist, since he lives in the neighboring province called "Rhode Island" and teaches painting to the most gifted young artists in the country. Peter Edlund offers reimagined landscape paintings for our consideration, and Nicholas Galanin creates sculptures from books and offers the important objects of his People as a kind of demented music video.

We are presented, then, with intelligent work about the United States and Indians and history where it isn't always obvious who is Indian and who is not. This is progress. Eva Hoffman, whose parents survived the Holocaust, wrote an essay that asked: "What attitude should we take toward this painful history? . . . I think the task in our generation is exactly to examine the past more strenuously, to press the questions raised by our memories—or, more frequently, received ideas—further; to lift, in other words, our own prohibitions on thought."

No Reservations is as unlikely, surprising, and unpredictable as the history it interrogates. Every blanket, video image, muffler, and artificial fungus knows exactly where it is and speaks from the power of buried truths, grief, triumph, and pain. With silicone from General Electric, and filled with visitors on their way to Foxwoods Casino, the exhibit offers no easy answers, only tantalizing, unsentimental glimpses of a common past and a looming future that, like it or not, we are all going to share.

Delta 150

The following comments were delivered at the opening of "Vision, Space, Desire: Global Perspectives and Cultural Hybridity," a symposium held on December 13, 2005, to mark the participation of Native artists in that year's Venice Biennale.

Welcome. My name is Paul Chaat Smith, I'm Comanche, I live in Washington, D.C., and I am associate curator at the Smithsonian's National Museum of the American Indian (NMAI). Gerald McMaster (Plains Cree and member of the Siksika Nation) is the chair of the symposium, so he bears most of the responsibility for this event, but I'm also implicated because I am the second most responsible person. Complaints should go to him, compliments to me.

The title of my presentation is "Delta 150," and I'm going to talk about airplanes, genocide, and rainbows.

Which I'll get to right away, after bringing everyone up to date on recent developments. As you know, the 2005 International Art Exhibition of the Venice Biennale featured James Luna (Luiseño) at the Fondazione Querini Stampalia and Rebecca Belmore (Anishinabe) at the Canadian Pavilion. The two shows were smash hits and made them both rich and famous. How rich? you ask. Well, in the past few months, Luna bought Jay-Z's old place in Malibu, the Rock and Roll Hall of Fame and Museum in Cleveland, and a pair of teal blue Lamborghinis. Interestingly enough, although he could easily have resigned his position as academic counselor at Palomar College, the Jesus of

Cool still shows up for work just like before, except now he arrives by helicopter.

Rebecca bought Pier D of the Vancouver International Airport. She's transformed Gates Forty-nine through Fifty-six into a rehearsal space for current projects, like turning passengers boarding flights to Calgary into performative ready-mades. It's a temporary arrangement, just until Doug Cardinal finishes building that castle up on Whistler Mountain. None of us was especially surprised that our most regal artist will soon be living in a castle. Actually, some of us thought she already lived in one ("so she's getting a bigger castle or what?"). We were shocked, however, to hear last week that the Cardinal project is on time and under budget. Truman Lowe (Ho-Chunk), who curated the Luna thing with me, bought a nice cottage on Lake Monona, and I've been busy with my new column for *Artforum,* plus last week I signed a six-figure contract for a book I'm writing on Damien Hirst.

Hey, just kidding! We didn't really make out like bandits!

Life after Venice is not radically different than before Venice, or even liberally different. It's much the same, actually. But how did we get here, and why are we back?

INDIANS IN VENICE

A very brief history of Indians in Venice begins in recent times with the selection of Gerald McMaster as commissioner for the Canadian Pavilion for the 1995 Venice Biennale, and Gerald's selection of Métis artist Edward Poitras. That made Edward a household name in the houses of art-loving sophisticates in Canada, and a hero to many Indians, mostly also in Canada. But lots of us heard about this, though we didn't know too much about the Venice Biennale. Also, and not particularly connected to the Poitras show, Jimmie Durham has been a regular at the Arsenale. And also, not particularly connected either, a group of artists and activists based in Santa Fe staged their own exhibitions at the Biennale in 1999, 2001, and 2003. Nancy Marie Mithlo (Chiricahua Apache) spoke about that. In 2003, my institution sponsored a reception with them to host Mohawk artist Shelley Niro. Everybody had a great time, which led the National Museum of

the American Indian to decide we should come back, and we launched a project to try to win the United States Pavilion in 2005. We decided that if we were not selected, we would go to the Biennale anyway as a collateral project. We never got a chance to compete for the U.S. Pavilion and partnered with the Fondazione Querini Stampalia. It was pure serendipity that Rebecca Belmore, like James Luna a performance and installation artist, was selected to represent Canada. It made us feel like we were on the right track, and we began hyping these interventions as Indian summer in Venice.

My point here is that there was no grand scheme or anything inevitable about Luna and Belmore in Venice in 2005. I would argue, however, that even if Poitras had never been chosen by Canada ten years ago, if Gerald McMaster had decided to remain a painter instead of becoming an international curator, or if the NMAI didn't have a visionary director who strongly supported contemporary art, Indian artists would still have dreamed about Venice, because artists all over

Shelley Niro, *Mohawks in Beehives,* 1991. Courtesy of the artist.

the world dream of Venice. In the larger sense, Indians in Venice were inevitable, because our best artists are really, really good, and like really good artists anywhere, they want to be in the most important shows. Indians were going to be here sooner or later, one way or another, because that's what we do: we go places and do things.

For me, there are three reasons why we are in Venice. The first two are good ones and important but not superimportant. A few months ago, Rosa Martinez, cocurator of the 2005 Biennale, gave an interview about her experience and said one of her main regrets was that she didn't have the time to travel and research art production around the world, so she was limited to looking at artists who had been in other biennials. James Luna and Rebecca Belmore have been major figures for decades, but neither had been in the major art festivals. They were off the map; now they are on it. The second reason is that the crew that organized "Vision, Space, Desire" believed that the discourse around contemporary Native art was stale and in need of

Jolene Rickard, *Corn Blue Room* (detail), 1998. Courtesy of the artist.

new ideas and new energy. Which is why, instead of a panel of only Indians, we have a panel of Indians and non-Indians, some of whom are not expert on our issues at all. This is quite controversial, since it obviously means we are leaving talented Indian artists and scholars off the agenda and replacing them with people from Turkey and England.

But the third reason is the most important. We have a responsibility to be here. I wish someone else had said it better but no one has, so I will reference once again artist Jimmie Durham. He wrote that Europe is an Indian project. Europe is an Indian project—now, that sounds intriguing, a little mysterious, and goes well with another formula, this one in the public domain of Indian truisms, which is that every place is an Indian place. But what are we really talking about here?

Let me break this down. For a long, long time, not like geologic time or even dinosaur time, but believe me, a really, really long time, half of the world didn't know about the other half. Africa, Asia, and Europe knew of each other, even if much of what they knew was rumor and misinformation. They were pretty sure they constituted the world. The Americas, which weren't the Americas yet, didn't know anything about Europe and Asia and Africa. The people not yet Americans were fairly sure they were the whole world. But, guess what, both halves were wrong. Parenthetically speaking, sure, once in a while some boat from half A landed in half B, or vice versa, and sometimes they even stayed for a while, but nothing really came of it.

And remember we're not just talking about people here: plants and microbes and animals lived separately for eons. What changed everything wasn't the first Columbus voyage, but the second, and soon they stopped counting.

Anyway, in 1492 the two halves of the world became permanently, irretrievably connected. It was the most consequential and profound event in human history, and created the world we know today. Contact changed everything, and we are still coming to terms with it. Based in large part on the massive transfer of wealth from the Americas, Europe—which a few centuries earlier was something of a backwater in what was known as the known world—quickly became home

to the most powerful empires in human history. The Atlantic slave trade decimated Africa and further enriched Europe. Tens of millions of people in the Western Hemisphere, having no immunity to microbes that had never existed there before, died of the most widespread pandemic the world had ever seen. Corn and tomatoes and tobacco and potatoes, all Indian technologies, spread throughout the planet. It wasn't all death from diseases and wholesale murder and plundering the likes of which one rarely sees, although it was mostly that. It was also less brutal exchanges that produced new ways of thinking both here and over there. We became Indians, living in America. For a brief time in the early eighteenth century, we were actually called Americans by the English colonists. But we lost that, too, which I've always thought was a drag because it's a better name for us than Indians or Natives or whatever. Lately, I've tried to popularize Reds, but that seems to be going nowhere fast.

To wrap up the depressing part, the biological invasion was at least initially nobody's fault. It was just a horrible thing that was going to happen sooner or later, and made possible a colonialism that looked different from other colonialisms at the time.

The stunning inequality of that exchange is what presents us with difficult problems. And there are very particular, very specific, unique problems that make the Indian question so difficult. European colonialism ruled most of the world for centuries, and even after it stopped directly ruling the world, it still ran huge chunks of it for a long time after that using the gauzy curtain of neocolonialism. By the mid-twentieth century, most of Asia and Africa had at least bad nation-states with less than perfect governments and armies and air forces and a seat at the United Nations. But in the Americas, that never happened. Yes, there are Indian nations of a kind, with sometimes real power, and yes, there's a province in Canada with autonomy, but colonialism in the Americas never allowed a result like China or India or Zimbabwe. Now, I'm not suggesting that modern nation-states are the solution to our problems, or that most Indian people want such a thing now. I'm only pointing out a circumstance that is unique to us and different from that of other colonized people. And I think this factor explains

why the discussions over the last several days about so many things just don't fit our experience.

So unless you can persuade me that Europe would have become rich anyway, the Atlantic slave trade wasn't one of the major events of the past thousand years, and wealth and technologies from America didn't change the world, then I'm going to insist that the Indian experience is at the very center of how the world we live in today came to be. When James Luna tells a story about a member of his tribe who was sent to Rome in the nineteenth century, he is telling an Indian story, but it is also an Italian story.

Native people insist on maintaining that difference in a way that is sometimes baffling to others. As my comrade Jolene Rickard (Tuscarora) so memorably wrote, though it may seem we've been pushed to the water's edge—dispossessed of nearly all of our homelands, populations, and wealth—instead of surrender, we've drawn a line in the sand. In front of us is the seemingly unstoppable dispossession machine, at our backs the roar of pounding surf, and Native people calculate the odds, nod to each other, and say, when do we attack?

But what is the value of that difference? I think it means that we have all kinds of things to offer. We see things differently. We come from a different place. For all the centuries of colonialism, for all the ways in North America we've come to believe racist lies draped in romanticism, for all the times it may seem like we're vacationing on that beach instead of drawing a line on it, or serving as lifeguards for the colonists, we still come from a different place with a different history. The land question just won't go away, and neither will we.

The work we have to do to contribute to any serious dialogue is partly about confronting the anti-intellectualism in our own communities. It means giving up on the Indian belief that our people are always out there fighting colonialism, instead of being divided. It means acknowledging the vast differences even within the U.S. Indian world, which is all I can really speak about. Our conference cannot pretend to represent the indigenous people of the Americas. It is as narrow with its own social and economic networks as any other. All we can do is try to be transparent about what we are doing here.

So "Vision, Space, Desire" is part of a larger ongoing effort for Indians to be present in the world. Success by Luna, Belmore, or this symposium won't be measured by how many Indians are in Venice or Kassel next time. It will be measured by something much harder to quantify, which is how much we contribute to the broader dialogue. Our presence in the global salon and its exhibitions, debates, arguments, and parties may seem important, but I would suggest that alone isn't success either. What really matters isn't the numbers or particular outcome, but whether we can build new understandings of what it means to be human in the twenty-first century. It isn't about us talking and you listening, it's about an engagement that moves our collective understanding forward.

Wednesday night, nonstop JFK to Venice, Delta flight 150. A bunch of us are on this flight, me, Gerald McMaster, Edgar Heap of Birds, Jolene Rickard, Alan Michelson. We're approaching Europe, it's dawn, the lights are out, we're flying east. Rosa Martinez said something the other day about believing in chance, and Rob Storr, who will curate the Biennale in 2007, talked about Delmore Schwartz and the redemptive power of movies, which reminded me about the night before at JFK, when our researcher Rebecca Trautmann said, "Look, there's Liza Minnelli." And it was either Liza Minnelli or her double. So I knew that probably meant something, but I didn't know what.

So anyway, here we are on Delta 150. I'm listening to tunes, the flash music player is set on random, so the zeros and ones are playing DJ and they select Eva Cassidy. The song is "Over the Rainbow," Judy Garland's signature tune. I listen as the late, great Eva Cassidy steals this song from Liza Minnelli's mother. Which gets me to thinking about rainbows, something I don't generally do a whole lot, and remembering that my employer, the National Museum of the American Indian, has crystal prisms built into its vast rotunda, which create rainbows on the walls when planets line up or something. (Note to self: find out if other museums manufacture rainbows.) I'm thinking about how much I love to fly, even though I am terrified of air turbulence, and about how sappy that song makes me feel, and how happy I am to be alive in this century despite how truly horrible things are.

And how glad I am that this dreadful year is finally over. One of the worst ever, I think, in the past thousand years.

That might be an exaggeration.

Anyway, the song ends, and Joy Division's "Love Will Tear Us Apart" comes on, and I decide to turn that off and wait for this lousy thing they call breakfast. And so we land in Venice, and at baggage claim somebody tells me that Rob Storr was on the same flight. So I'm thinking about how we've been flying across the ocean together, eight miles high, and here we are at the baggage claim, and thinking about all the potential for embarrassment this trip affords us. I am famous in my little crowd for saying that we are not ready for prime time, no, we shouldn't do it, whatever it is. And what I think was really terrific is that none of us knew what was going to happen in that next week.

Luna Remembers

"Authenticity" is among the founding lies of the modern age.

—Henry Louis Gates Jr., *Thirteen Ways of Looking at a Black Man* (1997)

James Luna is a visionary, a truth teller, a romantic, and a hanging judge. For these reasons, I wish he lived someplace other than up in the clouds on a mountain located on the extreme western edge of North America. Or at least that his mountain looked over a nondescript valley of crows and cows instead of the Pacific Ocean. And I really wish his mountain wasn't next to the one named Palomar, in the state called California.

The truth is, he does live up there in the clouds, on Indian land, sharing the sky with the Palomar Observatory, for much of the twentieth century home to the most powerful telescope in the world. He lives in the richest state in the richest country in the history of the world, ten miles from the horizon where the continent meets the sea, where destiny became manifest. California: the end of the line, the final stop on the trail. It is the last destination and therefore the newest place, where everything could be remade and forgotten. Media critic John Leonard must have been in Los Angeles when he spoke about "the unbearable lightness of being American."

It is all too convenient, too fitting, and our interest here is with things inconvenient and ill fitting, things forgotten and lost. Because we are speaking of James Luna, widely considered one of the most

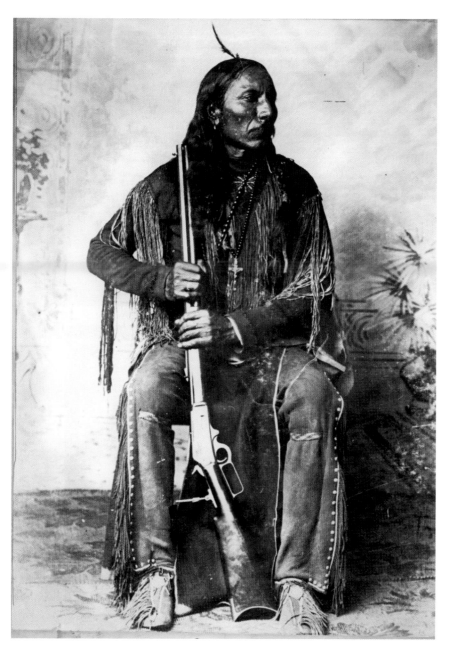

Nahwats, one of the author's Comanche ancestors, wearing cross and holding rifle. Date and photographer unknown.

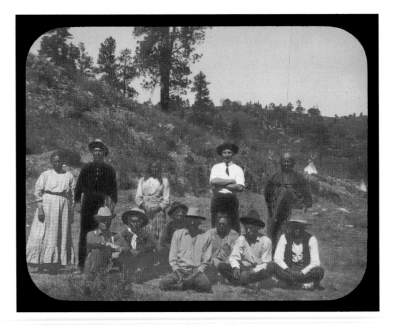

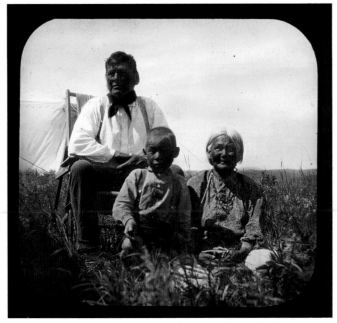

Four glass slides, 1930s, photographer unknown. Reverend Robert Chaat, the author's grandfather, used these images to raise money for the Comanche Reformed Church.

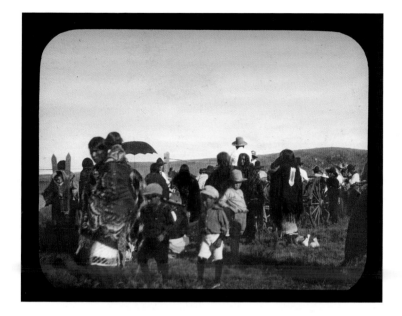

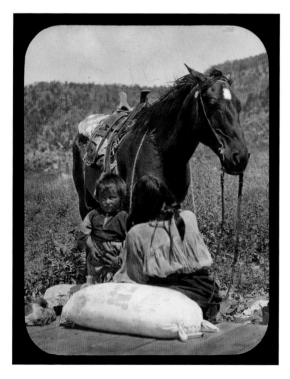

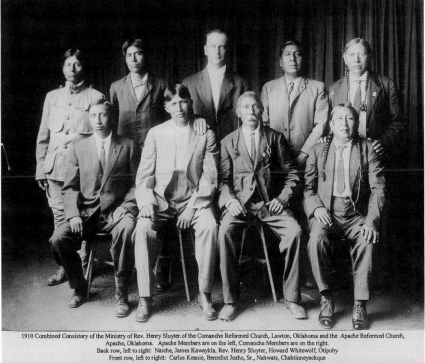

1910 Combined Consistory of the Ministry of Rev. Henry Sluyter.of the Comanche Reformed Church, Lawton, Oklahoma and the Apache Reformed Church, Apache, Oklahoma. Apache Members are on the left, Comanche Members are on the right.
Back row, left to right: Naiche, James Kawaykla, Rev. Henry Sluyter, Howard Whitewolf, Otipoby
Front row, left to right: Carlos Keanie, Benedict Jozhe, Sr., Nahwats, Chahtinneyackque

Leaders of the Comanche Reformed Church (Lawton, Oklahoma) and the Apache Reformed Church (Apache, Oklahoma), 1910, photographer unknown. Chahtinneyackque, the author's great-grandfather, sits at the end of the first row on the right.

dangerous Indians alive, a story already dramatic enough, and the last thing we need is details that make him sound like some comic-book superhero skulking about in his mountain compound. Personally, I would rather be reporting that he lives in Fresno, or perhaps Akron.

But of course James Luna lives on a mountain in California, the most exalted and perfect piece of the United States, the biggest and most beautiful, and the most forgetful place in the entire country, whose state religion often seems to be amnesia. You might think Luna hates California. Listen, I have news for you: Luna *is* California.

The creation myths of North America allow little room for Indians. We are inconvenient reminders of a tragic past. There is not really much room—conceptually or literally—for Luiseño Indians in the first place, and even less for Luiseño performance artists such as Luna, so any Luiseños who wish such a career must somehow make their own room while avoiding capture by the amnesia police.

California forgets. Luna remembers.

There are several ways to describe James Luna. He is a contemporary Native American artist. He is, undoubtedly, a conceptual artist. He works these days in the disciplines of performance and installation. To carry out these activities, however, he must also be an escape artist. The traps that lie in wait for Indians like Luna are endless and lethal.

Avoiding these traps is nearly impossible. The paradigmatic career of another artist, Jimmie Durham, offers one of the few successful examples of such room making and trap avoidance. In the past few decades, he has become an elder statesman and godfather for a new breed of Indian artists and thinkers. They recognize him as our toughest fighter, our bravest theoretician, and most accomplished escape artist. Twice Durham left the United States for good: His first self-imposed exile took place in the 1960s and was cut short by the firestorm of rebellion that he felt required his active participation. He left Switzerland for South Dakota in 1973 and was a leader of the American Indian Movement for the next six years. The second exile began in Mexico City, is ongoing, and apparently has no end in sight. Durham now lives in Berlin, a critically acclaimed artist who never lacks for work. He made it over the wall. Jimmie Durham is our Houdini.

He famously wrote once that if only he had a place to stand, he felt certain he could address the entire world. It is the hope of so many Indian people, but one seldom realized. It is rarely realized because the United States and most other countries are places without an Indian history, and the constructed amnesia turns the ground beneath our feet into quicksand.

There are two other Durham formulas that are relevant for our discussion. He advises that we must speak and listen well, and remember everything, especially those things we never knew. And, he claims, Europe is an Indian project.

Authenticity. Place. Memory. All are at the very core of today's conceptual artists who choose to venture far from the safe confines of neotraditional contemporary art production. And these ideas are especially at the core of James Luna's work. Luna insists that authenticity is not a goal for Indian people but a prison. He insists that there is no place for Native people in the conventional discourses and will never be unless we begin to create such spaces ourselves. And he insists on remembering, especially those things we never knew.

If amnesia is the state religion, then the act of remembering turns you into a heretic, a revolutionary, a troublemaker. The problem is as much the present as the past, and it is Luna's insistence to remember the past from an active standpoint as an artist who lives in the present. This is the challenge facing Indian conceptual artists: being outside the official narratives, to even assert the relevance of an Indian past and present makes one hostage to identity politics, multiculturalism, and other narrow and suspect agendas. The very assertion makes one an amateur, a poseur, a primitive.

To mount a serious challenge to the accepted order of things involving Indians, a prerequisite for making Indian conceptual art, one must become an expert in the fine art of staging jailbreaks. I don't mean to say these artists are frequently in jail, although that does happen from time to time. I am speaking not of literal jails but of the ideological apparatus that powerfully creates its own world of expectations and normalcy. Indeed, it becomes "reality," which despite the implications of its name is always subjective, or as Lily Tomlin said once, basically just "a collective hunch."

In North America, the ideological prison that confines Indian agency has unique features. We have never been simply ignored, or simply romanticized, or been merely the targets of assimilation or genocide. It is rather all these things and many more, often at the same time in different places. The prison is a dreamcatcher, a vapor. It is both vicious and flattering, flexible, and never monolithic. It can't be refuted or denied, it just is. Most devastating of all, the ideological prison is capable of becoming an elixir that we Indian people ourselves find irresistible.

The particular kind of racism that faces North American Indians offers rewards for functioning within the romantic constructions, and severe penalties for operating outside them. Indians are okay, as long as they are "traditional" in a nonthreatening (peaceful) way, as long as they meet non-Indian expectations about Indian religious and political beliefs. And what it really comes down to is that Indians are okay as long as we don't change too much. Yes, we can fly planes and listen to hip-hop, but we must do these things in moderation and always in a true Indian way.

It presents the unavoidable question: Are Indian people allowed to change? Are we allowed to invent completely new ways of being Indian that have no connection to previous ways we have lived? Authenticity for Indians is a brutal measuring device that says we are only Indian as long as we are authentic. Part of the measurement is about percentage of Indian blood. The more, the better. Fluency in one's Indian language is always a high card. Spiritual practices, living in one's ancestral homeland, attending powwows, all are necessary to ace the authenticity test. Yet many of us believe taking the authenticity tests is like drinking the colonizer's Kool-Aid—a practice designed to strengthen our commitment to our own internally warped minds. In this way, we become our own prison guards.

Critic and artist Joseph Kosuth observes that to understand conceptual art in the United States, you must also understand the sixties and "appreciate conceptual art for what it was: the art of the Vietnam War era." In the same way, understanding the work of Luna and his peers requires appreciating Indian conceptual art as the art of the Indian movement of the late 1960s and early 1970s. Both linked to

and distinct from the antiwar and civil rights activism of the time, the rebellions, takeovers, and demonstrations that swept through Native communities across North America profoundly changed Indian consciousness. It would not be an exaggeration to call them a cultural revolution.

The three most celebrated events took place during a forty-two-month period between November 1969 and May 1973. Each was wrapped in a self-consciously theatrical sensibility, with a sophisticated understanding of what it would take to convince the international news media to pay attention to the political grievances. At the former federal prison on Alcatraz Island in San Francisco Bay, it meant a nighttime invasion by dozens of college students who refused to leave no matter what. Three years later, on the eve of a presidential election, it meant hundreds of Indians, some with Molotov cocktails and other improvised explosive devices, occupying the Bureau of Indian Affairs, daring police to attack them, just blocks from the White House. Three months later, it meant taking over the village of Wounded Knee, South Dakota, the place where U.S. soldiers massacred hundreds of Sioux Indians in 1890, and this time facing heavily armed U.S. marshals and the occasional Phantom jet.

In other words, it took a lot to get the world to pay attention.

The Indian movement was far more than just political theater, and its ramifications are still being felt. It is a common observation that the Indian movement is partly responsible for the existence of a national museum devoted to Native Americans in Washington, D.C. The political space of the museum, however, was also present in each of these very different events, occurring in very different places.

At Alcatraz, the students wrote a clever proclamation that offered to purchase the island for twenty-four dollars in glass beads and red cloth, and explained what they planned to do with the property. Restaurants, job training, and a spiritual center would rise from the rocky ground. There was also this intention:

Some of the present buildings will be taken over to develop an American Indian Museum which will depict our native food and other cultural

contributions we have given to the world. Another part of the museum will present some of the things the white man has given to the Indians in return for the land and life he took: disease, alcohol, poverty, and cultural decimation (as symbolized by old tin cans, barbed wire, rubber tires, plastic containers, etc.). Part of the museum will remain a dungeon to symbolize both those Indian captives who were incarcerated for challenging white authority and those who were imprisoned on reservations. The museum will show the noble and tragic events of Indian history, including the broken treaties, the documentary of the Trail of Tears, the Massacre of Wounded Knee, as well as the victory over Yellow-Hair Custer and his army.

At the Bureau of Indian Affairs headquarters, occupiers seized the building's impressive collection of Indian artifacts and appropriated arrows and clubs for use against a police attack. They also gave the building a new name: the Native American Embassy. Only a few of the objects could be used as weapons, but when the siege ended and the protesters left town, they took with them every artifact they could carry. The collection ended up in living rooms all over Indian Country. Although many Indians who took part in the occupation expressed regret at the massive destruction inside the building, few showed remorse about removing the paintings, rattles, blankets, and pots from a place where, in their view, they never belonged in the first place. Looting? We called it liberation.

At Wounded Knee, a store called the Wounded Knee Trading Post and Museum was one of the most despised institutions on the reservation, and one of the first casualties of the occupation. Furious Lakota ransacked the store and left the display cases broken and empty of headdresses and other artifacts.

The rage demonstrated in Washington and Wounded Knee was directed not simply at abstract notions of inaccurate representation, but arose from a deeply personal sense of violation. Often the people who wore or made the headdress, the pot, the arrow are our relatives. Indians are keenly aware that the objects were originally acquired by museums through methods few would consider legitimate. If there is

any people on earth whose lives are more tangled up with museums than we are, God help them.

In 1985, Jimmie Durham created a prescient installation called *On Loan from the Museum of the American Indian,* filling a vitrine with photographs of his parents and goofy, brightly colored arrowheads. (In a few years, the Museum of the American Indian would move to Washington and add "National" to its name. Perhaps he knew even then.) But not even Jimmie Durham dared to climb inside the thing.

The Artifact Piece would have been a powerful installation if Luna had spent just a few minutes inside that box after closing time, with only an accomplice or two around to witness and take photographs. I doubt Luna even considered such an alternative; after all, he's said that in his work, he's the object. *The Artifact Piece* demanded much more of him than a photograph. It required that he spend hours motionless inside that box, that he invite visitors to stare at his nearly nude body, read labels pointing out the origin of various scars and bruises, and poke and prod as they wished. It required that he become a California Indian object like those that surrounded him. And some visitors cruised right by, never seeing him at all, or if they did notice an Indian lying there in the room, they assumed he was a prop. One label read: "Having been married less than two years, the sharing of emotional scars from alcoholic family backgrounds was cause for fears of giving, communicating, and mistrust. Skin callous on ring finger remains, along with assorted painful and happy memories." Another read: "Drunk beyond the point of being able to defend himself, he was jumped by people from another reservation. After being knocked down, he was kicked in the face and upper body. Saved by an old man, he awoke with a swollen face covered with dried blood. Thereafter, he made it a point not to be as trusting among relatives and other Indians." A nearby case showed visitors cultural relics belonging to the Indian, referencing his favorite books (Kerouac, Ginsberg) and music (Sex Pistols, Hank Williams).

The Artifact Piece offers everyone a chance to change the narrative if they wish. If the constructions that make Indians invisible and deceased are aimed most directly at Indians ourselves, they are also a

trick played on everyone else passing through the San Diego Museum of Man. The narratives that suggest Indians are of only marginal importance to California's past and irrelevant to its present also deprive others of the agency that might result from a more accurate picture of the place where they live and work.

Few works of contemporary Indian art have been so perfectly conceived and executed. Outrageous and brilliant, *The Artifact Piece* rumbled across Indian Country in the late 1980s like a quiet earthquake, making fine work by other Native artists suddenly look obsolete and timid. Luna's first masterpiece raised the stakes so high that the air that previously enveloped Indian contemporary art, for so long stifling and self-satisfied, turned thin and bracing. Luna brought danger into the equation, and in that new atmosphere, anything seemed possible.

With all the attention *The Artifact Piece* received, 1992 would have been a good time to sell out. But when galleries and museums phoned Luna during the modest gold rush that the five hundredth anniversary of the Columbus voyage brought to Indian artists, Luna sent this message from his mountain compound: "Call me in '93." He knew the sudden attention Indian artists were receiving wasn't likely to last, and it didn't. "Curators want a certain kind of Indian and a certain kind of Indian art," he said at the time. "They want you to be angry, they want you to be talking it up. So when people call me I have to ask, 'Why didn't you call me before? You're calling me now, but will you call me in '93?'"

As it happened, Luna collaborated with Guillermo Gómez-Peña in 1993 for a new work called *The Shameman Meets El Mexican't at the Smithsonian Hotel and Country Club*. Gómez-Peña described what transpired:

> It's Friday morning. Luna and I share a diorama space at the Smithsonian's Natural History Museum. We are inside an ethnographic prison cell. I sit on a toilet costumed as a mariachi in a straitjacket with a sign around my neck that reads "There used to be a Mexican inside this body." I attempt unsuccessfully to get rid of my straitjacket in order to "perform" ("entertain" or "educate" my audience). A Mexican waltz

mixed with rap contributes to the pathos of my tableau. Meanwhile, James paces back and forth, changing personas. At times he is an "Indian shoe-shiner," offering to shine the shoes of audience members. At other times, he becomes a "diabetic Indian," shooting insulin directly into his stomach. He then transforms into a "janitor of color" (like most of the janitors in this, and other, U.S. museums) and sweeps the floor of the diorama. Hundreds of visitors gather in front of us. They look very sad. . . . Next to us, the "real" Indian dioramas speak of a mute world outside of history and social crises. Strangely, next to us, they appear much less "authentic." The visibly nervous museum staff makes sure the audience understands that "this is just performance art . . . and they are famous artists." James and I have been rehearsing our next "intervention" at the Natural History Museum. The piece consists of a selection of irreverent monologues, songs, dances, and staged conversations that problematize our bittersweet relationship with mainstream cultural institutions. This time the performance will take place in the main auditorium. It's 10 p.m., and James and I decide to take a break in our dressing room. Roberto and our producer, Kim Chan, are with us. James lights up some sage. I light up a Marlboro. Minutes later, several security guards break in and try to bust us for "smoking dope." When they finally realize it's just sage, they feel embarrassed and leave. I write in the margins of my script: "The performance is never over for us. No matter how much we understand that ethnic identity is a cultural and ideological construction, and that as performance artists we have the power to alter it at will, nevertheless, we are always confronted in the most unexpected moments by the guardians of fetishized identity and the enforcers of stereotype."

When Aleta Ringlero, the curator of Native American art, finds out what happened, she gets furious, calls each and every Smithsonian undersecretary, and lets them have it. James, Roberto, Kim, and I prefer to have a drink at the bar. It's just another day in our never-ending pilgrimage towards the ends of Western civilization.

In My Dreams challenged audiences with new memories, including those of Dean Martin, Marlon Brando, and Dennis Hopper. In one

sequence, an Indian of Luna's age and physical description, played by Luna, sits at a table and has lunch. He pours artificial sweetener into an empty Styrofoam cup and pretends to drink coffee, then adds another packet of sweetener. Then he prepares a feast of Spam garnished with packets of ketchup and mustard. Next, he takes out what the audience quickly understands are pieces of medical equipment, matter-of-factly pricks his finger, and watches as a glucometer takes measurements. With that information, the Indian draws several units of insulin into a syringe and then injects himself in the abdomen. Finally, before eating, he silently prays before the coffee, the Spam, and the medical implements.

Another sequence features Luna riding a stationary exercise bike in front of a white screen, where images from *Easy Rider* and *The Wild Ones* are projected to pop music from the 1950s and 1960s. The bike is a travesty, decorated with chicken feathers in electric shades of red, white, and blue. Luna wears a sequined vest and a flashing orange light in the center of his head. He rides his bike to the music and images, opens a beer, and performs tricks that mimic the stunts that Brando and Hopper perform on their motorcycles on the white screen in the background.

Critic Jane Blocker has suggested that the sound track for Luna's memories was recorded from Dean Martin's music and television variety program, popular during the late 1960s and early 1970s. Despite his genuine affection for Martin's music, Luna says during his performance of *In My Dreams* that it is not really about Dino. Instead, "it's about the memories he conjures up. The music helps us remember. He did something for us."

The television show made Martin the most famous fictional drunk in America. His cheesy overacting of endless one-joke skits was a signal to viewers that he was only playing a character for laughs. This was television, after all, and Martin was bigger than the small screen. On the variety show, he was slumming. Blocker writes, "In the end, Dino is worthy of Luna's dance because, as a professional drunk, Dino *cannot* remember, and thus becomes the celebrity mascot for the white man's customs of forgetting."

When Luna's *In My Dreams* character says, "We like good music, and we like sad songs," he builds on each word, so that by the time he says "sad songs," it's somewhere between a boast and a warning. But he's not defensive, not even a little bit. He doesn't care if you think it's strange he should position the music of Dean Martin as part of Luiseño culture. So there he is, weeping about Dino, shooting himself with insulin.

I saw Luna perform *In My Dreams* in a packed school gymnasium in Tulsa, Oklahoma, in 1996, preposterously feathered yet never quite ridiculous, absurdly flapping his crutches in front of a video playing *The Wild Ones*. I thought of two lines from the last great song by the Clash, recorded in 1982 when leader Joe Strummer's countrymen and -women thrashed helplessly against Margaret Thatcher's iron restraints. "This Is England" is the music of failed revolution. Strummer's singing captures the grief and sadness of living amid the ruins of that defeat, of community torn asunder, of dreams turning into nightmares, of hope mocked and finally destroyed. "I got my motorcycle jacket / But I'm walking all the time" are those lines.

Our feathered jackets are beautiful, often drop-dead gorgeous. But here's the thing: Like Joe Strummer's defeated exiles, we're walking all the time. And the original idea, after all, was to ride.

In Washington, a large photograph of *The Artifact Piece* greets visitors in the National Museum of the American Indian's third-floor gallery. On a winter afternoon a few months after the museum opened, Luna himself was one of those visitors. It must have felt like walking into one of his own installations.

The Artifact Piece is elegant and, yes, beautiful. Yet there is also something necessarily harsh at work here, and perhaps in its doppelgänger in Washington. The two projects—the museum requiring more than $200 million, fourteen years, and an act of the United States Congress, and the artwork requiring not so much money but perhaps even more than fourteen years, as well as the receptiveness of a single curator at the San Diego Museum of Man—share fundamental similarities. Both are about reversing the five-century, thousand-yard gaze of a narrative that got just about everything wrong.

The new museum proposes another way of looking at this history. Most of the gallery space is taken up with exhibits developed in collaboration with individual communities from across the Americas. Giving Indian people a voice in museum exhibitions is not new. Today there are scores of tribal museums in North America, and more are built every year. Other museums, including large, established history and natural history museums, have been working with Indians for years. In fact, the first Indian employed by the Smithsonian is not W. Richard West Jr., the NMAI's founding director. The Smithsonian has been employing Indians for more than a century. West is not even the first Cheyenne. What is unprecedented about the new museum is that all of the exhibits did this, not just a few. This meant a radical departure from normal museum practices. The National Museum of the American Indian created alternative ways for how objects would be displayed and described, how history is understood, and who should tell it. This led to scathing reviews by critics, certainly much of it deserved. Sharing power and authority doesn't guarantee excellent exhibits, only different ones.

One striking difference in how Indian audiences and many critics responded can be seen in the museum's insistence on mixing old objects with new, demonstrating its belief that the past lives in the present and conveying its overall message that we are still here. Critics and some visitors said, okay, we get it, you're still here, why do you keep telling us the same thing? One reviewer said, "This isn't a museum, it's a public service announcement." Indian visitors tend to approve of all those images and stories of confident, assertive, contemporary Native people. The reality for many American Indians is that this seemingly obvious point is ignored and denied by the world they live in on a daily basis.

Few of Luna's performances could have been as exhausting as lying motionless in *The Artifact Piece*. He said later that what kept him going was the knowledge that at the end of those hours, he could get up and leave. The California Indians represented in the objects around him could not. I remembered this point when I talked with some of the NMAI staff a few months after the museum's opening. The Indian

floor staff have become objects, and it's safe to assume all of them knew this would happen when they signed on. They are the first living Indians many visitors have ever "seen," although Washington is home to thousands of Indians. Visitors often have their pictures taken with the Indian staff, who are nearly always gracious and polite even in the face of casual insults, like the giggles and presumed Indian war whoops that signal the arrival of another pack of schoolkids. The floor staff say they love working at the museum, but they also talk about how it is so physically and emotionally draining that at the end of the day, all they can do is go home and sleep. The museum is their life.

The Artifact Piece's harshness lies in the formula: "I am the object." Indians have become conflated with the things we made, and with the fictions that others made up—using oil paints and paper and celluloid and zeros and ones—an intolerable and suffocating circumstance that requires many of us to become Luna, placing ourselves over and over again in the same rooms with those things museums call artifacts, asking others to notice, to *see,* as we perform a work titled *Not Dead Yet.*

James Luna helps out at the National Museum of the American Indian, 2005. Photograph by Katherine Fogden. Courtesy of National Museum of the American Indian, Smithsonian Institution.

In *Emendatio,* his project for the Fifty-first Venice Biennale (2005), Luna creates an imagined Native place of worship built in honor of Pablo Tac. A Luiseño Indian (of the same tribe as Luna—from the San Luis Rey Mission in California), young Tac traveled to Europe with San Luis Rey's Father Antonio Peyri, arriving in Rome in 1834 to study for the priesthood—and to be studied by others. Before his early death from disease in 1841, Tac produced a written history of the mission-ization of his people in California. Luna's installation houses artifacts of the kind that Tac might have possessed or made during his stay at the Vatican, as well as actual Luiseño objects, placed on an altar and in shrinelike vitrines. The interior walls re-create the look of a California mission. "Emendatio" is a word that Pablo Tac himself may have used when he attempted to correct errors in the way Europeans understood his people. *Emendatio* is a project that collapses the time between 1834 and 2005, and the space between Rome and California. *Emendatio* claims Venice as part of Indian history, and in doing so demonstrates a belief held by Luna and many other Native people: that every place is a Native place.

Indian agency has often been read as a demand to return to a utopian past that never was. Another emendation would suggest that we know very well such a return is impossible: instead the conversation is about a different kind of today, where we are present in the world like anyone else. We always have been trying to be part of the world. Pablo Tac did what he could. And that big stone barn of a museum off Independence Avenue in Washington, D.C., is, in its own imperfect, earnest way, trying, too.

So is James Luna. In his costume of feathers and empty bravado, he uses his crutches as wings, and though he never leaves the ground, he almost seems to take flight. But he's not riding a beautiful motorcycle up the Pacific Coast Highway, heading to the next powwow or the next commune. He's not going anywhere. He's pedaling on a stationary bike, a bike with pedals and wheels but clipped wings of its own, and no matter how fast he pedals, how hard he flaps his crutches, he's going no place at all—except in his dreams.

When people, most often Indian people, ask Luna why he doesn't

focus more on the positive aspects of Native life, he answers, "I make art about life here on the La Jolla Reservation, and many times that life is not pretty. . . . Our problems are not unique, they exist in other communities; that is the Indian unity I know, unity in pain." He adds, "I am not just criticizing a condition. I am in the condition." Luna has successfully avoided the prison of being labeled a "political artist," another absurdist American term designed to marginalize dissent. Of course Luna's work is political, but it's never simple and never rhetorical. Luna keeps faith with a basic, inconvenient truth of the matter at hand, and that is that Indians are the poorest people in the Western Hemisphere.

From his mountain outpost on the far edge of America, James Luna scans the horizon and sees everything. On clear days he can see the Pacific Ocean. On clear nights, ancient starlight washes over Palomar Mountain, and he can see forever.

Luna watches and remembers.

James Luna, *The Spirits of Virtue and Evil Await My Ascension,* 1998. Courtesy of the artist.

Standoff in Lethbridge

About seventy-five million years ago much of North America was underwater. The water that covered everything from Texas to the Arctic was called the Bearpaw Sea. Not then, of course—that's the name that scientists gave it much later. The Canadian province of Alberta, where the HeavyShield family lives, was underneath the shallow waves of the Bearpaw Sea. All the usual dinosaurs lived there, and also extinct mollusks called ammonites. They were preyed upon by mosasaurs, who ate them for lunch. Sharks lived there, too.

Time passes. A huge comet hits the earth and wipes out the dinosaurs and the ammonites. More time passes, and lots of complicated and boring geological things happen that turn the ammonite shells into something called ammolite, a magical and extremely rare gemstone that refracts light into every color imaginable.

Although you may have never seen one, the spiral shape of ammonites is instantly recognizable, and some people consider it humankind's first icon. The broad curve that disappears into nothingness suggests the journey from nothing to everything and back again, infinity to zero, and perhaps lays the foundation for mathematics. Versions of this form are found all over the world in ancient carvings.

Most of the ammolite anyone knows about is found in Lethbridge, Alberta, and is collected by members of the Blood Tribe. They don't have gaming yet, so they make money from mineral and gas leases, ranching, ancient shellfish, and commissions for the odd installation art piece.

The sharks stuck around. Today, they look more or less exactly the way they did then, except that some were more than one hundred feet long.

March 2004: Lethbridge

Faye HeavyShield stands on a ladder; light shines from an overhead projector. On the projector is an acetate photocopy of a tree. It appears to be winter since the tree has no leaves. One tree is already on the wall, and she finishes this one quickly. I ask Faye how it's going; she says fine and that she'll be done drawing in a couple of minutes. I say, "You know, technically, I think that's called tracing," but she ignores me. I knew she would.

The trees feel out of place and completely right at the same time. What the hell is this tracing-drawing of trees doing in a HeavyShield installation anyway? But I already know this is a stupid question, and here's why. When I arrived at the Southern Alberta Art Gallery an hour earlier, Faye was nowhere in sight. It was just me and *blood,*

Faye HeavyShield installing *blood,* her solo exhibition at the Southern Alberta Art Gallery, 2004.

half installed, and already shocking in its power and glowing with confidence. I thought to myself, Jesus, this is the best thing she's ever done.

Turns out, the tree is a tree just down the hill, along the Oldman River. Someday there'll be a name for the field that goes up around a HeavyShield work. Not magnetic exactly, not electric, something else, something like the charged air in a thunderstorm, or near a waterfall with all those oxidants, a kind of *whoosh*. It was this blast of patented HeavyShield hushed silence that greeted me even before I had a chance to take it all in. *Whoosh*. Who else makes work with that kind of commanding presence? Nobody, that's who. (Not for nothing did 1992's Land, Spirit, Power, the twentieth century's defining exhibition of Canadian Native art, arrange for a HeavyShield to be the first thing visitors would see.)

I felt relieved and happy, really happy, not because I thought it might not be great, but because of how great it was, how bold and unexpected, with all the spooky elegance, that mysterious beauty, and that presence that makes her work unmistakable. *Whoosh*.

I thought about something Faye told me once. She said she never heard her father raise his voice. I said, "Never? Not even once?" She said, "No, never. Not even once." Power. Confidence. *Whoosh*.

I watch as she finishes the second tree and then draws numbers in the branches of each. The left one reads 1910–1971; the right one reads 1916–1991. She is referencing the Kainai practice of placing their deceased in trees.

The trees are her parents; *blood* is her life.

Now she's in the light again, tracing a fax cover sheet. Her name is misspelled, just like it was on the cover of the *Nations in Urban Landscapes* catalogue eight years ago. Faye *HeavySheild*. She doesn't correct the spelling. Next she's tracing a sheet of notebook paper with numbers on it, and some rough sketches, like things that were just lying around her house or hanging on her refrigerator.

I don't remember exactly when Faye told me the name of the show, but I do know that's when it began scaring the hell out of me: *blood*. Jesus, talk about raising the stakes, this was off the charts, this was

setting the amp to eleven, this was outrageous. Blood. I had been try-
ing to deal with my fear by teasing Faye about it, which she didn't
appreciate. I told her my essay would be called "A Sort of Homecom-
ing," after the U2 song, and said, "This better be good, Faye, because
like they say in the NFL, nobody likes to lose at home." Or I would
bring up another sensitive point, Faye's lengthy absence from the art
world that had only recently ended. "Remember the *Elvis Comeback
Special* that was on TV in 1968? That's what this *blood*'s gonna be, Faye
HeavyShield, back in black and better than ever." Maybe the essay
will be called "The 1968 Elvis Comeback Special." Lethbridge, she
explains, is not her home, so it's not a homecoming. Faye didn't
respond directly to the other thing except by the look she gave me.
Anyway, LL Cool J had already answered for her, with his song "Don't
Call It a Comeback."

The opening a few days later is a smashing success, jammed with
people from the reserve village of Stand Off, the town where Faye
really is from, and after it ends we walk across the park to a bunch of
other openings at other galleries, including some that feature local
Indian artists, and on this night Lethbridge is the center of the art
world. Down the street, a theater is showing Mel Gibson's *The Passion
of the Christ*. It's the biggest movie in North America. I ask Faye if she's
seen it. She says no, not yet, but it's on her list.

September 2004: Washington

So much waiting. So much longing. At long last, finally this day arrives.
September 21, 2004: the twenty-fifth anniversary legacy edition of the
Clash masterpiece *London Calling* is officially released.

The National Museum of the American Indian (NMAI), where I
work, opens on the same day. Practically every single member of my
family is there. Practically every single member of everybody's fam-
ily is there. The weather is perfect, the building is gorgeous, and so
are we. The museum director, the Smithsonian secretary, Peter Jen-
nings, and the president of Peru are photographed in front of the
gold wall my little gang dreamed up, and the pictures go all over
the world.

My father-in-law buys me a new suit. I wear it but keep a low profile. The days are inspiring, long, and humbling. The exhibits are not such a big deal after all. It's the amazing procession, the astonishment at the building, and the fact that it's going to be around for centuries.

My whole family marches in the procession. My dad, who became an enrolled Choctaw long after my sisters and I were adults, marches with his people; Mom, Marti, Parker, and Diane walk under the Comanche banner. I'll wear suits nearly every day the whole week, but today I'm dressed in my regular clothes, except that I'm wearing a pair of white Chuck Taylor high-top sneakers my Dad sent last Christmas. I've never worn them before, and they squeak when I walk. I skip the procession and take the P6 bus downtown and head upstairs to the fourth floor. It's about 11:00 a.m., just an hour before the

The National Museum of the American Indian, a.k.a. the state museum of the Red Nation, under construction in Washington, D.C., in early 2003.

official opening. On the fourth floor nobody is around, and I spend thirty unforgettable minutes alone in this new place that had owned practically every waking moment of my life for the past thirty-two months.

So much isn't finished, like the names of obliterated nations, or the portrait of George Gustav Heye, the man who collected most of what comprised the NMAI, and the case with his typewriter and cigar. The invasion wall is a mess, labels are missing, and so on. And yet the gold and the swords and those figurines from a thousand years ago, the guns and Bibles do everything we ever dreamed they would. It's sleek and beautiful, and the walls really do change color. It looks nothing like an Indian museum. In the euphoric days, back in the beginning, I wrote memos promising to create the most controversial, most talked about, most emotionally compelling exhibit in Washington. I specifically said I wanted our exhibit to surpass the United States Holocaust Memorial Museum.

Well, we never came close to that. You could say it was time or money or talent, or that the space for the biggest story never told wasn't as large as even one of NMAI's two gift shops. You could say lots of things, including this: during that half hour, the air around the installations felt charged; they seemed to hum slightly, and at times I heard a faint but very distinct *whoosh.*

November 2003: Banff

Even ten months before this moment, this was the best job I ever had. And at that time, it was becoming the worst job I ever had.

We had decided the gallery should look nothing like an Indian museum. My boss was down with our crazy ideas. (Think Richard Serra! *Minority Report!* Cognitive dissonance! Glass walls that change color!) From nothing we created art installations of gold, guns, Bibles. We crammed two dozen original George Catlin paintings into a room called "Making History" and filled a cabinet with the scales Mr. Heye used to weigh the gold. We put his Explorers Club pin, his typewriter, and one of his cigars in there. We even found walls that changed color. But there wasn't enough time or money or people.

Here's the thing: I didn't know what to say about those two hundred Bibles in two hundred Indian languages we planned to display. The script deadline approached. By chance, a few months earlier, the Banff Centre for the Arts had invited me and dozens of the Red Nation's scholars, artists, and curators to a residency called "Communion" whose sole purpose was to answer the question, "What do we think of two hundred Bibles in two hundred Indian languages?" They even threw in brothers and sisters from Australia and New Zealand to help out.

Oh, and Faye HeavyShield would be there.

There's a *New Yorker* cartoon that shows two men around a fire in hell, surrounded by devils and brimstone. One says to the other, "On the other hand, it's great to be out of Washington!"

Alberta was a far nicer place than hell. I rolled the dice and bet that inspiration from the mountains and stars, combined with the brightest lights of Turtle Island, would be enough to save the project.

Banff is unforgivably beautiful as always. It's even snowing. Faye understands my situation and agrees to check in and provide moral and intellectual and spiritual support. People think Faye has profound thoughts about Christianity and so forth, and maybe she does, but I've known Faye for almost ten years, and she's not likely to say anything that you can steal and put in an exhibition script. Mainly she listened to me complain and offered advice that I tried to follow. When not doing that, she would be in her studio, cutting out hundreds of tiny pieces of cloth, tying them onto long pieces of rope, then drenching them in paint. They were attached to the ceiling, and this looked like the rigging for a ship. She would also show me sketches of her project, roads not taken, and so on.

Somehow, Banff begins to work, and I draft the words that would become the final wall text in the exhibit in Washington. Ten months later it would stand next to the names of hundreds of tribes.

All My Relations

Entire nations perished in the wave of death that swept the Americas. Even their names are lost to us. We cannot tell you where they lived, what they believed, or what they dreamed.

Their experiences are buried and unknowable. Like much of Indian history, we have only fragments.

This wall lists the names of our relatives who are still here, with those of ancestors who vanished without a trace. The list will always be incomplete, ruptured, and fragmented. It can never be whole.

Nine of ten perished. One in ten survived. All Indians alive today are here because our ancestors used intelligence, skill, planning, strategy and sacrifice. They didn't fear change; they embraced it. They survived because they fought for change on our terms.

Their past lives in our present.

As descendents of the one in ten who wake up in the 21st century, we share an inheritance of grief, loss, hope, and immense wealth. The brilliant achievements of our ancestors make us accountable for how we move in the world today.

Their lessons instruct us, and make us responsible for remembering everything, especially those things we never knew.

Two feet of snow falls. Helicopters crash in Iraq. On Thanksgiving night a big snowstorm arrives and the Indians from Oklahoma prepare a feast. Later we all walk down the mountain path into town for karaoke. We pass deer sleeping in the woods by the road. Christmas lights are everywhere; Banff is lit up like a Hollywood sound stage. Local skins join the party, and Richard Bell, the top aboriginal artist in Australia, performs "Born to Be Wild." Snowballs are thrown.

I write more labels. After two weeks I return to Washington and find that for now I'm no longer in charge of those Bibles. Welcome to what one chronicler of the process of putting together a museum has called Phase 4: Punish the Innocent. But that's not right either. By now, I realize I wasn't innocent. None of us was. This is how I know.

NOVEMBER 2004: BALTIMORE

A few weeks ago I watched this program about sharks. I am not especially interested in sharks, but I had recently visited the National Aquarium in Baltimore, which features sharks in a big way and this made me slightly more interested than usual.

Did you know sharks can be trained to do tricks just like dolphins? On this show, I watched a fish handler rub the stomach of a pretty good-sized shark. He or she seemed to enjoy it, but who really knows the mind of a shark? But why would a shark put up with stomach rubbing if it didn't like it? You might say, for the same reason dolphins jump through hoops at Sea World: dinner. But since when do sharks have to beg for their dinner?

At the National Aquarium on a freezing November night the day after Thanksgiving, my wife and I walked past acres of fish of all kinds, including lots of sharks. We liked best the mysterious and beautiful rays. Some were as big as Cadillacs, others tiny. And we loved the sea turtles. There were tons of sharks, often graceful, always menacing, with pitch-black eyes that looked completely soulless and dead.

Everyone inside the aquarium seemed to get along fine. We spent an hour looking through Plexiglas at the turtles and rays and fishes, usually at eye level, wondering whether they saw us, and if so, what they thought about as they swam back and forth in what's essentially a giant swimming pool: Were they were bored or content or wondering what we were doing there, walking back and forth? How did they understand their situation? Did they vaguely perceive they were in Baltimore, like the clever fish in *Finding Nemo* would have? Did they believe they were in captivity? Maybe they loved all the attention, plus being cared for, three square meals a day, doctors standing by, and so forth. Perhaps they imagine they are in heaven.

Although we may never know what lies in the hearts of the shark nation, that isn't true for the shark keepers. They tell us straightaway and often why they do this: it's for the good of the sharks, the rays, and the big lovable turtles. Sharks, they told us, almost never kill people. Also, sharks have an extraordinarily high resistance to disease, including cancer. Possibly, through the study of sharks we could learn why they do. Anyway, the main thing is that humans are inextricably linked to the oceans, and if we keep polluting the seas and wiping out marine life we might as well just shoot ourselves in the head and get it over with, that's how inextricably the finned and the two-legged are linked.

The shark keepers explain this connection with the slightest touch of regret. I think maybe they would rather turn all the animals loose, and privately consider themselves not so different from prison guards. It's as if they wish they could just open up the aquarium doors and let every last one of them race to freedom, first into the Inner Harbor, dolphins leaping for joy and startling the tourists in their silly duck boats, giant sea turtles flying just under the surface, showing off, tunas zipping every which way, and the sharks—all business, naturally—are halfway to the Atlantic by the time the last of the manta rays make their stately, dignified exit, with sea horses clinging to their backs, looking up at the sky for the very first time. (It's blue! Blue!)

But understand this is no ordinary prison: it's a prison for the greater good, of the oceans and the animals that live in them, and also for humans, because we are inextricable. If they are in prison, and nobody's saying they are, then they're serving time for a damn good reason.

In Lethbridge, meanwhile, *blood* has already come down; it's history. Faye HeavyShield is already working on her next big thing. She's scoured the riverbanks of Alberta for rocks to import to the rivers of New Brunswick, in an installation titled *Rock Paper River* that coincides with the four hundredth anniversary of the French arrival in Canada and the summer solstice.

Struck by Lightning

Miyoshi, the city where you can meet mists, history, and the unusual.
The ancient and the modern stand side by side, and before you even
know it, you will be happily time surfing. A living textbook, Miyoshi is
dotted with interesting places. Come on! Wouldn't it be fun to travel
through time?

—Official Web site of Miyoshi, Japan, spring 2001

The thing is, Baco Ohama didn't even know there was a
Miyoshi, Japan.

The word—miyoshi—came to her, she claims, in a dream.
And from the word and the dream came the vision, and the vision
was of hundreds and hundreds of fuzzy red cats, in boats, in trouble.
During the past few months those cats have entered my dreams, unin-
vited, and there seems to be little I can do about it. We travel through
space and time, across storm-tossed seas, dreamers exploring a dream-
like land dotted with interesting places.

As I write it's very late on a warm Monday night in April 2001 in
Washington, D.C., which would make it Tuesday morning in Tokyo,
and midnight in Vancouver. On television tonight there was news of a
formal reprimand for the American submarine captain who crashed into
a Japanese fishing boat in Hawaii in February, and commercials for the
new blockbuster *Pearl Harbor* that opens next month. Do the red cats
know or care that the State University of New York at Buffalo's Depart-
ment of Linguistics is carrying out research on "Comanche–Japanese
clause linkage," or that in the 1960s, before she started wearing turquoise
and silver, sometimes people would tell my mother at cocktail parties
how much they enjoyed their recent trip to Japan? Does it matter?

Baco Ohama and I live on opposite sides of North America and have met in person only twice. Mainly, we communicate through e-mail. She also sends beautiful and amazing postcards. Her correspondence is usually full of encouragement and optimism, and bucketloads of ellipsis dots. If dots cost money she would owe somebody thousands. She is, in fact, the Queen of Ellipses, sailing cheerfully down the stream of consciousness, wherever it may lead. Once, Baco sent me a ceaseless ramble that spanned two postcards, joined by her trademark punctuation. They arrived on different days. I responded with a lengthy posting of one very long paragraph that attempted to parody her elliptical style, which she ignored. Irony is beneath her. (Alas, it's practically the only thing I know.)

Stream-of-consciousness rambling and contempt for sentence structure are surefire indications of sloppy thinking and worse writing, of

Baco Ohama, *Miyoshi: A Taste That Lingers Unfinished in the Mouth* (detail), 2002; from solo exhibition at Southern Alberta Art Gallery, 2002. Copyright 2008 Arthur Nishimura. Courtesy of the artist and James D. Brown.

an undisciplined mind, of feckless anarchy. Except in this case. Baco's insistence on the value of the accidental disconnectedness and ceaselessly rambling nature of life and history is about as lazy and carefree as life on a potato farm in Alberta. Which is to say, not at all.

Here goes what remaining chance I may still have to write art catalogues for those new young artists one is always hearing about, which in truth probably wasn't very much to begin with, as I explain the secret connections between Bob Dylan and Baco Ohama. In the Calgary airport last December, the day after *Miyoshi* opened in Lethbridge, I searched through newsstands for the perfect airplane time-killer, and found it. A special issue of a British music magazine called *Q* devoted to Bob Dylan, big and fat and loaded with gossip and pictures and interpretations and revisionist theories. It wasn't cheap, but it was worth it. Four hours never went so fast. The reason for the special issue was this: 2001 is Zimmy's sixtieth year.

So I read the magazine and eventually landed at National and that was that. A few months later, noting the creeping invasion of red cat confluences, I sent Baco an e-mail listing a few of them, and quoted from "It's All Over Now, Baby Blue": "The highway is for gamblers / better use your sense / Take what you have gathered from coincidence." The message back revealed Baco to be a Dylan fan. She had enjoyed watching him on the Academy Awards a few days earlier, though she observed, with characteristic generosity and tact, that "there were some strange camera angles on him." (Actually, he looked dreadful, not only ancient but inexplicably wearing an absurd, thin mustache. The next day's Letterman show, not nearly as generous or tactful, listed one of the top ten things overheard at the Academy Awards as "I didn't even know Vincent Price played guitar.")

I started putting the pieces together. Dylan turns sixty in May; Ohama turns fifty in August. He's from Minnesota; she's from Alberta. Both are Jewish. Each can be fairly described as obsessed with rain. In Zimmy's case, it is generally acknowledged he uses it as a metaphor for memory. The premier Dylan Web site, interestingly enough, is called Expecting Rain, after the wonderful lines from "Desolation Row": "Except for Cain and Abel / And the hunchback of Notre Dame /

Everybody is making love / or else expecting rain." Ohama's first book is named *Red Poems of Rain and Voice*. (Okay, they're not both Jewish.) Thinking of mist and rain and fog, but with no particular objective, I checked into the Expecting Rain Web site and learned that Dylan had played Hiroshima on March 10, just two weeks before our e-mail exchange on coincidence. And from there the red cats sent me to Miyoshi, both a word that came to Baco Ohama in a dream and a real city, a city that turns out to be a virtual suburb of Hiroshima.

Thanks, Bob. Thanks, red cats.

Come on!
Wouldn't it be fun to travel through time?

Using the Internet, the last, great invention of the twentieth century, I continued my research. I learned some things, including this: on September 17, 1945, six weeks after the atomic bomb destroyed Hiroshima, a typhoon hit the city and left the burnt ruins completely submerged. I found this account:

After the typhoon had passed, autumn suddenly arrived. Beautiful weather continued for some time and green weeds started to grow here and there in the burnt city. The plants were horseweed, which grew as tall as an adult person. Using the horseweed as a main ingredient, dumplings were made and sold in Eba and other areas which had remained unburnt. People who could go no longer on an empty stomach ate them to relieve their hunger, though they were unappetizing.

According to foreign news dispatches, Hiroshima, contaminated by radioactivity, would be barren for the next 70 years and no one would be able to live there. However, finding green weeds starting to grow again, hibakusha (A-bomb survivors) were given new hope for life. Around the middle of September, elementary school children who had been evacuated returned to the city and schools were reopened in the burnt-out shells of ferroconcrete buildings. However, many classes had to be held outside and there were no teaching materials. Moreover the children could not concentrate on their studies because of their empty

stomachs. Among those children who had returned were some who had lost their homes, parents, and brothers and sisters. Some of them were eventually either put in the custody of relatives living at a distance or adopted.

Winter in the burnt-out city was the severest one in many years. In this freezing cold weather, hibakusha made fires with the unburnt pieces of wood they had raked up. With this scanty heat they warmed themselves and managed to survive.

The atomic bombing of Hiroshima and Nagasaki changed everything. Before August 6, even with half the world at war, even with flying machines and V-2 rockets and genocide carried out on a massive scale with scientific precision, even with these and other newly invented forms of terror and warfare, humans still fought wars, for the most part, the same way they always had, with armies and guns and strategy, with ships and bayonets. Within a decade after World War II, there would be enough nuclear warheads to kill tens of millions and to change the climate for years. By the 1970s there would be enough to end human life on the planet. This was new. This was different. It is not entirely clear that atomic bombs are even weapons. Former generals on both sides of the cold war privately, and later publicly, have spoken of them as not just insane but useless, from a military standpoint. This is a minority view to be sure, one most generals would dispute, though few would argue that an atomic bomb is not simply a much bigger and better bomb but something else altogether.

This is the truth all of us live with every day, and most of us have lived with our entire lives, and still it defies language and comprehension. There are other truths here as well: for Americans, the uncomfortable truth that the only country ever to use atomic weapons on humans is the United States; for the Japanese, wherever or whoever they are, it's the truth that the weapons were used on them.

Miyoshi is not about atomic weapons or Hiroshima or Nagasaki, but I see them anyway. For that matter, Ohama is not Japanese. She's visited the place only once. She is defiantly, proudly, confusingly, of

Canada, of the prairies, well, she's lots of things. Like the rest of us, she's the product of accidents and empires, of chance and fortune. In her case, she's from the prairies instead of British Columbia (what a concept, British Columbia) because of a hundred things, including her ancestors being from a country so xenophobic that for centuries it was closed to outsiders, her grandparents having made their way to the west coast of North America, to the long and storied history of racism toward Asians in California and the Pacific Northwest.

The main reason, of the hundred reasons that Baco Ohama's childhood memories are of country music, big skies, and potatoes instead of the bustling streets of Vancouver's Japantown, is, of course, Pearl Harbor.

> Studying history, enjoying nature. This is a resort that will let you forget time. You get the feeling that when you turn a street corner, you will meet a scene of long ago. In Miyoshi you can fully enjoy walks through rich nature and history—the beautiful scenes of a village of water. Doesn't that sound fun?

I read lots growing up, so as a kid I would have known the date in any case, but the reason I knew it so well is because Grandpa Chaat was a minister in the Dutch Reformed Church, the first Comanche ever to hold that position, and because of the church itself. I spent most summers in Oklahoma, either at the farm in Dibble, where my dad was raised, or in Lawton, where my mom was raised. The Comanche Reformed Church looks across a highway at the Fort Sill Indian School, and past that lie railway tracks. The church is modest but rather beautiful. Outside the entrance is a small monument made of stones with a plaque that describes in a few sentences the history of the mission and the church and gives the date of its dedication.

Mom remembers:

> I was thirteen years old. My days and months were spent in watching (and probably getting in the way) of the last stages of building the church. Since we lived in the parsonage, we were able to watch the old lodge, in which all activities, including church services were held, being

torn down by members of the church. That old lodge was built in 1906, so it was with great rejoicing that a new church was being built.

I remember watching the old women in their long native dresses, with apronlike "peechquenas" tied around their waist sitting on the ground, pulling nails out of the wood which would be used in the new church. When they got a bunch of nails, they would gather them in their peechquenas and take them to a large bucket. My grandmother was one of those women, so I was on call to get them some water or carry nails to the bucket.

Horses and wagons carried numerous loads of stone and dirt, and the early labor was done by the men, which included my uncles and my three brothers. It was difficult work, especially moving the stone from the wagons to the side of the building on which they were working. We were all praying for a good day weatherwise, since it had been cold and wet. As I recall, it warmed up a little by the time the weekend came, and by Sunday, was warm enough for just a jacket. We had visitors in our home because of the dedication, and so all five of us children had to be on our best behavior. We dressed and went to church.

The Dedication Service was held, and at the end of it some men came to the church and said something to my dad. He then announced to those around him that Pearl Harbor had been bombed, and asked his family to come to the house so we could listen to the radio to find out more. Some of the church members came with us. My first thought was, "Where is Pearl Harbor?" As we listened to the radio, we gained a little more knowledge, but the full significance of what it meant did not affect us until my brothers enlisted and two were sent overseas.

Her brothers came back. Two of my father's brothers didn't.

From Autumn to early Spring, the Miyoshi basin is filled with a deep sea of mist every morning. The mountains seem to float like little islands in the sea, and between the waves of mist shapes come in and out of view, but they are just illusions.

Believing in God is a matter of faith, not proof. However, I'm always looking for evidence, and not just any evidence, either. The world

is full of the amazing and wondrous, even the miraculous. There's the Great Barrier Reef, paintings by Vermeer, *The Simpsons* during the mid-1990s—miracles for sure but not necessarily proof of divine existence.

A solar eclipse, on the other hand, isn't simply fabulous. It is a precisely engineered—okay, everyone knows what it is: the moon slides in front of the sun, and if it's a total eclipse then day becomes night. Maybe it's just me, I don't know, but only in the past few years have I finally appreciated how the entire trick depends on the most unlikely of coincidences. Here it is: if you live on earth, the sun, which is a star ninety million miles away, appears to be exactly the same size as the moon, which is 250,000 miles away. The sun is a fairly unremarkable star, but it is still gigantic, vastly larger than earth, and the moon is basically just a rock out there, a piece of dust compared with the sun. What are the odds these two utterly dissimilar bodies would end up in a perfect rendezvous, the gray rock exactly blocking out the distant star, with the over-the-top demonstration (showing off, really) of the corona, the thin, blazing edge of light that surrounds the moon?

Everyone talks about the darkness at noon aspect, which is certainly impressive, but it would happen just the same if the moon appeared to be, say, 30 percent larger than the sun. It would be interesting if the moon appeared to be only half as large, a big dot in the middle of the sun. Or maybe their orbits never intersected, or hardly ever intersected. Instead, we get a stunning, perfect alignment, and for a few minutes the moon and the sun are proved to be the same size. You know, that's how people figured out there were mountains on the moon, seeing their ridges and peaks in the solar backlight.

Exactly the same size.

I happen to believe this is convincing, compelling evidence of a supreme deity, of a creator, but whether or not you buy that I don't see how anyone could dispute that solar eclipses prove schoolteachers and reporters are simply brilliant at missing the point.

The other reason is that for more than sixty years there have been at first a few, then dozens, and soon hundreds, and for the last thirty years tens of thousands of nuclear weapons, and since 1945 none has

ever been used in warfare or produced a nuclear explosion accidentally. Possibly they somehow don't actually work, except that there are all those tests documented on film and by eyewitnesses. Maybe once the weapons are left alone in their silos the plutonium starts to rust, and that's why the tests aren't affected. If it isn't that, then I have to conclude God is the reason. What is more accident prone than the military? Everything that can go wrong does go wrong, usually pretty often. Soldiers shoot or bomb their own men, planes crash, boats sink, radar and computer systems fail, rockets explode at the launchpad, or just after being launched, or before the launch while the rocket is being fueled right in front of visiting dignitaries who are also blown up. The gun jams, in every war. You can look it up.

It is true that dropping a nuke from a tall building isn't enough to vaporize the building and the city the building is in. Many extremely complicated things must happen within millionths of a second to get the mushroom cloud. Still, all these things are set to happen if the right buttons are pushed, to happen without fail, and every single day for fifty years people like Nikita Khrushchev and John F. Kennedy and Jimmy Carter, leaders demonstrably lacking in sound judgment, could have pushed the buttons and didn't.

Dumb luck? Since when have humans ever been particularly lucky? Maybe, but I don't think so.

I happen to own one of these cats, an early production model that didn't make the final cut. The shade of red was not quite right, and in a Baco Ohama work few things are more important than the shade of red. I understand the red. But why a cat?

These are special cats, the *maneki neko*. The words are Japanese for "beckoning cat." One legend tells of an event at a temple in 1615. The temple had few parishioners, and the building itself was falling apart. A dispirited monk took in a stray cat and looked after it for a time. The monk said, "Kitty, I can't blame you for not helping, after all, you're just a cat. If you were but a man, you might do something to help us."

Then, one day, a rich and important man out hunting was caught in a storm and took refuge under a tree near the temple. As he waited

for the storm to pass, he noticed a cat beckoning him to come inside the temple gate. He was so startled by this strange sight he left the shelter of the tree to have a closer look at this unusual cat. At that moment, the tree was struck by lightning. As a result, the wealthy man befriended the poor priest and the temple became prosperous. The priest and his cat never went hungry again.

The ancient Egyptians are said to have believed cats are gods, and possibly they are. They've colonized humans utterly and completely, and if at this writing they have yet to sneak into the dismal outposts of Antarctica or into the weightless corners of the International Space Station, who would seriously bet against them? Animal scientists believe cats sleep more than any other mammals, and surely they must dream more as well. Perhaps the dreaming is the source of their power to bewitch humans. Perhaps their dreams tell them secrets of the universe, the orbits of planets, and the path of lightning.

Baco Ohama's maneki neko cats, alone of all the world's maneki neko, wear expressions of alarm, fear, and worry. Only some of them are frightened. No two cats are the same, after all. Others are calm, determined. And the entire armada have their arms raised in resistance. They are maneki neko transformed into something else, something new: *ganbari neko.* Ohama turns the kitschy and the cute into a brave army of Red Panthers, ready to bear witness, to remember, and to fight.

I think they are alarmed because in the past century dark magic entered the world in a New Mexican desert, magic that even special beings with special powers cannot predict or control or understand.

The ganbari neko know they don't stand much of a chance, but they are going to fight the dark magic anyway. They are going to stand against the internments and the confiscations and erasures, and against the wild stupidity of our time.

Come closer, they beckon. We have things to tell you.

Meaning of Life

They were anxious and bored, for all the right reasons. Nothing was happening anywhere, and most days it seemed likely that nothing ever would. Indian kids of North America—angst-ridden, their moods swinging in a heartbeat from dreamy to despairing—waited with dramatic impatience, wondering if time had actually stopped, or if it just seemed that way. They weren't even sure exactly what they were waiting for, or how they would recognize it if it ever showed up.

On that score, at least, they had nothing to worry about. You could see the issue of *Life* from two blocks away, with or without sunglasses. The most influential magazine in America was known for its bold covers. But no previous cover had ever looked like this.

Letter carriers in a thousand small towns must have been tempted to bury the thing under John Deere catalogues and weekly newspapers, or at least fold it so that only the cigarette ad on the back would be visible. That way, at least, pedestrians, and especially children, might be spared the shrieking psychedelic atrocity that, inexplicably, occupied the cover. The new issue of their trusted friend, *Life* magazine (*Life* magazine!), looked like a recruiting poster for hippie subversion.

Famous long ago: *Life* magazine, December 1, 1967. Art by Milton Glaser. Photograph by Mark Kauffman; courtesy of Yvonne Tavalero.

The graphic design legend Milton Glaser was the culprit. Executed in the style of pop artist Peter Max, Glaser's screaming oranges, violets, yellows, and pinks made the magazine's famous red and white logo all but disappear.

A small black-and-white photo of one of those Indians from the past century was at the center, wearing an army coat and staring hard straight into the camera. He was engulfed by a crazy Day-Glo illustration of, presumably, an Indian from this century. The Indian had a Mohawk and looked left; open the gatefold and you saw his twin looking right. The cover headline offered this explanation: "Return of the Red Man."

The articles were an uneven lot and spent more time on hippies than Indians, but once you got past Julie Christie modeling "hippie Indian leather breechclout and beads," there it was: a spread on the Institute of American Indian Arts (IAIA) in Santa Fe. The article offered powerful evidence that something, in fact, was happening somewhere, and it answered the prayers of lost teens from Medicine Hat to Miami. *Life* had given them life.

At this school that was like no other, "you can even hear the cultures colliding." Diana Ross and the Supremes coexisted with war chants and drumming. There were Indian kids talking about their identity, about the modern art they were making, about the new trails they were blazing, even as they kept faith with the old trails, participating in Hopi and Navajo ceremonials. They had a kind of cool self-confidence that was for the time revelatory, even shocking. "In the painting classes, students who have been scarcely exposed to the Western tradition of realistic representation turn out to be naturally gifted abstractionists." (The article attributed this to "hereditary talents" from so many centuries of geometric art.)

Turn the page and there's a color photo of an Indian rock-and-roll band, four guys and a girl singer, apparently just returned from a successful shopping trip to London's Carnaby Street. English hair, English clothes. Ties, turtlenecks. The singer's dress is black and white striped, and she's wearing white shoes and white tights. They are perfect. A guitarist wearing shades is captured in midleap, and the drum kit announces the name of the band: The Jaggers.

Surrounded by posters with Indian motifs, Julie Christie models a hippie Indian leather breechclout and beads.

Happy Hippie Hunting Ground

Hollywood movie star Julie Christie. I always liked her, and I bet she's embarrassed by this now. Photograph by Henry Grossman for the interior of *Life* magazine, December 1, 1967. Courtesy of Henry Grossman.

Never had the tired, shopworn platitude supposed to guide the lives of Indian people—the one about walking and living in two worlds—looked so vibrant, so exciting, so sexy, so alive. We could have Rothko and beadwork, Motown and the British Invasion and the tradition of our Crow and Navajo and Apache ways. We could have it all, and here in *Life* magazine was irrefutable proof.

If it had all been some kind of cruel hoax and there were no articles inside at all, just the *Yellow Submarine* cover and the promise of returning red men, it still would have been pretty thrilling for Indian kids who lived in small towns with no apparent future, towns where the sixties were little more than a vague rumor. (The subversion of all those self-conscious mailmen was a cause for celebration all by itself.) But for the ones who had been waiting, the December 1, 1967, issue of *Life* magazine was nothing less than a postcard from the future.

It changed everything for Richard Whitman, a young Indian living in Oklahoma. By the time he finished leafing through the glowing pages, he was already planning to make that future his own.

The Jaggers, the house band of the Institute of American Indian Arts, Santa Fe. Future Native studies professor Alfred Young Man plays lead guitar. Photograph by Steve Shapiro; appeared in *Life* magazine, December 1, 1967. Courtesy of Steve Shapiro.

The stories and pictures electrified Indian kids in Oklahoma and Montana and Los Angeles because Indians in 1967 were invisible and boring. Guys who, decades later, would be renowned as movie actors or revolutionaries often claimed to be Italian or Greek, not to avoid rednecks, but because it was more stylish. Anything was.

The famous joke from those days, the one that proved Indians had a wonderful sense of humor, nailed the era exactly. An Indian, because of some Bureau of Indian Affairs (BIA) error, is assigned an excellent piece of land by the river. He makes the most of it, working hard, sunrise to sunset, and his diligence and the rich land make his farm a success. He falls in love and marries the woman of his dreams. After a few years he's doing so well that he decides to take on a farmhand. The farmhand is white. One evening the farmhand is drinking cheap whiskey by the river, wondering why he is working for the Indian when it should be the other way around. He drinks some more and becomes more and more angry at the injustice until he sneaks up to the main house and sets it on fire. The Indian returns from town to find his wife dead in the smoking ruins of his house. The white man is nowhere to be found. The Indian is devastated and vows that he will find the white man who did this, no matter how long it takes. Ten years later, the Indian finally tracks down the farmhand at a gas station in Timbuktu. The Indian confronts him and says, "Ain't you the one that burned down my house and killed my wife?" The white man looks back and says, "Yeah." And the Indian says, after a long pause, "Well, you better watch that shit."

The tragic hero of the age was Ira Hayes, the Pima Indian who helped raise the flag at Iwo Jima in World War II. His celebrity burned so bright that Hollywood made a movie of his life starring Tony Curtis. But Ira Hayes returned to his Arizona reservation to find nothing there for him but drink and pain, and he died at thirty-two in a drainage ditch. A maudlin song by Johnny Cash provided the sound track: "Call him drunken Ira Hayes, he can't hear you anymore . . ."

We were, in those days, losers. We were England before the Beatles, Russia before Gorbachev. Indians were history, an elementary school homework assignment, tedious pictures from a family vacation.

But then *Life* magazine arrived and said it could be different, that it already was different, at least in Santa Fe, where Indians were beautiful and mod and happening and traditional all at once. This was real. It wasn't a joke. No wonder Richard Whitman decided it would be his next destination.

Decades later, the color photos and breathless text are, if anything, even more compelling. They are visions of a parallel universe of sorts, a recruiting brochure for what might have been, provoking the same kind of wonder as trinkets and home movies from the 1964 World's Fair: how could we have ever been so naive, so young, so optimistic, so wrong? They each predicted a future that never arrived.

The pavilions in Queens imagined technology as the solution to every need, with safe atomic power and flying cars and homes under the ocean and in outer space. The new and better Indian future would arrive through the miracle engine of education. It was no accident that IAIA was a showcase for this alternative future. IAIA was, in fact, the crown jewel of the BIA's much-maligned school system. Foreign dignitaries often visited, and once students even performed at the White House.

Critics might argue that IAIA had about as much in common with most BIA schools as Harvard did with the average high school, but training elites was hardly a discredited strategy in the 1960s. They were our best and brightest, and who else should be at our best institution?

At the same time that Indian kids in Santa Fe were mastering rock and roll and abstract expressionism, others, only a bit older, were challenging established Indian organizations in the United States with a brash, confrontational attitude, freely borrowing language and lessons from Third World anticolonial movements. The National Indian Youth Council (NIYC) was the political equivalent of the campus in Santa Fe: the cutting edge of Indian radicalism in 1967. They were smart, ambitious college students, mainly from the southwest, often from better families, who were proud to call themselves intellectuals and who ran their meetings using parliamentary procedure. They also had an uncommon flair for self-promotion, describing themselves,

for example, as "Red Muslims" or giving NIYC leader Mel Thom the nickname "Mao Tse-Thom." They stayed current with the latest French philosophers, and they spoke easily of Vietnam and the War on Poverty, automation and the emptiness of modern life. It was true they had perhaps more press clips than troops, but that was starting to change. They fought the state of Washington over fishing rights, bringing Marlon Brando along for the ride and with him some national press.

Dig the new breed: dazzling creative ferment in the southwest and a cadre of indigenous radicals already setting their sights on the Indian establishment. Few doubted they would be key figures in the political and cultural change everyone knew was coming.

The future arrived even sooner than expected, and the changes it brought were more startling and wide-ranging than most imagined. And the hip kids of Santa Fe, along with their cousins in the NIYC, had almost nothing to do with it. November 1969, two years post-*Life*: boatloads of Indian college students staged a daring nighttime invasion of the abandoned federal prison on Alcatraz Island in California. They claimed possession through a clever and witty proclamation, and the event became a media sensation in the San Francisco Bay area, winning headlines across the country. The students bravely defeated a naval blockade, managed the intense press attention, and, suddenly, realized that the media and even the federal government were taking them more seriously than they ever could have dreamed.

They tried to organize themselves so that an occupation most thought would last a day or two might survive weeks or even months. They named themselves "Indians of All Tribes" because that is what they were. For a brief time it was inspiring and wonderful, and then everything blew up.

A month after the landing, a coup had replaced the popular and charismatic leader of the occupation, a child had fallen to her death under mysterious circumstances, and the shower of positive news stories had been replaced by dark accounts of teenage thugs, drinking, violence, and mindless destruction.

The college kids who led the occupation had returned to their campuses. They were replaced by Indians from the Bay area who for the most part led much harder, and very different, lives. The occupation would remain troubled throughout its nineteen months, and it never came close to achieving the dubious and impossible goal of creating essentially a "reservation" on the island.

Yet Alcatraz, despite its many failures, changed the rules of Indian activism. It had captured more press attention than all the Indian struggles of the entire century. It showed that Indians from all walks of life were far angrier than anyone thought and more willing to use militant forms of protest previously thought to be "un-Indian." And the event's profoundly democratic essence would establish the style, attitude, and nature of the Indian movement to follow. Alcatraz was open to every Indian, from middle-class business owners to the drunks from the Mission District, urban and reservation, young and old. It was exhilarating and sometimes dangerous. The newly liberated territory's "every Indian" rule didn't include exceptions that banned rapists, bootleggers, opportunists, and psychotics. Governance was virtually impossible. And it was crazy to think the decaying maximum security prison could ever have been a university or social center. But even with all of that, more Indians responded to Alcatraz than to anything the more responsible elements of the Indian world offered. They responded because they felt invited, and no Indian organization had ever invited them to one of their conferences. They responded because the joke about the Indian and the white farmhand was no longer funny. They responded because, just maybe, at Alcatraz they would find answers to questions they were only beginning to realize they had.

After Alcatraz came a season of rebellions and occupations that touched nearly every part of Indian Country. Some actions were well organized; most were not. Street fighting, bravado, and apocalyptic rhetoric became the signature of the movement's leaders, none of whom described themselves as intellectuals. The American Indian Movement (AIM), which had become the leading organization in the United States, often spearheaded campaigns and provided support to

local activists, but many times Indians would stage a demonstration or takeover without any outside connections. With few exceptions, the activism was, like Alcatraz, democratic, perhaps to a fault; usually it was made up of people from many different tribes and from both cities and reservations. Unlike other social movements of the time, it embraced people of all ages, from the very young to the very old. College students were there, too, but usually as followers.

In March 1973, the movement included Richard Whitman. He had made good on his promise to attend IAIA, and later he moved to Los Angeles to pursue further art studies. It was there that he listened to a speaker who had just arrived from South Dakota to explain the incredible pictures Richard and others had seen on the television news. AIM and Oglala Sioux activists had taken over the village of Wounded Knee, and the government had surrounded them with hundreds of federal agents armed with Vietnam-era weaponry. The speaker pleaded for reinforcements, and Richard Whitman, two days later, found himself a very long way from art classes in Los Angeles. He was now one of the distant, wavering images on the evening news, armed with a hunting rifle, looking out across the frozen prairie at a thousand heavily armed federal marshals.

It is our people at our looniest, bravest, most singular and wonderful best, and moving beyond words even to those of us who resist cheap sentiment and heroic constructions of complicated and flawed movements. Yet there it is, over and over again: Indians who objectively have little or nothing in common choosing to join people they often don't even know who are engaged in projects as bizarre as laying claim to a dead prison on an island that is mostly rock, or picking up a gun to take sides in the byzantine political struggles of the famously argumentative Sioux.

If Richard Whitman had been black and living in Chicago as the civil rights movement organized its campaign for voting rights in the American south, things would have been a lot different. A pair of unsmiling organizers in suits would have interviewed him at length, checked his references, and asked him probing, difficult questions, trying to determine whether he was tough enough to get knocked upside

the head by some cracker and not fight back. They would look carefully at his academic record, church attendance, personal habits. He probably would not have been chosen. (If black Americans had had their own NASA, it could have been only slightly more difficult to become an astronaut.) And if he did succeed, the movement would provide formal, mandatory training before he would ever be allowed anywhere near Mississippi.

Certainly this is one reason the civil rights movement managed, in less than a decade, to destroy a system of legal segregation many thought would last for generations and win voting rights for black Americans.

The Indian method is less formal, less bureaucratic. Still, the very weakness of the Indian way of doing things turns out to be a profound strength, although one not without a high cost.

Alcatraz merits designation as the first Reservation X of the contemporary era. It was Indian initiated and directed; it was pan-Indian and intertribal; it was democratic and unexpected. For the outside world, it was understood as protest, a demand for recognition, a stand for respect and justice and acknowledgment. But it was also a place where Indians came for answers, to learn from people of different backgrounds, from different regions of North America, of different spiritual beliefs.

Significantly, people journeyed from vast distances to look for these answers. What compelled people from even the most intact of our nations, Navajo or Iroquois or Sioux, to go to San Francisco in 1969?

What did people mean when they stood in the cold wind on the broken concrete of Alcatraz and said they had never felt so free? And what did it say about the Indian political leadership, nationally and on a community level? About the Christian and traditional religious leaders of those communities?

I believe the spirit that moved so many Indians during that time comes from the recognition that rebuilding our shattered communities requires extraordinary intervention, daring, and risk. There was a clear-eyed, if often unspoken, acknowledgment that frequently our elders are lost or drunk, our traditions nearly forgotten or confused,

our community leaders co-opted or narrow. They knew only one thing for sure: business as usual wasn't working, their communities were in pain and crisis, and they had to do something.

It was pretty much all over three and a half years after Alcatraz, when exhausted, hungry rebels signed an agreement that ended the Wounded Knee occupation. There were other actions and protests, but none came close to capturing the imagination of the Indian world or challenging American power.

Although the movement won few specific victories—there was no fundamental change in Indian–U.S. relations, no other success that matched what the civil rights movement won—communities were nonetheless changed. Young Indians today are surrounded by messages, from the mass media to band councils to government officials, that at least claim to support Native culture and values.

The defining moment for this Indian generation, the one Madison Avenue calls X, was everything the inspired craziness of the sixties and seventies was not: planned far in advance, well funded by governments and foundations. It was about dialogue, not barricades; education, not sedition. It was the activity surrounding the Columbus quincentenary in 1992, and its spectacular failure has much to teach us.

The year 1992 was the logical extension of the postrevolutionary sensibilities, where pretty much any Indian this side of Wayne Newton could talk about Elders and Mother Earth and the Pipe at the drop of a hat. (It was as if we had collectively decided to forget it was post–*failed* revolution.) And as we started talking more in generic terms about fuzzy concepts that sounded good and felt good, the non-Indian audience caught on and then moved on.

During the run-up to the big five-double-zero, a cartoon appeared in the *New Yorker* that we should have understood as prophecy. Two aboriginals are carving inside an igloo. One says to the other, "Sure it is. Everything we make is art." Obviously certain people were onto us.

Others liked *Dances with Wolves,* which swept the Oscars and which, at the time, seemed to be the perfect stage setting for the main event. Instead, it stole what little thunder was left in the humorless, Eastern Bloc–style public service campaign that we, along with our friends from

the New Age and environmental movements, had carefully designed. The quincentenary was essentially an effort toward the political re-education of white people, who, as it turned out, couldn't have cared less about Columbus. And anyway they had already seen the movie.

The X had been answered. The answers were wrong, but they were easy to understand. "Oh," everyone said. "So that's it."

The curtain rose on opening night, and as we prepared to address the human race, we found ourselves looking out at a few hundred million empty seats.

It was, as failures are often reputed to be but rarely are, the best thing that could have happened. We should be thanking our grand-mothers even now, and here's why. The world tuned us out for some bad reasons (racism, guilt, obsession with celebrity), but also for some solid reasons. We had become boring and preachy, an earnest documentary speaking to the converted. Somehow we had forgotten our native tongues and instead were using a patronizing dialect good only for clearing rooms.

The whole world wasn't watching. And this meant that instead of addressing the entire planet, we'd have to settle for talking to each other. And the conversation immediately became smarter and way more interesting.

The conversation is about love and loss, ceremony and drinking and histories and futures, legends and gaming, and how none of us has a clear idea of what to do next.

Since the 1940s, almost any Indian who painted or wrote, attended a university, played the violin, or flew a plane, in at least a small way made history. It was a political act simply to be human in the con-temporary world. There was genuine doubt about whether we were going to be around, and if we were, whether we could cut it.

Those doubts have vanished. The work of affirming a continued Indian existence, of convincing ourselves and others that our culture is alive and dynamic, that history has often lied about us, that we are not all the same: this work is done. It will never be completed, and I fully expect that, in the year 2027, Indians will be answering ques-tions about what Indians eat. But those items can now be safely

crossed off our list. Indian people are clear about this: they want to remain Indian.

The debate today becomes harder, more painful, but just as important. The question is no longer whether we will survive but how we will live. It isn't about battling dead icons like John Wayne but rising to the challenge of creating our own visual history.

We are the ones who must make sense of Indian kids in Mexican villages who grieve at the death of a rap artist, or the implications of a new upper class being created by gaming and trade in some communities. We are the ones who have to consider when tradition becomes another style or when spiritualism becomes fashion.

In the 1960s, Richard Whitman journeyed to Santa Fe to realize the intoxicating vision promised in the glossy pages of a weekly magazine. He found instead a cold, soulless place where commerce meant the same thing as art, culture was often a pose, and cynicism came as naturally as breathing. Whitman survived Santa Fe, and a few years later he even survived carrying a rifle on the front lines at Wounded Knee. These days he exhibits his photographs and video work in New York and Paris. Sometimes he'll make droll asides about the way life changed his life, which it did, in fact, for the better. In the years after Wounded Knee and before 1992, the Cherokee artist Jimmie Durham wrote, "I feel certain that I could address the entire world, if only I had a place to stand." It is probably his most widely quoted remark. He believed that no relationship in the Americas is more profound or more central than that between Indians and settlers, and that nothing is more lied about. Indian artists who refuse to accept the lie, and who refuse to collaborate with the twisted colonial refuse of guilt and romanticism, he promised, would find it rough going.

He was certainly right about that.

I don't think we can lay claim to having built such a place—not yet, anyway. Perhaps, though, we've built something else: a space carved from hard lessons and bitter disappointment, a ruthless ambition for intellectual integrity and rejection of tired rhetoric, a passionate belief that our endlessly surprising communities are capable of anything, and a willingness to laugh, especially at the latest regulations from the

Indian thought police. It's a whispered exchange in the cheap seats of the Toronto Skydome, a Cree manifesto inspired by Allen Ginsberg and Cochise posted on the Internet, and the work of the artists in these pages.

The space may not be grand, but it's ours, free and clear. Every other Thursday, you'll find it in the back room of a border town bar, the one on Highway 17, dead east of Reservation X.

Bring lots of quarters. The jukebox is legendary.

States of Amnesia

Anyone who doubts the Creator has a killer sense of humor obviously hasn't spent much time in Oklahoma.

Welcome to the Sooner State, America's national park of the absurd. You can ditch that Foucault guidebook at the Kansas border; you won't be needing it here. Forget your coded symbols, the frayed maps leading to buried evidence of stolen history and conquest, and secrets hidden in names of streets and mountains. This is the Land That Irony Forgot, a place where the locals never bothered to put up facades: no deconstruction necessary.

Who better to show us around than Richard Ray Whitman, a native son from Gypsy, a small Yuchi community near Bristow. Whitman found and then lost paradise in Santa Fe in the 1960s, carried a rifle at Wounded Knee in the 1970s, launched an international art career in the 1980s, played a Sioux Indian in a made-for-TV movie about Wounded Knee during the 1990s—in other words, he's as average a red Oklahoman as you're likely to find, and so a perfect guide for our tour.

Whitman's people, the Yuchi, have no word in their language for history; what comes closest is the word "memory." He could live anywhere (and he seems partial to France, judging by some recent shows), yet he chooses to live in this prison house of nations. He's just

an afternoon's drive from the absent black neighborhood Tulsa fire-bombed into oblivion in 1921, not even that far from the jail outside Lawton where they held Geronimo.

Fun things to know about Oklahoma: it has the largest Indian population of any U.S. state; it is home to seventy different tribes but not one federal reservation; it has been the victim of many recent man-made and natural disasters. First it was called Indian Territory, because Indians from all over were relocated there against their will during the mid-nineteenth century because of a changing real estate market; later it became known as the Sooner State.

What are Sooners? In 1889 it turned out that lots of non-Indians wanted to live in the Indian Territory, so on Monday, April 22, of that year the land was opened up to settlers. They came from far and wide. *Harper's Weekly* recorded the events this way: "As the expectant home-seekers waited with restless patience, the clear, sweet notes of a cavalry bugle rose and hung a moment upon the startled air. It was noon. The last barrier of savagery in the United States was broken down. Moved by the same impulse, each driver lashed his horses furiously; each rider dug his spurs into his willing steed, and each man on foot caught his breath hard and darted forward. A cloud of dust rose where the home-seekers had stood in line, and when it had drifted away before the gentle breeze, the horses and wagons and men were tearing across the open country like fiends."

There really weren't any rules except one, which was that you had to wait until noon to cross the Arkansas or Texas border. Even this restriction was deemed excessive by many, who jumped the gun and claimed their homestead the morning or night before. They were federal lawbreakers, and have now been enshrined in Oklahoma folklore as heroes. This is a fine example of the one genius of Oklahoma: the ability to turn past embarrassment into pride, crime into virtue, to mostly erase history and when that doesn't work, wear its troublesome details as badges of honor.

The show tunes have been terrific for the state's image, effectively masking Oklahoma's rather extraordinary history of racism. Examples of racism toward Indians nearly always, over time, turn into something

else. The Trail of Tears is a famous, regrettable tragedy. An American president defied the Supreme Court and death-marched the Cherokee, Chickasaw, Choctaw, Seminole, Creek, and Yuchi from their ancestral lands to the hard dust of Oklahoma; everyone agrees this was a really bad thing. Later the exiled would include tribes from nearly every part of the new republic: the Great Lakes, the Northwest, the Southwest, the northern plains. Indian Territory became the American Siberia.

When Oklahoma won statehood in 1907, the very first order of business of the new government was turning Senate Bill 1 into law. SB 1 segregated the entire state. Lots of cities have race riots in their past, but Oklahoma's was something special. There was in Tulsa in 1921 a black community (with many Indian members) so prosperous it was called the Black Wall Street. When the usual made-up transgression sparked the fury of whites against blacks, huge mobs of whites looting and burning homes and carrying out summary executions were not enough. Survivors tell of airplanes pressed into service and, under the direction of law enforcement, dropping nitroglycerin bombs on the neighborhood. Entire city blocks were leveled and never rebuilt. No one knows how many died, hundreds at least. (In 1999, after years

Richard Ray Whitman, *Everything Is Okay in Oklahoma*, 2000. The numbers on the photograph indicate four generations of Choctaw women. Courtesy of the artist.

Richard Ray Whitman, *Man's Best Friend.* Courtesy of the artist.

of pressure from black residents, the city of Tulsa established a commission to determine the facts of the riot.)

Oklahoma, of the Trail of Tears and the Tulsa race riot, now proudly calls itself Native America on every license plate the state issues, and on every map and tourist brochure it prints. While other municipalities timidly explore the benefits of multiculturalism, Oklahoma reinvents itself as not simply a place welcoming of red people but one that evidently belongs to red people.

In the dead center of the country, Oklahoma is a bull's-eye in the heart of North America, less a state than it is a dare. Stripped of the veneer that protects our delicate sensibilities in California and Vancouver and New York and Alberta, Oklahoma is America without tears.

Whitman remembers. He loves Paris, and who knows, maybe he'll move there someday, but for now he lives in Norman, Oklahoma, and paints from memory.

Part III. Jukebox Spiritualism

A Place Called Irony

I t is hard to say when we first met, because I cannot remember not knowing him, or feeling his presence. It's sort of like asking when do you first remember meeting your older sister. But if you want a starting point, maybe it was 1960 at Cherokee Lane Elementary School. I have vivid memories of hanging out with Irony during recess in the first grade. At first I guess I thought he was just another imaginary friend (okay, like you didn't have any, right?), but there was something about the way he critiqued the other kids' performances in dodge ball, or the funny looks he gave me when we ducked and covered during civil defense drills. I remember him during Thanksgiving, advising me on what colors the feathers should be on the turkeys and the Indians, but I could tell he wasn't really into the academic side of things. He was cool, like the hoods in their green work pants and black Chuck Taylor tennis shoes, smoking Marlboros at the bus stop, but unlike them he never looked like he was trying to be cool. He just was.

As my childhood unfolded I relied on him more and more. A few times a week he'd fall by the crib and we would watch Bullwinkle together, Irony explaining things I didn't get, like who Norman Mailer was and why Russians are funny. He told me scandalous stories about

Hanna and Barbera, agreed that I would make an excellent pilot with a pretty good chance to become an astronaut, and listened to my theories on turtles and slot cars and ice cream. He was there for me when I earned my Indian dancing merit badge and when I and other privileged Scouts lined Pennsylvania Avenue one January for President Nixon's inaugural parade. I stood there in my uniform, beyond frozen, and he kept me in stitches with his color commentary on the floats. When the presidential limousine rolled by, Irony, wearing black leather from head to toe and a red bandanna that said KILL FOR PEACE, offered a power salute and I remember thinking, wow, am I really glad he's invisible.

He was the only one who seemed to understand how weird it all was, the Comanche stuff, parents, sisters, geometry, SATs, girls. I gradually came to understand something of his role in the cosmos, although even now I don't know what he was exactly. The Big Guy's bastard son? The patron saint of strange peoples in strange times? I realized he was not just an interpreter of the bizarre but was actually a kind of fixer of the bizarre. Sometimes he would slip and talk about things from the last century like they happened last week, and he was there. Once, I asked him the basic Comanche political question (Quanah Parker: sellout or patriot?), and he started rambling about the time he and Quanah got so trashed in Fort Worth that . . . well, the details aren't important. The main thing is he seemed to have been around forever, and always had front row seats to the main event. He was there when Sitting Bull and Black Elk signed up with Buffalo Bill and toured Europe, when Montezuma looked at Cortés and concluded the Spanish adventurer was a deity, when Cher recorded "Half-Breed," and when the first Mohawks built their first skyscraper.

The next inauguration I was on the other side of the barricades, with Rennie Davis and his splinter group of seditionists, and was almost run over by a humorless motorcycle cop. By then it was 1973, and though the sixties were plainly over, I wouldn't hear of it. I knew everything then, even more than Irony, and our relationship cooled. I grew tired of his endless puns and wisecracks—he couldn't seem to take anything seriously—and after he dozed off during one of my explications on

lessons from the anticolonial struggles in west Africa, I wouldn't speak to him for a year. The truth is I started taking him for granted, never imagining that someday he might be gone.

Like others of my generation I joined the Indian movement, a social protest just getting under way as others faded into oblivion. They say timing is everything and in this case that was certainly true.

We lost touch for a while. I thought I had learned everything Irony had to teach me, but I was wrong. I knew how to read the signs. Yes, I had the basic fluency all Indians must have to make sense in the empire of the senseless, but I was really at the 101 level. I cringe now at my arrogance back then.

We had a terrible fight in 1975, when I pleaded with him to choose someone, anyone, to be our number one friend instead of Marlon Brando, but Irony wouldn't hear of it. He loved Marlon, and they talked on the phone for hours. Irony even claimed that Brando gave him a bit part in *One-Eyed Jacks*. (I don't know if this is true or not, since I have never seen the film.)

The movement broke my heart, as movements do, and I found solace in the oldest new place on the continent, New Amsterdam. It was the eighties. Irony and I had achieved a détente of sorts. He was pretty busy, flying around the country for important clients, but he would call up a couple of times a year and invite me over to his suite at the Plaza. We would order in Chinese and Irony would slap a favorite video into the machine—the Grammy Awards, or a Reagan press conference—and argue about Cyndi Lauper or who should coach the Knicks.

I respected him, but I also felt overloaded by Irony. He seemed to be everywhere at once, and it became too much. I saw newspaper ads for sweat lodges and vision quests and wanted to shake him, and say, "Yo, if this isn't going too far, will you please tell me what is?" To be Indian you had to be spiritual and environmental all the time, and the whole scene started feeling like church.

I should have asked him for some clarity on all this, but after I saw a picture of him in the *New York Post* twisting the night away at Studio 54, I decided to keep my questions to myself.

A few years later, as the eighties turned into the nineties, I picked up the phone and heard the familiar voice, though slurred and weary. He was at the Kahala Hilton, obviously tanked and just as obviously lost. I was shocked. Yes, I had heard the talk, at Veselka's on Second Avenue and at the Calgary Stampede and the Crow Fair, wherever Indians gathered, the whispers that Irony had lost a step, or maybe two steps, that his recent work was lacking in verve, in heart, in a certain complexity that had always been there before. People talk, people gossip, that's the way of the world. I couldn't believe it had gotten to Irony, yet here he was holed up in some twelve-hundred-dollar-a-day cottage in Honolulu, asking the same questions. Worse than the criticisms, he said, was that some people didn't even recognize his work anymore, or confused it with that of his so-called rivals. He complained bitterly about the recent spate of academic books on coyote and trickster and Madonna, "those pretenders," he called them.

I tried to talk him down as best I could, saying he was the Man and he shouldn't demean himself this way, and telling him how much I and all of the Nations loved him. That sort of worked, but it might have had more to do with the pitcher of Kamikazes at his side. Eventually he said he loved me too and maybe he would be remembered, damn straight should be after all the crap he's been through stuff nobody even knows about and on and on, then he started singing "Danny Boy" and we finally said good-bye.

He rang a few days later from some strategic planning conference in Aspen, a bit embarrassed, and laughed off the whole episode. After that I paid closer attention to his career, and to me it seemed that he was back on top. Casinos were exploding across Indian country, *Dances with Wolves* swept the Oscars, Russ Means played Chingachgook in *Last of the Mohicans,* the Indian Arts and Crafts Act passed, Louise and Michael wrote an airplane best seller that stiffed. Funny, brilliant stuff, and 1992 was still coming up. I looked forward to Irony's best work, maybe ever.

I was about to send him a congratulatory telegram when a mutual friend told me Irony was gravely ill in some clinic in Switzerland (the one where Mick Jagger and Keith Richards went to kick heroin by

having their blood replaced), being treated for some exotic form of iron-poor blood. He'd been there for months.

It struck me fast and it struck me hard. He had nothing to do with these recent episodes! We were doing this stuff on our own! But why?

I consulted my animal guides for the answer. My animal guides happen to be rock bands, and at this dark moment I asked everyone for help, living and dead, even Lou Reed. And really, they all helped (thanks everyone!), but the ones that spelled it out the best were Zappa and Westerberg. Frank gave up the timeless question: "Is that a Mexican poncho or is that a Sears poncho?" Paul mumbled this, from the smoky end of a south Minneapolis bar, "He who laughs first didn't get the joke."

Over tears, banana cream pie, and bad coffee at Denny's, I came to understand that the pressure had finally proved too much. He was like that political comic I heard about once who gave up his promising career the day Henry Kissinger won the Nobel Peace Prize. I never imagined Irony could be upstaged by reality, but that is apparently what happened.

That night I dreamed of him, poolside at the Kahala, wearing dark glasses and blowing cigar smoke, telling me to chill, offering neither apologies or regrets, just a weak Norma Desmond imitation: "Whattaya mean big? I am big, it's the pictures that got small."

A phone call the next morning brought news of his passing.

Some people say that Irony did not die in a clinic at the foot of the Alps on the eve of the odd anniversary that went largely unobserved in 1992. They say he lives on, wearing disguises, shape-shifting at will and turning out his best work even now. Others say he is on hiatus, like a temporarily canceled television show waiting only for a better time slot. Still others are glad to see him go. They say irony has outlived its usefulness. They argue that we cannot maintain our spiritual beliefs and traditions and rebuild our Nations with cheap laughs.

They have a point, but they miss something, that ineffable something that lets us keep on keeping on, despite many good reasons not to. His laughs were not cheap, but dear. His best work—Walking in Two Worlds, collective decision making, Oklahoma, Miss Indian

America, Wayne Newton—will live forever, teaching our children unto the seventh generation the lessons of the past.

Dead? I don't think so. Wherever Germans build tipis, government officials announce BIA reorganizations, Indians star in westerns, and tribal chairmen argue that high-stakes casinos are a traditional affirmation of sovereignty, Irony lives.

After all, it's his world. We just live in it.

Life during Peacetime

I wanted to fight against the Secret Police takeover, but from within
the Party.

> —Leonard Cohen, *Beautiful Losers* (1966)

As you can see, there's no one around.

> —Billy Corgan, "1979" (pop single, 1996)

Things weren't supposed to end up like this.

Failure, yes, we were ready for a thousand kinds of defeat.
We even looked forward to it in dark, private moments,
believing it would offer opportunities for last-minute redemptions to
make up for dubious and misguided strategies, absurd tactics, and
blind faith. Obliteration no doubt had its drawbacks, but the endless
wait for revolution to fail or succeed was hell.

I showed up late for the party, as usual. I participated in the sixties
in the most authentic way possible, through television. Later, in the
seventies, when I was old enough to make disastrous choices about my
own life, I shrewdly opted for a college at one time regarded as bravely
experimental, but when I applied it was in serious decline. The school
had no grades. You passed or you failed, and since I had barely passed
high school this sounded good to me. Also, classes were more or less
optional, and you had to spend every other quarter working at some
kind of job somewhere else to gain life experience. This was a won-
derful system for self-directed, highly motivated coffee achievers who
as often as not had been to prep schools or high schools better than
most prep schools.

For some reason, I never quite fit in and drifted off a year later to join the struggle. In August 1974, for a suburban Indian like myself, the struggle could be found in Sioux Falls, South Dakota.

A year and a half earlier, the Oglalas of Pine Ridge had asked the American Indian Movement for help in their fight against a fascistic tribal chairman. The AIM people took over the village of Wounded Knee, and the government sent FBI agents and federal marshals to support the hated tribal chairman. The siege lasted ten weeks. I was in high school then and had watched some of it on television. It ended badly, with little honor for either side. After the early moments of in-spired brilliance and breathtaking heroism, AIM self-destructed even faster than Nixon's White House. The Justice Department looked inept during Wounded Knee, and was sick and tired of Indians and their teary lamentations, and so chose to indict everyone they could who participated in the rebellion. This number totaled more than five hundred. The indictments were petty and vindictive, and were meant to teach a hard lesson to the grandmothers and schoolkids and Vietnam vets and drunks and workingmen who took part in Wounded Knee. Legal action wasn't necessary. It seemed like every AIM leader was in jail or on the run, and the movement was broke. The feds could have quietly dismissed all the charges, since their goal of destroying AIM had been achieved, yet for two years they insisted on bringing to trial every case no matter how weak. You can look this up: the U.S. government tried some Wounded Knee defendants on charges of cattle rustling. The siege lasted two months, but the trials would go on for two years, sometimes taking place in several cities at once.

Struggle HQ was in the Van Brunt Building, a huge, abandoned, brick apartment house on a main street in downtown Sioux Falls. It was slated for demolition, and much of the place had already been stripped, but in the meantime the city had arranged for its use by the Wounded Knee Legal Defense/Offense Committee. You can see why. The Indian movement had by that time destroyed Alcatraz Prison, the Bureau of Indian Affairs building in Washington, and the village of Wounded Knee, to name only the most famous campaigns, and the

city fathers of Sioux Falls felt it was a clever move not only to provide housing for the rabble and thus avoid turning the city into another AIM statistic but, in a really inspired touch, to furnish housing that was already predestroyed.

On my first night, as the sheetrock dust settled and neon lights from the Rainbow Bar blinked into my room, I thought, yes, this is going to be interesting.

For once I was right. The next day was filled mostly with paperwork and war stories. The paperwork was so that I could receive food stamps, and the war stories were not from Wounded Knee but from a bloody riot at the Sioux Falls courthouse a few months earlier. The seventy-one-day occupation was ancient history and rarely discussed. There were new rebellions, new arrests, and new defendants almost every week. The largest mass political trials in American history were under way, but nobody was paying any attention. A week after I arrived, Nixon resigned. A week after that, I attended a Sun Dance at Crow Dog's Paradise on the Rosebud Reservation. At night some of us would take to the phones, using rented Wide Area Telephone Service lines (where you paid for long distance by the month, not by the call; having your own WATS lines was a sign of prestige for movement groups in those days) to phone rich people thought to be sympathetic to AIM. They usually lived in California, and they usually said no. Sometimes, instead of calling prospective donors, we would call our counterparts at the Attica Legal Defense/Offense Committee. That summer the mail brought communiqués from the Symbionese Liberation Army, which had first kidnapped and then converted Patricia Hearst. The SLA promised an early death to its enemies, whom they unforgettably described as "fascist insects that prey upon the life of the People."

It was a glorious mess and a logistical nightmare. Mob lawyers donating their time and radicals who saw their legal practice as another way to defeat imperialism flew in for a few days, or a week or two, handled a case, and flew out. Legal workers were oppressed by the lawyers. White people ran everything, even though AIM was supposed to be in charge. Paranoia was rampant, and completely deserved because

security was both a constant obsession and almost nonexistent. Drinking was banned, and practiced frequently. The defendants were sometimes old men and women from Pine Ridge who barely spoke English, and other times unlucky adventurers who were clueless about AIM or fighting imperialism or defending Lakota sovereignty. We railed against the "media blackout" that kept the world from knowing the truth, never once imagining that perhaps the world was growing a bit bored by our harangues. Somehow, we even won most of the cases in the courtroom.

I loved it. For five years I bounced around the movement. I lived with other legal committee members at an abandoned air force base outside Lincoln, Nebraska, where another set of trials was under way, and later in New York, where AIM opened an office across the street from the United Nations. The week I arrived was also the first time Yasser Arafat addressed the UN. I remember seeing police sharpshooters on rooftops, looking for possible assassins.

In 1979 I lived in San Francisco, where I had been editor of a movement newsletter for two years. When the inevitable splits happened, and my comrades and I finally lost our battle against the secret police takeover, I moved to New York, cut my hair (only because I was tired of long hair, I insisted), and retired from Indian politics.

In North America that year, Nelson Mandela was a household name only in the houses of intelligence analysts, South African exiles, and perhaps a few thousand committed leftists. I was not particularly knowledgeable about South Africa, so I probably didn't know this name until later. Equally obscure was this: in the left ghettos of New York and San Francisco and maybe Ann Arbor and Detroit, you would occasionally hear one comrade gossiping that another comrade was always trying to be "politically correct." This was never a good thing. Being politically correct meant being holier than thou, a goody two-shoes, a crashing bore, and stone-cold drag. And it was never, ever, applied to anyone but another leftist. It would have been nonsensical to refer to President Carter's stated belief in social justice and diversity as an attempt at being "politically correct." Only true believers were eligible to be trashed for their political correctness; liberals need not apply.

When I left New York at the end of the 1980s, Nelson Mandela was as famous as Michael Jackson. If there had been an election that year for King of Earth, Mandela would have defeated Mikhail Gorbachev by a wide margin.

Mysteriously, that bit of nostalgic leftist patois had also achieved stardom, and I would read in the *Washington Post* fantastic articles on how some Republican chairman was being sniped at by opponents for being "politically correct." It was a trait available to anyone, and I even found myself using it in this new-wave interpretation.

I would say this is as good a date as any to chart the dawn of the Age of Whatever. For me, that is. Everyone is entitled to his or her own Year Zero when words and history ceased to have any apparent meaning, and when irony became obsolete. To call someone politically correct today, as I understand it, is to ridicule their insincere attempts to oppose racism, sexism, homophobia, colonialism, and imperialism. Among others. I always hated these laundry lists, and I'll say this much for my rather dreary gang of bourgeois radicals: even though we were wrong about almost everything, at least we never believed that naming a thing made it better. We stupidly argued about the particulars of hierarchy of oppression, but at least we agreed there was such a thing. Now, of course, all oppressions are equally oppressive, and as such all right-thinking people should oppose them all equally. Even the white men who run Texaco arouse shock and indignation when tapes reveal their use of unflattering terms for black people. The executives are terribly sorry and embarrassed. They don't know what came over them, really. They are presumed, like everyone else today, to be opposed to racism and colonialism and all the rest. When they are busted, it is a sensational news story that runs for months.

To cope with such nonsense, the masses have developed a rather sophisticated coded response that has become the catchphrase of the last decade of the millennium: whatever.

Terrible diseases sometimes require terrible remedies. The whatever vaccine is blunt and indiscriminate, and for those who want to rescue words from meaninglessness, this cure is as bad as the sickness.

I left New York in 1991 to write, and I ended up writing a book about the Indian movement. During the 1980s, a popular mythology had been created about those years that drove me crazy. It was all peace and love and suffering elders and the four directions, and none of the stolen rental cars and shoplifting expeditions and attempted treasons that I remembered so fondly. Even the most basic facts were up for grabs, or not important. I would always end up, half-drunk in some West Village bar, saying things like "confusing the shoot-out with the FBI in 1975 with Wounded Knee two years earlier, events that had nothing in common, since one involved thousands of people and a popular movement, and the other a few dozen who were mostly strangers on the reservation, is like thinking that it was Malcolm X who gave the I Have a Dream Speech!"

Twenty years later I find, for the most part, the language and methods of the North American left exhausted and useless, rusting away in abandoned fields like obsolete farm implements. Their ability to challenge power and defy authority has all but disappeared. It's the price of being wrong too many times, and of failing to find an answer to the insidious courtesy of multiculturalism and the brave new world of political correctness.

In such a dim and confusing environment, the very idea of a show whose stated purpose is to engage art in the continuing fight against colonialism is either a very bold move or a very silly one. And when that show self-consciously employs a Mohawk Indian, a West Indian, a Chilean expatriate, a Palestinian, and a Comanche "cultural critic," a reasonable person might fear precisely the kind of self-congratulatory exercise that has turned profound words like "colonialism" into cartoons.

Instead, through work that is political yet never didactic, accessible yet challenging, the artists in Across Borders offer a vision of a new kind of political engagement; of this decade, fresh and bitter and funny and intelligent, and not for one minute cynical.

In the cool spring Ontario night, after everyone leaves, the installations pass the time by telling cruel jokes on themselves. Did you hear the one about the priest, the rabbi, the minister, and the fall of the

Paris Commune? They whisper tales of crazy lost nights during the Spanish Civil War, the ridiculous strategic blunders and pathetic fashion sense of those losers who fought Pinochet, of doomed slave rebellions in Haiti and South Carolina. High as kites on cheap wine, they party till dawn, collapsing in giggles after a very bad rendition of "We Are the World," and in this at least, you can tell straightaway: they are absolutely not kidding.

Last Gang in Town

I used to live in Cleveland. My family moved there in the mid-1970s. I had enrolled in Antioch College, a few hours south and west in Yellow Springs. Antioch is famous for requiring its students to work, not just study, in a program called "co-ops." In fact, half the time you would be somewhere else. When I saw a listing for the Wounded Knee Legal Defense/Offense Committee in Sioux Falls, South Dakota, I signed up immediately.

For reasons I can't quite remember, I spent the summer of 1975 living at my parents' house in Shaker Heights, working as a dishwasher at a restaurant called James Tavern. I probably had no idea what I was doing with my life. The Indian movement was imploding, I was attending a school designed for self-actualizing people who worked best with little structure—and I needed structure, at least to rebel against. I had barely graduated from high school and chose Antioch because it didn't have grades. Eventually I would learn that I'm just not good at school.

I should explain why I was a dishwasher. No, it wasn't a co-op job that Antioch found for me. I found it myself, maybe because I loved the irony of washing dishes while living in Shaker Heights and attending, at least theoretically, a prestigious private college. I spent most of

those years full of angst and guilt. There was one great thing about living in Cleveland in the summer of 1975: WMMS had an advance copy of the Bruce Springsteen single "Born to Run," months before the album came out and months before anyone else had it. They played "Born to Run" at five o'clock every Friday afternoon. You remember Jon Landau's line: "I have seen the future of rock and roll, and its name is Bruce Springsteen"? Well, the people of Cuyahoga County were living in the future in the summer of 1975.

Apart from those four minutes and thirty-one seconds, I was a pretty dreary person to be around back then, full of the sort of guilt and angst self-involved twenty-year-olds from privileged backgrounds who have seen the light of radical politics are famous for.

My father was a vice president at Cleveland State. My mother worked for the federal government. My older sister had some kind of job related to scholarships for minority students. My younger sister went to Shaker Heights High. And they were all involved with the Cleveland urban Indian community. I was involved only with a certain clique in the Indian movement, and myself. But I do remember going to some events and dinners, and remember being absolutely floored when this family, my family, was chosen as the Indian family of the year.

Clodus, my father, wasn't even Indian! We lived in Shaker Heights! Real urban Indians were struggling in ghettos, over on the other side of town. They drank all the time and were usually shooting pool and living outside the law. They intimidated mayors and churches and guilt-tripped them for money for Indian centers that really were schools for revolution. Russell Means was the dean of the school. At least, that was my urban Indian imaginary. By then, even I knew better. But you know, I had that 1960s thing of being convinced there was always something way cooler somewhere else. When I arrived in South Dakota in the summer of 1974, I soon learned that I had missed everything. It was like showing up at the end of the last set at Woodstock: you knew what it felt like, but you missed the main event. Of course, at the time of Woodstock I was fourteen, and didn't know anything about that either. For people like me, that was what the 1960s were about: pretending you were somehow part of it, and knowing everything

happening now was just a pale imitation. Only later would I learn that that was what people thought in the sixties too: I once heard about a guy who was in Grant Park during the 1968 Democratic Convention, and he couldn't escape the feeling that the real action was going on somewhere else in Chicago that night.

South Dakota a year after Wounded Knee was lame; the whole world was really lame compared with 1968, which made Cleveland in 1975 superlame. In fact, Cleveland was something of a national joke, with its burning river. My parents found it all kind of exciting. They relished the city's bad reputation, saw it as an adventure. Meanwhile, I was shuttling between South Dakota and Nebraska and New York before finally moving to San Francisco, where I became a movement bureaucrat. I started a newsletter for the international division of the American Indian Movement, which barely existed anymore. When everything finally blew up in 1979 I moved to New York and spent the next eleven years as a political exile.

Or that's how I thought of myself, anyway. I cut my hair and watched the New York Indian scene, and the broader Indian world, from a distance. During the 1980s I watched a mythology develop about AIM that bore little resemblance to the movement I knew. AIM was like Cleveland in the 1970s, dangerous, wild, unpredictable. You never knew what might happen next. Rivers might burn. Indians with .22s could seize towns and hold off Phantom jets and a thousand federal marshals.

In the seventies, things were not safe, and sometimes they were out-right dangerous. I mean, when I arrived in Sioux Falls, the first thing they had me do was sign up for food stamps, and I got the distinct impression that we got way more foods stamps than we were supposed to, if you catch my drift. There were organized shoplifting expeditions. Transportation was sometimes provided by stolen rental cars. Credit card fraud was so much easier back then . . . Anyway, I kept waiting for someone else to rescue AIM from the dustbin of bland-ness, but no one did. So in 1996 Robert Warrior and I published *Like a Hurricane: The Indian Movement from Alcatraz to Wounded Knee*. Here's what we said in the preface:

We look forward to future works that will engage these questions from other points of view and with different emphases. Certainly many of the figures chronicled here merit full-scale biographies. We hope others will more deeply explore the Red Power activists of the early 1960s, the student movement, and the deep connections between Iroquois and Hopi traditionals and the militants of Alcatraz, to cite only a few examples.

Ten years later, we're still waiting for those books and that debate. Okay, it's not like nothing has happened. But we wanted most of all two things: for *Hurricane* to become the gold standard for books about those years; and for other books to challenge our ideas, and for those books to create a passionate argument about what happened and what it meant. Of course, I always wanted our book to come out on top, but not as much as I wanted other books to explore other characters, other stories, and even to directly challenge *Hurricane.* Because if you don't have that, you don't have a viable intellectual infrastructure. A hundred years from now people are going to be studying what happened between November 1969 and May 1973. In the long view of history, those events are huge, and *Hurricane* was simply one, beginning effort to understand them. Among those missing books is the one about Russell Means and the Cleveland Indians of the early 1970s.

What the Indian world in the United States has failed to produce on a significant scale and in sufficient quality and quantity is a cadre of public intellectuals. In my opinion, we used to have this: Clyde Warrior, Jerry Wilkinson, Hank Adams, and above all Vine Deloria Jr. As many of you know, Vine left us on Sunday (November 13, 2005). My boss Rick West, the director of the National Museum of the American Indian, described it as losing a piece of the sky.

At this moment, thousands of words are being composed to remember Vine. Tonight, I want to remember him as the very definition of a public intellectual. Which is to say, he wasn't always nice. He wasn't what you would call a people-pleaser. Vine Deloria, like all great public intellectuals from Frederick Douglass to Edward Said, took positions. He did not affirm conventional wisdom, he challenged

it at every opportunity. Like all great public intellectuals, his thinking changed over time, it was contradictory, and he always had a significant number of people, and I mean people he cared about, his constituency, mad at him at any one time. Those who weren't, who would profess belief in and support for his positions across the board, clearly hadn't read him. I'm still angry at him for his long, long detour into the world of amateur scientific deconstruction, and his bizarre theories that perhaps dinosaurs had warm blood and lived among us. I mean, Vine, seriously, what the hell was all that about?

I'm still deeply grateful for his political courage in taking positions and writing about people and organizations contemporaneously, for his outrageous ambition to write a political manifesto, and have it published and immediately become exactly what he wanted. Think how silly *Custer Died for You Sins* would look now if it had sold a thousand copies. That is a high-wire act few will attempt. But what I love most about Vine is that he always wrote to us, to Indian people, at the same time he wrote to the world. I believe too many of our intellectuals today are writing to white folks and pretending there's some Indian consensus out there and that the job of Indian intellectuals is to tell everybody else what it is. Vine knew better: he knew an Indian world that is full of argument and brilliance and foolish mistakes.

And I love his legendary impatience, especially how impatient he was for his peers to emerge and take him on. He died still waiting, still angry.

From Lake Geneva to the
Finland Station

I f you are Indian and live in the city you basically are screwed.
This is because a large flashing neon asterisk floats above your
head, which turns into a question mark, before again becoming
an asterisk. You are in the wrong place and you know it and every-
one else knows it too. Perhaps you have an explanation, but it doesn't
really matter because even if you are here just for the afternoon, visit-
ing Aunt Daisy, who has taken ill and requires the advanced services
of an urban medical center, or you have to work as an architect or a
dishwasher because there are no jobs back home, or maybe you are
using government archives to research the history of your people's dis-
possession and subsequent impoverishment, the fact remains that you
are in the city and you should be on the soil of your homeland. Per-
haps if you hitchhiked in and went straight to the bus station (okay,
you could window-shop for new Tony Llamas, and maybe a quick one
at the Indian bar—on second thought, forget about the quick drink,
you would miss the bus for sure on your way to the Calgary Stampede
or a Sun Dance in North Dakota), maybe that is technically not a vio-
lation. But couldn't you fly there, if you were a real Indian?

Actually, I never had much sympathy for urban Indians, because I
came of age during the late 1960s, the only time in recorded history

when it was cool to be an urban Indian, and I had the terrible misfortune to be coming of age in the suburbs. This was definitely not cool.

I did not particularly want to be an urban Indian, but I mainly did not want to be who I was. If I could not be a racially pure, culturally intact aborigine of the Comanche persuasion, I would gladly have chosen less desirable alternatives (imagine arrows moving like weather fronts, heading north, and west, hitting the big tribes with vast reservations first, then slowly going East, South—the B list) and even settled for a ghetto in Oakland or Minneapolis or Winnipeg.

I would still be alienated, sure, robbed of my birthrights, but it would be a righteous, militant alienation, and I would join my lumpen proletariat brothers (I'm tempted to say "and sisters," but let's face it, back then it wasn't that kind of party) and we would together awaken the sleeping red giant.

Sullen worked for me, and I think urban poverty would have too, but instead of the seething, Black Panther–like rage that might have led to . . . something, I grew up in a mostly white middle-class suburb of Washington, D.C.

In my entirely undeserved teenage angst, I secretly believed that no red person on earth had ever gotten a worse deal. Yes, I knew that was wrong, because I had never been hungry, except for that time in LA when my parents left my two sisters and me with relatives who gave us cold cereal for lunch, and I knew terrible things happened to people lucky enough to be from reservations or urban ghettos, but this is what I believed at the time.

There were even dark moments when I thought it would be better to be adopted out, live with a white family, not even know any Indians till I hit my first year at Dartmouth, when I would trade my alligator shirt for, well, I don't know for what, maybe some indigenous dialectic, or turn into a drug addict or a poet. At least then the whole situation is spelled out, and your life becomes a journey to connect with what you never had.

I wanted everything to be different from what it was. Take the suburbs, for example. Washington is ringed by prosperous jurisdictions

that rank among the richest in the country, but did we live in Mont-
gomery County or Fairfax? No, we lived in Prince George's, more blue
collar than white, called "the ugly sister" of the metropolitan area's sub-
urbs. No European sports cars on my sixteenth birthday. We should
have been rich if we were going to live in the suburbs. Otherwise
what's the point?

Both parents were problematic. Admittedly, Mom packs an impres-
sive résumé: two full-blood Comanche parents, raised by an extended
family with lots of old people in blankets who didn't speak English,
fluent in Comanche into her twenties. But then what the heck are
we doing in the ugly-sister county in Maryland? It is both of their
faults, clearly. Dad, a white guy from a farm in Dibble, Oklahoma,
should be a redneck or maybe an anthropologist. Instead, it seemed
like he couldn't care less about the profound issues of race mixing
and colonialism and its tendency to produce confused offspring. Paula
and Clodus (he claims to have no idea why some aunt named him
that), from loving, strong families, and the first thing they did after
getting married was move out of the state.

This is why I was born in west Texas (no memory) and soon moved
to Ithaca, New York (maybe one memory), before landing in Mary-
land in 1959. We lived in the suburbs, but we visited Oklahoma at least
once and often twice a year, and I sometimes spent the whole summer
in Lawton, where my Indian grandparents lived, or at the farm where
my white grandparents lived.

However, I could just as easily tell it this way: they call it Texas now,
the place where I was born, but when my ancestors roamed those end-
less stretches of the plains, Texas was an idea whose time, fortunately,
had not yet come and the country was better known as Comancheria.
When Ten Bears visited Washington in 1864, President Lincoln showed
our chief a globe on which our territory was so labeled.

My home is the staked plains of Texas and the red dirt of Okla-
homa. Home is the little house in the foothills of the Wichita Moun-
tains where my grandmother lives, just down the road from our tribe's
bingo palace and at the edge of the wildlife refuge where unhurried
buffalo block roads and golden eagles arc through a turquoise sky.

Thunderheads build to the west. Geronimo is buried just a few miles away, and sometimes we stop by and pay him a visit. It is, we say often and in a thousand shades of emotion, hard to be an Indian. Yes, it is hard, and yes, our homes are modest and our cars rusting, but at least we know who we are and where we are from.

All of the above, incidentally, is true. Grandma really does live in that house in Medicine Park, in the heart of the heart of Comanche country, and buffalo really did block the road last time I was there.

I felt persecuted by history, tortured by fate. I wanted it all to be one thing or the other. I hated being half-white and half-Indian. We were the only Comanches in a white suburb, and even the white suburb was unsatisfyingly lame. The contradictions were halfhearted, as it were, ineptly constructed, lacking dramatic power. On one hand, Dad was a successful white guy who wore a suit and worked at a university, but he was also straight out of Dibble, still active in the Future Farmers of America, and bragged about never reading books, although he managed to write one called *Rural Recreation for Profit*. On one hand, Mom fit the image of someone who "married white" and craved assimilation, yet she was fluent in Comanche into her twenties and seemed remarkably free of confusion about her identity. Grandpa Chaat was a Christian, but he led a church full of Comanches who sang Comanche hymns.

Nothing really worked out. Grandpa Chaat should have been a self-hating, colonized oppressor, yet he carried out the duties of a spiritual leader and on both sides of the family there was no one who more clearly offered unconditional love. Dad should have been a gung-ho Republican, but he voted Democratic and refused to be drawn into issues of race and politics.

I want my contradictions to have the bold, clean lines of Scandinavian furniture. Instead they are more like junked cars on acid.

The truth is that I longed to be a stereotype. Mainly I wanted to be the full-blooded Comanche, secure in his own Comancheness, raised on the stories of his people. (Somehow, the full-blooded Comanches whom I had known my whole life, who had never moved away from southwest Oklahoma, who almost always married other Comanches,

would not suffice. They were Christians and not traditional enough. I think over the next rise I imagined more suitable Comanches.)

For most of my life I could be paralyzed with either one of two questions. The questions, though rarely asked with malice, were devastatingly personal ones masked as polite conversation. The questions were, "Where are you from?" and "How much Indian are you?"

I knew the right answers, but I could not give them without feeling like a liar. The first question caused only tension about what was sure to follow, but not paralysis. Since I either have a remarkably even tan or happen to be non-Caucasian, the first question would be are you Indian or are you Mexican, Japanese—basically from whence does your color originate? This I could answer. Indian, Comanche. My sisters and I never imagined a different one; and if we had offered something else, no one would have been more surprised than our parents.

Very often follows this one: how much Indian are you? Then we move on to the question of origins.

I knew the right answers. The right answers were "Oklahoma," and "full-blooded." If I credibly gave up the right answers, there could be a dignified exchange on various aspects of life as a bona fide Comanche Indian. I probably never even considered whether I would like such a conversation, and I see now I wouldn't have, but anything would have been better than the mixed-up, unsatisfying responses I mumbled.

These questions absolutely leveled me. Actually, they still do; I just handle it better. Essentially, without considering the question, which wasn't necessary because it was so obviously true, my authenticity as a person was in direct proportion to those very standards I said I disagreed with.

Every question ends up having a simple, expected answer and a complicated, unsatisfying one. Mom is full-blood, but actually there may not have been any full-blood Comanches since the last century because of our fondness for taking captives. Dad is white, undeniably so, but his mother was one-eighth Choctaw, an enrolled member of the tribe, and the farm Dad grew up on, and where I drove tractors and shot bullfrogs with .22s, was allotted Choctaw land (a piece of family

history I learned only a few years ago). I often think of myself as a suburban Indian, yet I have not lived in the suburbs in twenty years.

At another, simpler time I had political answers to some of these questions, which I only halfway believed and worked as marginally effective defense shields. The right answers say there are Indians and there are other people, but we have our own intricate rating systems for authenticity and can be ruthless when judging others. (For me, enrolled membership in a famous western tribe, skin color, and a certain social ineptness I marketed as a genetically determined stoicism were the high cards.) We have trouble believing in our own authenticity no matter how many times we tell ourselves we're okay.

In this contest who really wins? I believe blood quantum is a bunch of racist nonsense, but I also bitterly resent individuals who discover they are Indian as adults and then become Indian experts or Indian artists or writers or whatever. Saying you are Indian or not sounds good, but it also makes people choose one ancestry over another. I don't see urban Indians as second-class citizens, or reserve Indians as the epitome of all that is truly red, but if the land question is not central to our struggle and the reason for our continued survival, then I don't know what is. I despise the whole concept of tribal certification, but I have to admit I felt all warm inside when I picked up my own Comanche ID card.

There has become a victim mentality accepted by many Indians that sees us as pawns of government policies and the result of historical forces. Those elements are there, of course, but so too are individuals with minds of their own who make decisions based on factors far removed from patriotic national feeling, fighting or collaborating with colonialism, or economics. As some see it, there's never been an Indian who left the reserve out of a passion for bright lights, skyscrapers, and all-night newsstands. There's rarely an acknowledgment that reservation life, like rural life anywhere, can often be confining, mean, and provincial. Just as the dominant society has frozen its image of Indian people with a snapshot of Plains Indians of the nineteenth century, so too have we ourselves adopted some of the same limited thinking in how we see ourselves.

We have set up a bunch of binaries as if they represent most people's experience. The choices, as I understood them, were urban or rural, full-blood or not really Indian, traditional or sellout. My own existence never fit into the categories, and so, I thought, I never qualified.

Culture is continually being refined and changed, and always has been. The question is, according to whose blueprints, and to what ends? There is, I think, a growing impatience among dissidents within the Indian world with many aspects of the recent constructions. In the 1960s this all would have been called "a negation of the negation." It was probably necessary and often a lot of fun. We had been rendered invisible, disappeared, vanished; so we raised hell and generated a pretty impressive level of noise for our numbers. We had been stripped of our culture, and yet never mastered being white, which left us neither one nor the other; so we became spiritually reborn and envied by much of the dominant culture.

Masquerading behind a name of deceptive calm, Nations in Urban Landscapes (Contemporary Art Gallery, Vancouver, British Columbia, 1995) is a provocative exhibition that rejects the tiresome language of victimization. The concept is simply and elegantly stated by the show's curator, Marcia Crosby: "It is not an exhibit that constructs aboriginal peoples and their cultures as models for stewards of the land or keepers of Culture and Spirituality."

This sentiment runs counter to that of a great many Indian artists and intellectuals these days who busy themselves with pretentious and vapid constructions of ever more grand (and ever more humorless) cathedrals and training schools dedicated to the indoctrination of Unbelievers.

Shelley Niro, Eric Robertson, and Faye HeavyShield have better things to do. The three artists are models of their own flamboyant individualism. They don't so much defy categories as ignore them altogether, as if the subject is beneath contempt. Robertson, whom I met in Montreal only six months before and who seemed so at home there I figured he'd never leave, had relocated on the opposite coast as the show opened. ("I am not a political person," he says.) HeavyShield is a Blackfoot Indian, confusingly from a Blood Indian Reserve with

the mythic name of Stand Off, not far from Montana. (Call Faye's art minimalist if you want to start a fight with her.) Niro was born in the breathtakingly ridiculous place of Niagara Falls, New York, a rather miserable little town said to be run by gangsters. Already you can see how they would not be your first choice to teach Sunday school.

But make no mistake: these artists have lofty dreams of their own. "I'm looking for planets," Faye HeavyShield said quietly as we drove through the downtown Vancouver streets. A few moments earlier I had marveled, like a tourist, at the lights and bustle. Much more happening here at night than most American cities. (I must have sounded patronizing. Marcia said lightly from the front seat, "Paul is such an American." I turned to Shelley and whispered, "Is that an insult?" Shelley, after the briefest of pauses, laughed and said yes.) If the name of the show challenges the usual paradigms of land, city, and state, it occurred to me that even those weighty issues might be too limited, especially if Faye has her sights on outer space. I found out later she was talking about fabric instead of the final frontier.

In Vancouver the show opened at a gallery next to a small hotel surrounded by blocks of buildings that headquartered the hydro company that turns the raging waters of British Columbia into energy. The power company wanted the building where the hotel and gallery are as well, but the stubborn owners refused to sell.

Appropriately, the show signals its intentions even before you enter the gallery. In the window, visible from the street, you first see a parking meter in the window. It looks pretty much like any other parking meter. The meter has not been fed, and it registers in bright red its unhappiness with the word "violation." Inside the gallery are further violations—another Robertson piece in which crabs bravely explore lawns, as if they do not care they are someplace they should not be; Niro's "ironic" poses of "urban Indians"; and HeavyShield's gripping tale of dislocation, separation, and division ("we grew to love the sensation").

Crosby, Robertson, Niro, and HeavyShield seem to believe that Indian people are ready for what's next, to bust up the played-out definitions and replace them with something new, something unexpected,

who knows, perhaps even something interplanetary. They know there is more to be gained from hard questions than from easy answers.

A few weeks after the exhibition's opening in Vancouver, I am speaking at Johns Hopkins University in Baltimore, and during questions a kid asks about the Bering Strait. So, like, did Indians come here from someplace else or were you always here? I am at first charmed that there is still a Bering Strait controversy. The question is basically this: aren't you people immigrants like everyone else? I explain that although I am not an expert on archaeology, I find the radiocarbon evidence pretty convincing that my distant ancestors arrived here via the land bridge more than 10,000 years ago, but who knows and who cares?

Well, the questioner cared. He believed that if we had always been here we have special rights to land, but if we came over later, then it's really no different for us than for anybody else. Unless my ancestors battled mastodons and saber-toothed tigers in prehistoric Lawton and Abilene, I could take this whole indigenous business somewhere else.

I no longer found the questioner and his question charming, but it did help put things in perspective. There are some standards of Indianness I will never meet, period, and some parking meters that will never be satisfied no matter how many quarters I feed them. I drove back to Washington to the sound of a 1980s hit by the Pet Shop Boys, and the tune felt eerily appropriate, exactly like an anthem that turned the contradictions of dislocation into power: "In every city and every nation / from Lake Geneva to the Finland Station."

This extraordinary tension between the imagined past and the messy, uncooperative realities of our present is a crazy-making factory running twenty-four hours a day. If our confounding survival produces absurd questions in Baltimore, it has also created transcendent art in Vancouver.

Ghost in the Machine

They called my great-uncle Cavayo "Name Giver." He was the one who decided what to call the marvelous toys and dazzling inventions modern times brought to the Comanche in the last half of the nineteenth century.

He looks out at me from a framed picture taken at Fort Sill, Oklahoma, in November 1907. Cavayo and three dozen other well-known Kiowas, Apaches, and Comanches are arranged in the style of a high school class picture. Some wear ties, some wear bandannas, and most have braids. Each is numbered and then identified on the photograph: Maximum Leader Quanah Parker ("Chief of the Comanches") is 1. Quanah's mother was Cynthia Ann Parker, a captive taken by The People as a child, who found life with us quite agreeable and eventually married a chief. Cavayo ("Headman of the Comanches") is number 5. In 1907 he was nearly seventy, and he sits a few spaces to the left of Quanah, hat in hand, with long silver hair and a trace of amusement on his face.

To give something an appropriate name you must first understand it. Cavayo, to be charged with his responsibility, must have had a particularly sharp eye for technology. Over the decades he had surely seen the new and improved models of guns and beads and cameras,

and had to decide when those improvements justified a new name. By all accounts, Comanches were, and are, among the most practical tribes, with just a few taboos and nearly all of those could be waived in an emergency. It seems doubtful that Cavayo and his contemporaries would have fallen for that line about cameras as soul catchers. They were too busy trying to figure out new ways to obtain the latest firearms.

On good days, my ancestors were some of the finest people you would ever want to meet: generous and friendly and fun to be around, especially at parties. But we also were world-class barbarians, a people who for a hundred and fifty years really did all that murdering and kidnaping and raping and burning and looting, against Mexicans, Apaches, Utes, Pawnees, Pueblos, Americans, Poncas, Tonkawas, well, yes, pretty much anyone in our time zone. Compared to us, the Sioux were a bunch of Girl Scouts.

As a lifestyle it wasn't for everyone, but as a group we liked it. Others objected. The first guns that showed up were a joke and even though we traded for them and appreciated their usefulness in certain situations, real men preferred repeating arrows—two straight black grooves on one side, two red spiral grooves on the other side—instead of nonrepeating, unreliable, noisy, and frankly rather unattractive guns.

This would soon change. An arms race began that we were destined to lose. In 1840, with the war against us going badly, a visionary Texas Ranger named Sam Walker made an extraordinary journey. Walker knew that only with a vastly improved firearm could his Rangers prove successful, so he traveled to the Colt factory in Paterson, New Jersey, and worked with the great Colt himself to perfect the world's first repeating pistol. It was called the "Walker Colt" .44 caliber revolver. The gun that revolutionized Indian fighting, and weaponry in general, was a machine designed for one purpose: to kill Comanches. To make this very clear, each pistol carried an engraving of a battle between Comanches and Texas Rangers. We frantically tried to acquire the new guns but had limited success—imagine a member of the Crips trying to buy a dozen Stinger rocket launchers in the midst of the 1992 riots in Los Angeles: not impossible but really, really difficult.

Advertisement for the Colt repeating pistol, ca. 1850. Look close: those are Comanches on the engraved cylinder. From the Colt Collection of the Museum of Connecticut History; courtesy of the Museum of Connecticut History.

There should have been a special camera invented to shoot Indians as well, given the tremendous influence photography has had on us. If one machine nearly wiped us out—we numbered just over a thousand when my grandparents were born at the turn of the century—another gave us immortality. From the first days of still photography, anthropologists and artists found us a subject of endless fascination. When the pictures began to move, and then talk, they liked us even more. We starred in scores of movies. John Wayne's best-loved westerns always seemed to take place in Texas or some other part of Comancheria. In *The Searchers*, often considered his masterpiece, Wayne spends years trying to find a girl we abducted. He succeeds, but by then she's turned into a "Comanch," and he must decide whether to kill her. The Duke identified so strongly with this movie that he named his son Ethan, after the fictional character Wayne played. (Robert DeNiro once called *The Searchers* his favorite film of all time.) The movies gave us planetary fame. Without them, the Comanches would be an obscure chapter in Texas history books. With them, we live forever.

In the age of moving images, we remain a favorite target of still photographers. The pictures in recent Indian coffee-table books, the ones that always seem to feature "Elder" and "Spiritual" in their titles, are a bit of deceptive flattery. The clear, unstated message of these books is this: the vast majority of Indians today—there is no nice way to say it—disappoint. We have, apparently, lost our language, misplaced our culture. We rarely make rain anymore or transform ourselves into cougars and magpies. We use glass beads and disposable cigarette lighters and sometimes, when no one is looking, even throw trash out of our pickups. We are not worthy enough to be members of the coffee-table book tribe.

To me, those books and the photographers behind them are like big game hunters on safari, and their big game is the real Indian. They set out from Berkeley or New York or Phoenix in their Range Rovers or Grand Cherokees, armed with Leicas and Nikons and Zeiss lenses—trained observers who see nothing. They barely glance at the fourteen-year-old boy in baggy pants and the Chicago Bulls sweatshirt as he screams down the road on his Kawasaki dirt bike, too fast and with no

helmet either. They ignore the fat guy with the Marine haircut and bad skin who pumps their gas at the Sinclair station. Busy checking directions provided by a German anthropologist, they miss the pack of excited young women in designer jeans and damaged hair, trading gossip on their way to a friend's house where the satellite dish actually works, for an evening of *Melrose Place* and microwaved popcorn. If our visitors cared to stop for dinner, the basketball coach who lives alone in the trailer just past the power station would, I am sure, invite them in and share his chili and fry bread from the night before; his only plans for the evening are the Maple Leafs and catching up on the latest controversies in deconstructionist theory with the new issue of *Third Text* that just arrived from London.

I am afraid that we present a rather pathetic tableau to the big-game photographers. I imagine they feel sorry for the Indians they encounter on their way to an audience with their quarry, the Perfect Master. *Drunks stumbling in the road—reason is those broken treaties, cycle of poverty, stupid Bureau of Indian Affairs, whole gambling thing, I don't know about that . . .* And when they find his house in the middle of nowhere (the directions might as well have been in German), all their hard work pays off. The Perfect Master delivers, with astonishing tales and authentic wrinkles, and the equipment, *thank God,* works without a hitch and the PM, what a guy, even takes *our* picture with his little automatic 35 mm and seems fine with the money (five crisp new twenties in a discreet white envelope), doesn't even count it, and *wait until they see these prints in New York.* They dream of book deals and cable television infomercials.

They blow right past us, without a clue.

Perhaps the niece who likes bad television spends Tuesday nights teaching the Cheyenne she learned from her grandparents to her friends. Maybe the postmodern basketball coach finally sees his critique of Foucault published in Belgium (unfortunately for him, there is not one person on the entire Crow reservation who reads Flemish). I am pretty sure the truculent grandson finally agrees to wear his new helmet. And the overweight employee of the Sinclair station—I'm just

guessing here—leads a campaign that sends the crooked tribal chair-woman and all her cronies packing.

I do not know how their stories end, but I know the possibilities are there for the unexpected, the surprising, the improbable, and even the impossible. And these possibilities are precisely what escape the big-game hunters. They search for ghosts, for elders trapped in amber. Sometimes, they even find them. But no matter how their poltergeist expeditions turn out, no matter what they find, they miss far more.

The photographers in these pages, on the other hand, don't miss much. Their images show us our families, at our Sunday-afternoon best and our predawn, post-bar-closing worst. We see our grandparents, foolish in parade cars and ridiculous in war bonnets, laughing in a way you never see them laugh in most pictures taken by non-Indians. Like my bloodthirsty progenitors, these photographers demonstrate a fine appreciation for technology and all it can accomplish. They are fearless in other ways, and not just in technical proficiency. They dare to experiment, to theorize, to argue and harangue, to tease and joke. They are not following anyone's instructions. To use the parlance of the late nineteenth century, these Indians have strayed "off the reservation."

For a genre still relatively new, there is a remarkable amount of conceptual work being done. But that should not surprise us either. Exploration of the cutting-edge theoretical issues that photography presents is one of our traditions. Each of us has a complex relationship with photography, and we each know it. That relationship is one of culture, of history, of politics. It is immediate and concrete, and at the same time wrapped up in the kind of intricate theoretical issues that can give you a headache in five minutes flat. It is Sitting Bull push-ing his signed photographs in Europe in the nineteenth century, and Leonard Crow Dog inviting film crews to shoot the Sun Dance in the twentieth. It's looking for—and finding—old pictures of your rela-tives at the Smithsonian's National Anthropological Archives. It is our radical leaders from the 1970s finding steady movie work in the 1990s, and the haunting thought that comes at you like a freight train from

hell that no pictures exist of Crazy Horse, but the U.S. Postal Service issued a commemorative postage stamp of him anyway. It is our own frequent willingness to lead the searchers in their quest for the real Indian. It is the terrible truth that most of us, in dark, painful moments, have felt inadequate for not living up to the romantic images. We know they aren't really true, of course. We are somehow supposed to be immune from their powerful beauty, yet the reality is that we are particularly vulnerable.

We approach the millennium as a people leading often fantastic and surreal lives. The Pequot, a tribe that's all but extinct, run the most profitable casino in the country, and tribal members become millionaires. But guess who's still the poorest group in North America? Vision quest retreats and sweat lodge vacations are offered in the pages of *Mother Jones,* and one of our best so-called friends in the entertainment industry bankrolls fawning documentaries on us but refuses to rename the Atlanta Braves, and that *Dances with Wolves*—I'm warning you don't get me started—*not just the novel but even the shooting script said it was about Comanches and they only changed it because the production manager couldn't find enough buffalo in Oklahoma and they made the Comanches Sioux just like that—poof—and everyone in my family liked it anyway!!!!*

The brilliant Palestinian intellectual and troublemaker Edward Said wrote that "in the end, the past possesses us." Okay, Eddie, I get it. But is it supposed to possess us *this much*? The country can't make up its mind. One decade we're invisible, another we're dangerous. Obsolete and quaint, a rather boring people suitable for schoolkids and family vacations, then suddenly we're cool and mysterious. Once considered so primitive that our status as fully human was a subject of scientific debate, some now regard us as keepers of planetary secrets and the only salvation for a world bent on destroying itself.

Heck, we're just plain folks, but no one wants to hear that.

But how could it be any different? The confusion and ambivalence, the amnesia and wistful romanticism make perfect sense. We are shape-shifters in the national consciousness. We are accidental survivors, unwanted reminders of disagreeable events. Indians have to

be explained and accounted for, and to fit somehow into the creation myth of the most powerful, benevolent nation ever, the last, best hope of humankind on earth.

We're trapped in history. No escape. Great-uncle Cavayo must have faced many situations this desperate, probably in godforsaken desert canyons against murderous Apaches and Texans. Somehow, I know what he would say: get the best piece you can find and shoot your way out.

Afterword: End of the Line

This book, as you've figured out, is a collection of essays. The oldest was written in 1992, at the end of the first Bush administration; the newest (this one) is being written in the final months of the third. My obsessions haven't changed much: I continue to find buried history, pop music, failed revolution, television, and futures that never quite arrived subjects of endless interest. But the truth is, I'm not really the same guy who wrote these essays. Are you the same person you were in 1992? I hope not, especially if you're nineteen.

My career in the Indian business and in a way this book both began in 1974, in the midst of my extremely brief tenure as a college student, when I applied for an internship with the Wounded Knee Legal Defense/Offense Committee. The big idea that greeted me in South Dakota was that lots of Sioux people didn't care much for the United States and considered themselves a sovereign nation, and that it was possible, through legal and extralegal methods, to negotiate a new relationship based on existing treaties.

By 1993, I was giving worrisome lectures that said "many of us have lost sight of the ideals of not just the better aspects of the Indian movement of the 1970s but those of the resistance fighters of earlier

generations and centuries that are the reason we are here in the first place. Today, the cutting edge of the political Indian world in North America revolves around questions of gaming, tobacco, of representation, of mascots and burial sites. (It is too perfect that the biggest single donation for the National Museum of the American Indian comes from proceeds of the Foxwoods casino.)"

Now, after yet another fifteen years, I don't know what to think. This book is called *Everything You Know about Indians Is Wrong,* but it's a book title, folks, not to be taken literally. Of course I don't mean everything. Just Most Things. And the You really means We, as in all of Us.

In 1974, I liked the big ideas, but I mainly liked being part of the struggle, as we called it in those days. It was exciting! You never knew what would happen next. I wrote press releases about the trials, and a few years later I was assigned to the International Indian Treaty Council, the international wing of the American Indian Movement. They sent me to San Francisco to launch the *Treaty Council News,* which brought word to the Indian masses that through alliances with the African National Conference, the Palestine Liberation Organization, the Zimbabwe National Union, and other friends from distant shores, we could pressure the United States into reconsidering its policy of beating us up, throwing us in jail, and stealing our land. It sounds crazy now and was mostly crazy back then, but at the time it did seem that perhaps the American empire was receding fast. There was, for example, the military defeat in Vietnam. Watergate. Countries in Africa were being liberated practically every few weeks. Our friends in the Puerto Rican Socialist Party seemed poised to take over the island through the ballot box, and, even more amazing to me, in 1974 we filled Madison Square Garden with demands for Puerto Rican independence and Lakota sovereignty. If tens of thousands of New Yorkers were rallying for the Indian movement, who knows how many more, around the country and around the world, might be persuaded to join us?

The Treaty Council (or actually, the white lawyers we hired) wrote smart papers about international law and legal precedents, about how the Navajo Nation is larger than loads of countries in the United

Nations, about how a reborn Great Sioux Nation would be a friendly asset to its American neighbors, about how white farmers would be compensated or maybe even stay there and become citizens.

Except when I was reenrolling in school or living in my parents' house in Shaker Heights and working at a restaurant, I was part of AIM for about five years. I was even listed as a member of AIM's Central Committee (yes, my gang were self-identified leftists), but every month from the summer of 1974 until I left in 1979, AIM became more dysfunctional and irrelevant.

I moved to New York, cut my hair, and basically retired from Indian activism. What was left of AIM turned into a pitch-perfect version of the U.S. sectarian left, with competing factions and vicious infighting. Nobody cared, including me. As I would remember years later in the essay "All the Rage" (published for the NMAI exhibition New Tribe New York: The Urban Vision Quest), using the obligatory Jay McInerney second-person voice all of us were legally required to use in the 1980s: "You are moving to New York because your little crowd that used to run AIM no longer does, and you always felt like a tourist in San Francisco anyway. You're moving to New York because it's the capital of the planet, because your comrades are there, because it's the first choice of political exiles the world over. And because in New York, you can be anonymous."

Yeah, so thank you, Jesus, for New York. Here insert misty memories of thrilling bands at thrilling clubs, legends now but back then within the reach of nearly anyone. A right-wing governor of California had become president of the United States, but New York felt like rebel territory. Elvis Costello and the Clash were at the peak of their careers, and releasing brilliant new records what seemed like every few months. In 1987 I wrote my first essay for an art exhibition, one called We the People organized by Jean Fisher at Artist Space. Although that essay is too lame to include here, it was liberating to write about Indian space without having to advance organizational agendas.

I loved New York but realized that for me, living in New York and writing were both full-time jobs, so in 1991, on the eve of the first Iraqi war, I chose writing and moved to my family's empty vacation home

in central Virginia. It was perfect: in the morning I would drink coffee and read the *Washington Post* and watch herons spear fish in the artificial lake a dozen yards from my front door. But really, who can write in such an environment? So, bored with country life, I moved to Washington a few years later. By now I had a book contract, and in 1996 Robert Warrior and I authored *Like a Hurricane: The Indian Movement from Alcatraz to Wounded Knee.*

I felt out of touch during the Columbus Quincentennial, hated *Dances with Wolves,* and felt estranged from the triumphalism within the U.S. Indian world during those years. So I spent the Clinton administration writing *Hurricane* and exhibition catalogue essays about dissident artists. I also began curating shows. In Washington, I found paid employment as an office temp and watched suspiciously as something called the National Museum of the American Indian came to life, first in New York, and then in Washington.

The NMAI always struck me as a bad idea, but a bad idea whose time had come. When I was rummaging through my papers to put together this book, I came across something I wrote about the museum in 1993, when I thought I was too good to work at the museum. Back then, I was at least smart enough to realize that the museum would have an impact on all of us; I knew that "for artists and intellectuals today, many of whom came of age in the wake of the Indian movement of the 1970s, we are affected by the new museum and all it represents, both literally (what Indian artist would not love to have their work on display at the NMAI) and metaphorically." Even then, from my high horse, I knew that the museum was a place of great contradiction:

> We work and think in this contested and unresolved space, somewhere in between a disreputable past and a glittering future.
>
> The Indian movement genuinely shocked the ruling class partly because it was so completely unexpected. We had, in those days, a capacity that I fear we have lost, the capacity to surprise. In the early 1960s, the popular image of Indians, an image we internalized to a large degree, was that of a passive, docile people. The style, tactics and rhetoric of the militants turned those images upside down.

I believe one of our greatest traditions is precisely this. In earlier eras, Indians were suppose[d] to surrender; instead we fought. We were supposed to die off from war and starvation and disease; instead we survived. We were suppose[d] to assimilate; instead we kept our traditions and languages. We were supposed to leave reservations for cities; instead we live in cities, towns and reservations.

Our designated place today is similarly neat and confined. We are keepers of the earth, of the zoos, of the skies and stars and plants and animals and insects. We are spiritual teachers, wise elders, environmentalists par excellence. We are wonderful artists and gifted storytellers.

For some the new museum will be a proud symbol of our continued sovereignty; for others proof that we are Americans after all. It is a debate that is far from over.

The National Museum of the American Indian, I have little doubt, will be a beautiful place full of gorgeous art. I wish it well. At every turn it will endeavor to show us as a people still here, still changing, not frozen in the past but bravely marching into a new, Indian future of our own making.

Still, I can't help thinking about the symbolism of the NMAI rising on the last piece of open ground on the Mall. Indians are the last piece in the puzzle. It's as if, finally, with great relief, the country has figured out what to do with us, as if our place and role in the Nation [have] at last been decided and reconciled and determined. (Art. Culture. Beadwork.)

For some artists, however, we are a riddle that can never be solved, and these new constructions present an exhilarating challenge to turn it all upside down again. If some of us are shopping for designer gowns and black ties, others, I think, see the moment as a once in a lifetime opportunity for the unexpected, the daring, the dangerous. They also know the best parties are always in the kitchen, on the street, way downtown or way uptown.

See you in the after hours club.

The truth is, I always wanted to work there, even when I denounced it as a sellout enterprise. I wanted to work there because I was tired of being broke, but also for the very reason that it was such a splendidly

goofy idea, I was sure it offered extraordinary possibilities. For what, I wasn't exactly sure.

In August 2001, my secret dream came true. On a humid summer afternoon I reported to the Smithsonian for processing as a new federal employee, shopped for designer neckties at Union Station, and checked out the vast hole in the ground between the Air and Space Museum and the Capitol.

The first three years I was assigned to the permanent history exhibit. Since 2004, I have worked mostly on contemporary art projects. When people ask me what it's like, I usually say, "Best and worst job ever." Although I've written at length elsewhere about the NMAI project, I have chosen not to include those essays here. The reason is simple: I'm too close to the subject, and feel that I don't have enough perspective.

However, despite my best efforts, irony lives, and I'm not oblivious to the fact that my career in the Indian business began with AIM and I am now a curator for the Smithsonian: a government employee. People ask me how that feels, and I tell them that working for AIM in the 1970s and for NMAI in the 2000s has more in common than you might imagine.

Consider: Scrambled, their acronyms differ by a single letter. The histories of both are filled with controversy and often-negative newspaper articles. AIM said it was a movement and not an organization, though it had officers and chapters and budgets. NMAI says it is a center of living cultures, not a museum, though the letter *M* stands for museum and it has exhibitions and collections. With AIM, white lawyers and leftists raised money and did their best to keep people out of jail. Most NMAI staff are white, particularly at middle and senior management levels. Both see themselves as one of a kind, original, like no other, and are comfortable playing by their own rules. Actually, come to think of it, both *are* one of a kind, original, like no other, and comfortable playing by their own rules.

NMAI and AIM really, really mean well. In their own hearts and minds they are on the side of the angels. Yes, each organization has failed more than it has succeeded. How could it not? The shambolic

movement of the 1970s and the twenty-first-century museum that denies it's any such thing have been fabulous laboratories of imagination and daring. I owe them more than I can ever repay.

And yet, U.S. history teaches us that some of the most catastrophic forces visited upon Indians—boarding schools, allotment, relocation—were created by our most enlightened and progressive friends. Good intentions aren't enough; our circumstances require more critical thinking and less passion, guilt, and victimization.

I read once that Charles Dickens sometimes had his characters do things in his novels that Dickens himself would later do in real life, for example, buy a house in a certain neighborhood in London. I can see exactly how this would happen. Dickens is thinking over breakfast, maybe I should move, and he's heard good things about some place across town, and he's also writing a novel, why not have some of those people, the fictional ones, check it out? He's also thinking about all the pages he has to write that day, and combining the real estate research with the novel research looks like a pretty smart move.

These essays, written over a period of fifteen years about, well, all kinds of things, were never meant to be a book, yet through the magic of publishing the essays become chapters, and the chapters reveal themes, and there you have it. I would prefer you didn't, but it's possible to read this book as a list of complaints. I criticized the way Indian activism of the 1970s is either ignored or portrayed by Hollywood with a half-breed FBI agent as the hero, and a few years later I'm coauthoring a book called *Like a Hurricane: The Indian Movement from Alcatraz to Wounded Knee.* In the 1980s, I started writing about Indian artists, and soon I'm curating shows. In the 1990s, I point out all the reasons why the National Museum of the American Indian is probably a bad idea, and in any case certainly not the kind of outfit I would ever consider joining. Sure enough, some years later there's PCS, a government employee at the Indian Museum.

So, here's some advice to all you cultural critics out there: be careful what you write.

That's it for volume one. Thanks for reading.

Acknowledgments

I thank the University of Minnesota Press and especially Jason Weidemann for finding a book in these discordant essays. I admit to ambivalent feelings about Minnesota: I always seemed to be there during the absurd winters, perplexed by the tribal customs of the white liberals and the local Indians. How such a place managed to produce Bob Dylan, Paul Westerberg, and Prince is beyond me, but I doubt if a single essay in these pages was written without those guys keeping me company. Writing is a lonely business, and for me the best is very late at night; I came to see my records as invisible friends. Zimmy, the Replacements, TAFKAP, and a thousand others kept me company and, copyright law being what it is, graciously allowed me to appropriate song titles for my essays. (Thanks!)

I also have visible friends—astonishingly enough, too many to list here. (How did that happen?) Through the past fifteen years, Robert Warrior, Jolene Rickard, and Jimmie Durham have been more than friends. They are my most important intellectual comrades, mentors, and critics. They never let me get away with anything, and therefore I believe they should be held partly responsible for the mistakes in these pages. Not completely, of course, but since I usually do what they tell me it would be dishonest to pretend it's all on me. Find something here you disagree with? Look them up on the Internet and tell them what you think.

Publication History

"Every Picture Tells a Story" was published in *Partial Recall: Photographs of Native North Americans,* ed. Lucy Lippard (New York: New Press, 1992).

"On Romanticism" was previously published as "Home of the Brave," *C* 43 (Summer 1994). *C* magazine is published in Canada by C the Visual Arts Foundation, a nonprofit organization dedicated to fostering the understanding and appreciation of contemporary visual art.

"After the Gold Rush" is reprinted from the book *Off the Map: Landscape in the Native Imagination* (2007) with permission of the National Museum of the American Indian of the Smithsonian Institution.

"Land of a Thousand Dances" was previously published in the Sundance Film Festival catalogue, January 1994. It is reprinted with the permission of Sundance Institute.

"The Big Movie" was previously published in *Story of Our Lives: How Hollywood Won the West,* a film exhibition catalogue produced by the Dunlop Art Gallery in 1992. The essay is reprinted with permission of Dunlop Art Gallery.

"The Ground beneath Our Feet" is reprinted with permission of the National Geographic Society from the book *Native Universe: Voices of Indian America,* ed. Gerald McMaster and Clifford E. Trafzer (Washington, D.C.: National Museum of the American Indian, 2004). Copyright 2004 National Museum of the American Indian, Smithsonian Institution.

"Homeland Insecurity" is reprinted from the book *Indigenous Motivations: Recent Acquisitions from the National Museum of the American Indian* (2006) with the permission of the National Museum of the American Indian of the Smithsonian Institution.

"Americans without Tears" first appeared in the exhibition catalogue *No Reservations: Native American History and Culture in Contemporary Art* (2006), published by the Aldrich Contemporary Art Museum.

"Delta 150" is reprinted from the book *Vision, Space, Desire: Global Perspectives and Cultural Hybridity* (2007) with the permission of the National Museum of the American Indian of the Smithsonian Institution.

"Luna Remembers" is reprinted from the book *James Luna: Emendatio* (2005) with permission of the National Museum of the American Indian of the Smithsonian Institution.

"Standoff in Lethbridge" is reprinted with the permission of the Southern Alberta Art Gallery, Lethbridge, Canada. It was first published in 2005 to document *blood,* an exhibition by Faye HeavyShield curated by Joan Stebbins.

"Struck by Lightning" is reprinted with the permission of the Southern Alberta Art Gallery, Lethbridge, Canada. It was first published in 2001 to document *Miyoshi: A Taste That Lingers Unfinished in the Mouth,* an exhibition of work by Baco Ohama curated by Joan Stebbins.

"Meaning of Life" was originally published in *Reservation X: The Power of Place in Aboriginal Contemporary Art,* ed. Gerald McMaster (1998). Copyright Canadian Museum of Civilization.

"States of Amnesia" was originally published as "States of Amnesia, or Why Richard Ray Whitman Believes All Roads Lead to Oklahoma" in *Richard Ray Whitman: The Presence of Our Absence* (Banff, Alberta: The Banff Centre, Walter Phillips Gallery, 2000).

"A Place Called Irony" was previously published in the exhibition catalogue *Indian Humor* (1995). It is reprinted with permission of Janeen Antoine for American Indian Contemporary Arts, San Francisco.

"From Lake Geneva to the Finland Station" was originally published in *Nations in Urban Landscapes* (1997) by the Contemporary Art Gallery, Vancouver.

"Ghost in the Machine" was previously published in *Aperture* 139 (Summer 1995): 6–13. It is reprinted with permission of the Aperture Foundation, New York City.

Paul Chaat Smith is associate curator at the National Museum of the American Indian of the Smithsonian Institution in Washington, D.C. He is coauthor, with Robert Warrior, of *Like a Hurricane: The Indian Movement from Alcatraz to Wounded Knee.*